PETER LANG
New York • Washington, D.C./Baltimore • Bern
Frankfurt • Berlin • Brussels • Vienna • Oxford

Jeff Kaye and Stephen Quinn

Funding Journalism in the Digital Age

Business Models, Strategies, Issues and Trends

PETER LANG
New York • Washington, D.C./Baltimore • Bern
Frankfurt • Berlin • Brussels • Vienna • Oxford

Library of Congress Cataloging-in-Publication Data

Kaye, Jeff.
Funding journalism in the digital age: business models, strategies,
issues and trends / Jeff Kaye, Stephen Quinn.
p. cm.
Includes bibliographical references and index.
1. Newspaper publishing—United States—Finance.
2. Press--Economic aspects—United States. 3. Newspaper publishing—
Economic aspects—United States. 4. Online journalism—Economic aspects—
United States. 5. Digital media—Economic aspects—United States.
I. Quinn, Stephen. II. Title.
PN4888.F6K39 338.4'707057220973—dc22 2009053927
ISBN 978-1-4331-0678-1 (hardcover)
ISBN 978-1-4331-0685-9 (paperback)

Bibliographic information published by **Die Deutsche Nationalbibliothek.**
Die Deutsche Nationalbibliothek lists this publication in the "Deutsche
Nationalbibliografie"; detailed bibliographic data is available
on the Internet at http://dnb.d-nb.de/.

Cover design concept by Vivien Arnold

The paper in this book meets the guidelines for permanence and durability
of the Committee on Production Guidelines for Book Longevity
of the Council of Library Resources.

© 2010 Peter Lang Publishing, Inc., New York
29 Broadway, 18th floor, New York, NY 10006
www.peterlang.com

Printed in the United States of America

To Alex, Hannah, Jackson and Nathan

To John Tidey, friend and colleague.

Table of contents

Acknowledgements

Numerous friends and colleagues gave us valuable suggestions for this book and we are grateful to the people who agreed to be interviewed for it. We would especially like to thank Paul Brannan, Kris Dahl, Jeff Jarvis, Andrew Jaspan, Tom Johnson, Sandeep Kapur, Katie King, David Nordfors, Keith Perch, Stevie Spring, John Tidey and Stephen Wright. Thank you also to our families for their patience and support while we were locked away writing.

Introduction

Pay walls versus free access, hyperlocal coverage, search engine optimization, niche content – the discussion about how the news industry will survive in the digital age grows more intense as the speed of its financial decline quickens. Is Google devil or angel? Will Amazon and other makers of electronic readers resurrect the paid subscription model for news? If they do, will they grab an unfair share of the profits?

In newspapers and blog postings, at seminars and webinars, wherever journalists discuss their profession, the talk is of survival. How will journalism be funded when the business models that sustained it for centuries are crumbling?

The onset of the global financial crisis in 2008, and the dramatic drop in revenue that followed, raised the level of industry turmoil as news organizations slashed staffs and budgets to cut costs.

But not everything is doom and gloom – there is plenty to be optimistic about too. Advances in technology have enabled journalism to flourish in remarkable ways – from instant global distribution to community participation and more powerful storytelling techniques. And there are already instances where readers have shown they are prepared to pay for digital news content.

It's worth remembering too that despite these massive upheavals in business models and technology, the centuries-old perception remains widespread that an informed public is an intrinsic social good.

With these changes crowding into one another, we felt there was a critical need for a book about finding new ways to fund journalism's key role in fostering democracy.

In the following chapters we attempt to place these developments in their historical and economic context. We provide an overview of where we are now and look at new ideas and practical solutions that are being developed throughout the world.

Chapters 1 through 3 provide a context for the current dilemma. The first chapter explores the issues and challenges media companies face in trying to fund journalism as the industry makes the transition to primarily digital distribution. Chapter 2 examines how the commercial side of the news business developed, early attempts to move beyond "ink and paper" to electronic news distribution, why newspapers give away their content for free online and the rise of Web 2.0 and social media. Chapter 3 discusses business models that news organizations have used in the past and are using today – with varying degrees of success. Among the models and issues addressed are paid content, classified advertising, aggregation, hyperlocal news, search engine optimization, dayparting and the emerging concept of distributed media.

Chapters 4 through 9 explore new business models to fund journalism that are already being tested around the world. From microfinancing in San Francisco to massive citizen participation in South Korea to passion "blips" in London, we provide case studies of experimental commercial practices. Among other topics included are sponsorship, non-profit organizations, trusts, industry-university partnerships and strategies for creating valuable niche content. We also look at why online users appear more willing to pay for digital content that exists outside of web browsers – on iPhones or PlayStations for example – than on web pages.

The final section of the book, Chapters 10 to 14, looks at how we can adapt and create new products, services and operational methods that could help support journalism. Chapter 10 examines relevant economic concepts that could be used as tools to develop a greater commercial infrastructure for journalism, such as versioning, bundling and unbundling, price discrimination, network effects, switching costs and lock-in. In Chapter 11 we look at how e-commerce offers untapped revenue possibilities for news organizations, why so many online users are unable or unwilling to use current payment systems – and how that can be overcome. We also examine how media companies are engaging their online users and building transactional relationships with them.

Chapter 12 discusses the importance of innovation in driving businesses, why news organizations have been slow to innovate and how that is changing. We provide case studies of innovative practices at media companies around the world. Chapter 13 focuses on electronic reading devices – e-readers, such as Amazon's Kindle – and the effects this form of distribution may have on journalism. E-reader

owners will pay for digital content, and the number of users is rising steadily. But questions remain about how to split the revenue fairly between content providers and e-reader manufacturers and whether news companies will be able to build their own transactional relationships with customers who subscribe via e-readers.

Finally, in Chapter 14, we highlight key issues and trends we believe will help shape how journalism is funded in the digital age.

1

The challenges of paying for journalism

Summary

The value of news media companies around the world has crashed since the global financial crisis started to bite in 2008. In America alone, newspapers lost $64.5 billion in market value that year. Traditional news organizations are struggling to survive. But the economic downturn has only speeded up a process that has been underway for decades. Emerging technologies and changing social trends began to disrupt established media business models and practices long before the latest crisis on Wall Street. The news industry is making a transition away from print and broadcast distribution to primarily digital platforms. But the advertising and subscription business models that supported traditional media companies in the past appear unable to do so in the digital age. Massive competition to attract online advertisers, and an expectation among audiences that web content should be free, are two of the biggest factors behind the current crisis. Quality journalism is expensive to produce – so how will it survive as traditional sources of revenue shrink? This chapter outlines the issues and challenges that media companies face in trying to fund journalism. It should be read in conjunction with the next two chapters, which consider the business models that have sustained journalism in the past.

The economics of journalism are not straightforward. Most other businesses operate with a simple formula: they offer products and services for sale and people choose to buy them or not. But journalism has mainly been paid for through indirect means. Newspapers and magazines usually charge for a single copy or a subscription, although some publications are given away free. But even for

the ones that charge, the sales revenue is unlikely to meet the cost of production. The real money has usually come from selling advertising space. The news content attracts an audience and advertisers pay to get their message in front of that audience. So, in truth, news publications do not generally receive the bulk of their income from their readers – they get it from advertisers. Therefore, the notion that consumers have been "paying" for news is somewhat misleading. Consumers have been funding only a fraction of the cost of producing quality journalism. Yes, the income from single copy sales and subscriptions has been substantial and an important component of the news industry business model. But that is only part of the story behind journalism's financial crisis. The bigger picture is that print newspaper readership has been declining for years, that readers have been turning to online sources for news, that there is far greater competition for advertising revenue online than in print and that advertisers pay only a fraction for online space compared with what they pay for print and broadcast ads.

By the second half of the twentieth century America's newspapers, like many newspapers around the world, relied largely on advertising for their income. Professor Robert Picard of Jonkoping International Business School in Sweden, one of the world's most eminent media economists, noted that advertising rose significantly during that time as a proportion of total newspaper revenues. Advertising sales accounted for 71 percent of newspaper income in 1956 compared with 82 percent by 2000. The category proportion of advertising also changed. Professor Picard noted that in 1950 retail advertising made up 57 percent of advertising revenue, national advertising 25 percent and classified advertising 18 percent. Half a century later, retail and classified were nearly equal in terms of their contributions (44 percent and 40 percent respectively) and national advertising provided only 16 percent of total advertising revenue. "These shifts made newspapers more dependent on classified employment, automobile, and real estate advertising that tend to be more cyclical and respond more to changes in the economy than brand advertising that makes up the bulk of television advertising," he wrote in a paper headlined *Evolution of revenue streams and the business model of newspaper: The US industry between 1950–2000.*

Newspaper advertising is cyclical and affected by the business cycle and other changes in the economy, and newspapers' revenues mirror these trends. "Although circulation income increased in real terms by more than a third in the half century, that growth rate stopped in the 1980s, and circulation revenue has been flat since that time. Part of this revenue trend is the result of declining numbers of newspapers and their circulation and partly due to the reluctance of newspapers to raise their prices," Professor Picard wrote. "The newspaper industry was dependent upon

advertising for the bulk of its income across the five decades but that dependence grew stronger during the final quarter of the century." Newspapers have often used the cover price as a tool to manipulate circulation figures and advertising rates. So they have always been reluctant to raise the cover price for fear of losing readers and having to charge lower ad rates. Circulation at US newspapers peaked at 63.3 million in 1984. By the end of 2008, US weekday newspaper circulation had dropped to a combined 48.6 million. "The declines in print newspaper circulation, which had begun to accelerate alarmingly in late 2003, only became deeper in 2008," noted the Project for Excellence in Journalism in its 2009 *State of the News Media* report.

The global financial crisis

The full horror of the global financial crisis that started in 2007 emerged in 2008, and by the end of that year had crippled the mainstream media's primary source of income – advertising – in many countries around the world. This loss of income accelerated many changes that would have taken longer to occur, such as decline of print newspapers and magazines, and decisions to produce online-only editions or outsource content. In the US, advertising revenue plummeted between 2007 and 2009, marking the first three-year decline since the Great Depression of the 1930s. In 2008 American newspaper advertising revenue dropped 16.4 percent to $37.9 billion. And eMarketer estimated another $10 billion of advertising income would disappear by 2012, leaving the industry half the size it was in 2005.

With print and broadcast news companies losing audiences and advertising income, and online news providers so far unable to develop business models to support comprehensive, quality news coverage, the questions arise: How will journalism be funded in the long term? Will traditional news media companies remain viable? Alternative methods of reporting and distributing the news are already popping up with great frequency. But how will they be funded?

The global financial crisis reduced the options media companies had for borrowing money to expand, and forced them to cut costs to repay debt. "The perfect storm has arrived," noted Earl Wilkinson, executive director of the International Newsmedia Marketing Association, in INMA's eighth annual forecast, published in February 2009. In 2007 Rupert Murdoch paid almost $6 billion for Dow Jones, owner of *The Wall Street Journal*. By the end of 2008 the value of media companies had dropped so dramatically that the amount he paid was more than the market capitalization of Gannett, the *New York Times* Company, McClatchy, Media General,

Belo and Lee Enterprises combined. By the middle of 2009 you could have added a few more media companies to the list.

Professor Jay Hamilton of Duke University, another noted media economist, observed that by the start of 2008 the market value of America's publicly traded newspaper companies had dropped by 42 percent, to about $23 billion, relative to the end of 2004. In 2004 newspapers attracted 44.1 percent of local online advertising revenues, but by 2007 non-newspaper Internet companies enjoyed 43.7 percent of local online ads while newspapers garnered only 33.4 percent.

Job cuts followed the decline in revenue and market valuation. In 2000, there were about 56,400 newsroom workers in the US. But that number fell by more than 15,000 between 2006 and early 2009 because of layoffs. The number of full-time journalists in Australia fell 13 percent between 2001 and 2008, from just under 8,500 across all media to about 7,500. In October 2008 the Australian Journalists' Association published a report on the future of journalism, *Life in the Clickstream*. The report quoted Emily Bell, director of digital content for British newspaper *The Guardian*, who warned: "This is systematic collapse – not just a cyclical downturn. Even the surviving brands will have to go through a period of unprofitability." The report said the "disruptive and destructive difference" was new technology. "It is fragmenting audiences and stealing advertising, especially the classifieds – once rivers of gold for Australia's largest mastheads. Free-to-air TV is seeing subscription TV eat into advertising, audiences fragment and migrate online as time-shift technology lets viewers skip TV advertisements. In radio, podcasts act as time-shift technology, while the audience is spoilt for choice."

The ability of online content to reach a global audience means that the increased competition among news sites publishing stories on the same topics is driving down the value of news. Said Chris Anderson, editor of *Wired* magazine and author of *Free: The Future of a Radical Price*, "Abundant information wants to be free. Scarce information wants to be expensive." Most general news sites do not charge subscription fees, and revenue must come from advertising or another source. At the same time, the low cost of producing alternative online content sources such as blogs and niche websites has intensified competition.

"Traditional news providers are competing for attention with outlets offering personality, partisanship and passion," Professor Hamilton of Duke University said. Advertising dollars once destined for newspapers now go elsewhere. Many of the advertising functions served by newspapers, such as connecting workers with jobs or drivers with cars, are being performed by websites such as Craigslist and Monster. The issue has become most acute for regional newspapers that

previously enjoyed monopolies or near monopolies on classified advertising revenues in their geographical area. Anyone wanting to advertise a job, a house or a service traditionally turned to the local paper. These were hugely profitable enterprises.

Concern about the commercial viability of news organizations is about much more than a business dilemma, of course. The deeper issue involves the impact a shrinking news industry will have on journalism's vital social role of acting as the fourth estate. Citizens need quality news media to help them make decisions, and numerous studies have shown the correlation between reading newspapers and people's involvement in democratic processes. People who read newspapers vote in all forms of elections more often than non-readers. It is important to note that the newspaper business is just one form of journalism and that journalism exists in other forms – and that many more methods of producing and distributing journalism will emerge over time. But for now, newspapers, along with other traditional news providers such as broadcasters and wire services, are the main source of serious, credible newsgathering and production.

Newspapers' online sites have generally employed a commercial strategy that basically followed the print business model – build the biggest audience it can under the theory that the bigger the audience, the more that site can charge for advertising. But that model has problems in the digital realm: low online advertising rates and the small fraction of users who click on the ads (click-through ad rates are another advertising revenue model). Newspapers, in many cases, have been attracting huge numbers of readers to their online sites – far greater numbers than they ever attracted in print. But with the content mainly given away for free, and the online advertising rates far lower than in print, the revenue earned online has not been enough to make up for the drop in earnings on the print side.

News organizations are not the only content providers trying to come to terms with the problem. Social networking giant Facebook, for example, has a huge audience – it claimed more than 300 million regular users in 2009. But as an advertising platform it has been ineffective and revenue has been feeble in relation to the size of its audience. Likewise, YouTube has a massive following – accounting for 40 percent of the online videos played in the US in August 2009 – with its closest competitors barely in single figures. Yet it is still struggling to match that popularity with revenue and is effectively a loss leader for its owner, Google. YouTube is losing somewhere between $180 million and $470 million a year, according to various industry analysts. Twitter, which launched in 2006, was probably the most talked-about social media site in 2009. It had 54.2 million monthly visits in February

2009, the third highest of any social media site worldwide, and an estimated 10 million users. But it had yet to attract virtually any revenue at the time of publication and its executives were still exploring potential business models.

Free content online

Why did newspapers opt to put their content online for free? In November 2003 then Tribune Company president Jack Fuller gave the keynote address at the annual conference of the Online News Association in Chicago. Perhaps the most stupid thing the American newspaper industry had ever done, Fuller said, was to give away content on the web for free. With hindsight, many would argue he was right – although this is subject to some debate. But as the saying goes, you cannot put the toothpaste back in the tube once it is out. Would news organizations be suffering financially now if their websites had started charging for content when they first went online? We don't know. Is it possible to turn back the clock and start again? No. So what are the options? Media companies will have to start again and think about the newspaper, broadcast and online businesses in very different ways. Those companies will need to become more innovative and entrepreneurial. And ultimately, media organizations in the twenty-first century will become less profitable and hence smaller. This means business models will have to adjust, which is one of the themes of this book.

Writing in *The Wall Street Journal* in February 2009, *Free* author Anderson argued for the model that gave his book its title. "Over the past decade," he wrote, "we have built a country-sized economy online where the default price is zero – nothing, nada, zip. Digital goods – from music and video to Wikipedia – can be produced and distributed at virtually no marginal cost, and so, by the laws of economics, price has gone the same way, to $0.00. For the Google Generation, the Internet is the land of the free."

The global financial crisis may be helping to spread the "Free" business model. Anderson says that when money is tight, people look for free options – a bit of logic that is hard to argue against. "After all," he wrote in the *Journal*, "when you have no money, $0.00 is a very good price." He predicted an accelerating shift to free open source software and free web-based productivity tools such as Google Docs. Consumers are trying to save money by playing free online games, listening to free music on Pandora, canceling basic cable and watching free video on Hulu, and killing their landlines in favor of Skype. "The web has become the biggest store in history and everything is 100 percent off."

Anderson is correct when he notes that distribution costs are nearly non-existent on the Internet. But production costs are not. Quality journalism is expensive. Anderson argues the free concept will remain, especially while the economy is in recession. "The psychological and economic case for it remains as good as ever – the marginal cost of anything digital falls by 50 percent every year, making pricing a race to the bottom, and 'free' has as much power over the consumer psyche as ever." But Anderson admitted free was not enough: "It has to be matched with paid. Just as King Gillette's free razors only made business sense paired with expensive blades, so will today's web entrepreneurs have to not just invent products that people love, but also those that they will pay for." Anderson said free was a great marketing tool. "Free may be the best price, but it can't be the only one."

Connecting with the audience

People who love news and journalism delude themselves into believing that this is a widely held sentiment, according to Professor Picard. "The reality," he said, "is that the average member of the general public has never been highly interested in news and has never been willing to pay for it. Those most interested in news have always been the most economically, politically and socially active members of the community." Does this suggest a stronger market for the quality end of the demographic spectrum?

Figures from the *State of the News Print Industry in Australia 2008* report released by the Australian Press Council show that between 2006 and 2008 the Monday to Saturday circulation figures of the "quality press" – *The Australian, The Australian Financial Review, The Age* and *The Sydney Morning Herald* – held up against population growth. But the circulation of almost all the metropolitan Monday- to- Saturday tabloids declined about 3 percent. Many advertisers are interested in the A-B demographic the quality press reaches because of their purchasing power. Among broadsheet newspaper readers in Australia about 42 percent had household incomes higher than $70,000 a year and only 12 percent of broadsheet readers had annual household incomes of less than $35,000. Conversely, only 29.6 percent of tabloid newspaper readers had a household income in excess of $70,000, while 52 percent claimed a household income of less than $70,000.

Yet tabloid newspapers generally have higher print circulations than broadsheet newspapers, and in many cases higher online viewing figures. And tabloids also have been just as profitable, if not more so, than the quality press. So the

issue for news organizations is not about trying to attract a more elite readership, but connecting with readers. Too many news organizations have not understood their audiences.

In March 2009, amid the threatened closure of daily newspapers in Colorado, Detroit, Minneapolis, Miami, San Francisco, Chicago and Philadelphia, Juan Antonio Giner, principal of the Innovations International media consulting company, wrote that this marked not the death of newspapers but the end of an era of greed and bad management. More importantly, the problem had been a lack of re-investment in the core business. "Just as with any business casualties occur," he said. "But the newspaper implosion in the USA has very specific reasons. If your newspaper is boring, people will stop buying it. If it is essential to their lives they will go on buying it, and more will buy."

Audiences' information needs

Duke University's Professor Hamilton maintains people have four information needs: producer information, which relates to how they do their job; consumer information, which connects to what they buy; entertainment information, which relates to things that entertain them; and voter information, which resonates with their role as a citizen. The first three needs connect directly to a benefit, Hamilton said: "If you don't get the information, you don't get the benefit." But the fourth need is problematic. "You might really care which candidate is elected, and more information could help you make a better decision, but the probability is very small that your vote is going to be decisive." With other goods and services, information is useful. "If you learn more about a car, you get a better car. If you learn more about a candidate, you don't get a better candidate."

Journalism is a rare type of business in the sense that its product (news) provides a public good or service. Unlike other public-good activities such as education or scientific research, newspapers are not protected from market forces by government support in countries such as the US, Canada, the UK, South Africa, New Zealand or Australia. (Many European governments subsidise newspapers.) When a huge drop in advertising threatens the financial viability of the news business, the media's public good role is also threatened. Newsgathering is expensive, and becoming even more costly. Investigative and socially-responsible journalism costs more than "churnalism" and entertainment news. A paradox emerges at the same time: In periods of great uncertainty such as a global financial crisis, the public's appetite for information becomes even more ravenous. Traffic

to the web sites of financial newspapers such as the *Financial Times* in the UK, the *Wall Street Journal,* and Eureka and Business Spectator in Australia, soared during 2008.

Audiences are going online for news and information because it is free and easy to access. Advertising inevitably follows audiences. As advertisers see their customers choosing online ahead of traditional media platforms, more and more marketing and advertising budgets are being spent online. The pioneers tend to be the companies whose audiences are most likely to be online. For example, Microsoft's global advertising and marketing budget is about $6 billion a year, and about 40 percent of that total was spent online in 2008. In the next few years almost all Microsoft's advertising and marketing budget will be spent online, a senior Microsoft manager told one of the authors.

Given that industry analysts have predicted a long-term decline in circulation for printed newspapers, one question is whether newspapers should produce online-only editions and shut down printing plants and sell their distribution arms. And for any that drop print and go exclusively digital, will their online-only revenue streams generate enough income to support the news operation?

Another way of putting the question is: Will online revenues be enough to pay for content? Early in 2009 journalism educator and blogger Jeff Jarvis said newspapers were "on the cusp" of the time when online revenues could sustain a "substantial digital journalistic enterprise without the onerous cost of printing and distribution." In January 2009 the editor of the *Los Angeles Times*, Russ Stanton, said the paper's online advertising revenue had become sufficient to cover the paper's entire editorial payroll for both print and online. "Given where we were five years ago, I don't think anyone thought that would ever happen," Stanton said. "But that day is here," Jarvis quotes him in a column for *The Guardian.*

Newsroom cost-cutting

Beyond the changes happening in news media boardrooms, change also is happening at a rapid pace in newsrooms as editorial managers try to cut costs. In January 2009 the Telegraph Media Group in the UK signed a deal with Pagemasters in Australia: Journalists in Sydney would copyedit pages for the *Daily Telegraph* and *Sunday Telegraph* on the other side of the world. It represented the first major example of outsourcing from within the world of journalism. Reporter Miriam Steffens of the *Sydney Morning Herald* wrote that in trying to cut costs the

Telegraph Media Group decided to outsource sections of its flagship newspapers. These included the travel, motoring and money pages of the *Daily Telegraph* and parts of the *Sunday Telegraph*.

Pagemasters, a company owned by the news agency Australian Associated Press (AAP), is itself owned by Australia's two biggest media groups, News Ltd and Fairfax Media, and based in Sydney, on the other side of the world from the Telegraph Media Group. Production started in the second week of January 2009 with an editing team hired at the AAP offices in western Sydney. Unedited copy is transmitted from London to Sydney where pages are produced before being retransmitted back to London for printing. AAP's chief executive, Bruce Davidson, said the company planned to expand, noting that centralization of newspaper production was "on the radar of a lot of publishers not only in Australia, but around the world." Another AAP executive, Clive Marshall, said the company had received inquiries from publishers worldwide since securing its first subediting contract with APN New Zealand. Jobs tend to move to countries where salaries are lower. What has been occurring in other professions and occupations, from help desks to manufacturing sites, is happening in journalism. In August 2009 Pagemasters signed a contract to produce pages in Sydney for North American newspapers.

The need for innovation

Any solutions to the problems facing the news media will have to include a program of ongoing innovation. News organizations have often lagged at developing new systems and practices. Years of high profitability and limited competition brought complacency. But that must change. Too often in recent years the news industry has watched as content and technology startups have emerged from nowhere to grab a chunk of its audience or its income. In the 2008 book *Grabbing Lightning: Building a Capability for Breakthrough Innovation*, Gina O'Connor, Richard Leifer, Albert Paulson and Lois Peters point out that technology and competition are a constant drumbeat for business. Companies not ahead of the pack risk becoming marginalized. They need to develop the capacity for breakthrough innovation. It is emerging as an organizational function just as marketing became established as a function in companies.

Quality assurance and information systems have become embedded in big organizations. The same thing needs to happen for innovation. How many media companies have chief knowledge officers or chief innovation officers? Not many.

The authors of *Grabbing Lightning* maintain that large and established companies have never excelled at innovation. Their management processes and systems are designed to ensure highly reliable, repeatable processes. Their strategies are driven by financial objectives that they offer to the market or Wall Street. Their objectives are short-term because much executive compensation in the US is tied to quarterly performance. Media companies must embrace innovation. Chapter 12 is devoted to that subject.

For decades, most commercial media have employed the "eyeball" business model – give away content to attract eyeballs, and sell those audiences to advertisers. That model once produced healthy profits for media companies. But when profits slump, managers look for ways to cut costs, which means less money is spent on journalism. This book looks at ways to pay for journalism in this era of change. But first we need to have a more complete understanding of how journalism has traditionally been funded. That is the role of the next two chapters.

How the news business entered the digital age – a history

Summary

This chapter considers the history of revenue models for newspapers and other media companies. How did we get where we are today? It looks at early digital developments and the dot-com boom and bust, before the watershed year of 2004 which witnessed the arrival of broadband, the spread of the Internet and Web 2.0, and a boom year for newspaper advertising. It ends with Rupert Murdoch's Damascene conversion on the potential power of the Internet.

Way back in 1993, well-known newspaper industry analyst John Morton, looking at the future of newspapers and technology, said organizations behind new forms of electronic information delivery systems would never find it economical "to provide the mass amounts of local information that newspapers gather every day." Telephone companies and cable TV operators did not appear to be much of a competitive threat to newspapers, he reasoned, in an *American Journalism Review* (*AJR*) article entitled "Papers will survive newest technology." But while Morton did not foresee challenges to the core mission of newspapers to publish the news, he did warn against a serious threat against another essential aspect of newspaper operations – to make money. "What the electronic operators will do," Morton wrote, "is go after the backbone of newspaper advertising revenue – local retail and classified advertising. The electronic Yellow Pages, when they arrive, will offer far more than telephone numbers, and cable operators are likely to develop classified and retail advertising channels as counterparts to the national home-shopping channels they already carry. The threat of these developments is reason enough

for newspapers to invest in electronic publishing, especially now when they have the money to do it."

Morton seemed to think the newspaper industry would rise to the challenge. And though he had the vision to foresee the online threat to newspaper advertising, he did not anticipate the evolution of the World Wide Web and the speed with which it would alter the nature of communication and information provision. "Could electronic publishing completely replace newspapers printed on paper?" he asked. "I doubt it, but the answer will be determined by economics. The economic efficiency of printing mass amounts of daily information on paper is so great that it will take a long time for electronic publishing to make serious inroads, despite the predictions of futurists. I'm reminded of the predictions after World War II, which would have had us all commuting to work in personal helicopters by now."

Although we're all still waiting for our personal helicopters, the world has been transformed fundamentally and profoundly by the rapid entrenchment of the digital world into our lives in the years since Morton's warnings about the threat of online advertising.

Where's the money?

Not only was Morton right about the threat to newspaper advertising, he also was right that new companies involved in delivering electronic information would not seek to compete against newspapers by producing equivalent amounts of information every day. Turns out they didn't have to. Traditional news organizations still provide the bulk of essential information we call "the news" about daily events, local, regional, national and global. Where newcomers have made inroads as news suppliers has been through niche topics or citizen journalism efforts. And, of course, most notably, as aggregators of others' news content (more on that below). News organizations are losing their ability to make enough money from publishing to support the quality and quantity of journalism on which readers rely and which helps maintain a healthy democracy. So the issue transcends normal patterns of outdated industries disappearing to be replaced by new ones.

Innovations in new technologies and business processes, along with changing social trends have rendered the traditional newspaper business model virtually obsolete. And no new, sustainable, business model has emerged that can support the depth and breadth of news coverage that is required for journalism to fulfill its independent watchdog role in society. Skip from Morton's warning in 1993 to 2009 and essentially only one story is being discussed about the newspaper business –

how long will it survive in its present form? Newspapers in big cities and small have been folding, declaring bankruptcy, eliminating sections, reducing news coverage, shrinking the physical size of the paper, reducing the number of days they publish print editions. Journalists have been losing their jobs by the thousands.

Among the devastating effects of the global financial crisis that exploded in late 2008 was a severe downturn in advertising expenditure. Though it was not the cause of the news industry's decline, the economic meltdown speeded up the process exponentially. Print newspapers have relied on a simple and successful business model for centuries. Its two paying customers are readers and advertisers. Readers, attracted to the newspaper's content, buy the newspaper through single copy sales or by subscription. Advertisers, seeking to reach the newspaper's mass readership, pay to place their ads in the paper. Both of those revenue pillars are now crumbling. And the search is on to find business models to replace them.

How the newspaper business model became obsolete

There are huge variations among countries over what percentage of newspaper revenue has historically been derived from single copy and subscription sales versus advertising. According to *Pricing Strategies*, a report from the World Association of Newspapers, 15 percent to 80 percent of revenue may come from copy sales "with the higher percentage in emerging, developing markets and a lower one in mature, wealthier nations." In the US and the UK, revenues are overwhelmingly derived from advertising, with cover price revenue unlikely to meet the cost of producing the paper. Ward Bushee, editor of the *San Francisco Chronicle*, which was losing $1 million a week, revealed in early 2009 that it cost $10 to produce and deliver each copy of the paper's Sunday edition. The cover price was $2.

The first newspaper advertisement in the US was an announcement seeking a buyer for an estate on Oyster Bay, Long Island, published in the *Boston News-Letter* in 1704, according to *Advertising Age* magazine. The marriage between newspapers and advertisers that followed proved to be a long and mostly happy one – until relatively recently. Social and technological changes began, slowly at first, cutting into newspaper readership during the second half of the twentieth century. In the US, the rise of television viewing and growing suburban sprawl are often cited as leading causes. The growing popularity of television news and the logistical problems of delivering newspapers to outlying areas in a timely manner severely damaged the viability of evening newspapers. But on the whole, newspapers remained a highly profitable business, particularly in cities where competition was reduced or

monopolies existed. By the time "the web" started to become a well-known term in the US in the mid-1990s, wrote Pablo J. Boczkowski in *Digitizing the News*, "the print daily newspaper industry was quite profitable yet showing clear signs of economic decline." Publicly-traded newspaper firms had a median profit margin of 11.4 percent in 1997, he pointed out (citing economist Ben Compaine), a relatively high figure compared with 3.3 percent for the food industry, 6.1 percent for chemicals and 9.0 percent for metal products. Boczkowski also cited figures from the Newspaper Association of America showing that, in 1999, newspapers still had the largest share of advertising in the US with 20.9 percent (followed by 18.7 percent for direct mail, 18 percent for broadcast television and 12.1 percent for radio). Worryingly for the newspaper industry, however, the 20.9 percent share for newspapers in 1999 was a drop from its 29 percent share in 1970. With circulation also in serious decline in the run-up to the arrival of the Internet age – a drop of 34 percent between 1950 and 1995, according to Boczkowski – the downward trends for newspapers in the US were clear.

And yet despite evidence that the industry as a whole was in decline, profits for individual newspapers and newspaper companies were booming, with profit margins continuing to grow to levels other industries could only envy. As the number of newspapers in the US dropped, those remaining attracted even more adevertising revenue. And booming financial times meant huge growth in advertising expenditure. Newspapers saw revenue gains in the expansion of advertising for retailers, cars and property. Double digit profit margins were commonplace, with some groups seeing margins of 20 percent and above. Did high profit margins and the lack of competition, both editorially and commercially, lull the newspaper industry into complacency and a failure to act against looming threats? Industry analysts say publishers spent too much time protecting the status quo rather than responding to the downward trends with force and innovation. The charge may not be entirely true – newspapers participated in the early development of several electronic information delivery systems. But it wasn't enough.

Early efforts to move beyond "ink on paper"

Contrary to widespread belief, the newspaper industry poured substantial resources into finding ways to deliver news and advertisements to consumers in the decades preceding the arrival of the World Wide Web. Knight Ridder, the second-largest media company in the US until it was sold in 2006, along with partner American Telephone and Telegraph, invested more than six years and $50 million

on a "videotext" project called "Viewtron" to send news and information to the
TV screens of subscribers. It shut down the project in 1986 after failing to make
it commercially viable. "Viewtron's dream was very similar to the dreams of news
media publishers today: new ways of communicating with customers and new
ways of selling services to advertisers," wrote Howard I. Finberg, of the Poynter
Institute in 2003. "The promise to consumers was that they would have a new way
to get news and information, shop, bank, and communicate online. Interestingly
Viewtron got many of its content offerings right." He cited several examples:

- Getting news from the *Miami Herald* or *The New York Times* the night
 before the paper hit your doorstep. Or accessing the Associated Press.
- Looking up airline schedules from the Official Airline Guide (OAG).
- Accessing bank account information, although many customers would
 drop this feature after trying it.
- Ordering a meal via an online menu.

Times Mirror, which published papers including the *Los Angeles Times, Newsday*
and the *Baltimore Sun* before its sale to Tribune in 2000, also developed a similar
videotext service called Gateway during the 1980s. It closed about the same time
as Knight Ridder pulled the plug on Viewtron. (For an excellent chronology of the
development of electronic information delivery systems see the New Media Timeline
at http://www.poynter.org). Elsewhere in the world, other communications compa-
nies had more success with electronic information delivery systems prior to the web.
In the UK, for example, both the BBC and the Independent Broadcasting Authority
screened pre-Web teletext services that provided news and information.

In 1982, the then-combined French national post and telephone company
PTT, introduced a screen-based information service called Minitel that ran through
the phone lines. The service was a surprise hit, even surviving the arrival of the web.
PTT (later divided into France Telecom and La Poste) gave out Minitel terminals
for free as a way to avoid the cost of printing telephone directories. Phone customers
with Minitel terminals could look up phone listings for free. But they would be
charged by the minute for other online services, with the per-minute fee varying by
the type of service. The service charges were added to the customer's phone bill. Like
a proto-iPhone apps store, the Minitel team invited outside companies to provide
services that customers could access via Minitel. Minitel and the service provider
split the revenue. Minitel still exists, although its heyday has passed.

Knight Ridder also was experimenting with a precursor to the Amazon
Kindle and other e-readers back in 1994. The company had set up a research
and development unit in Boulder, Colorado called the Information Design

Laboratory (IDL), which was run by Roger Fidler, who had worked on the Viewtron project. Fidler, interviewed for an October 1994 story in the *American Journalism Review* (*AJR*), said he did not believe that either the television or the personal computer were the best way forward for the print newspaper business. "He's developing software for a third way: the electronic tablet," said *AJR*. "Fidler is betting that a portable, battery-powered flat panel, or what he calls a 'personal information appliance,' will become the main vehicle for newspaper, magazine and book publishers. He says the tablet – which will be about two pounds, a half-inch thick and roughly the same dimensions as this magazine – could begin replacing newspapers by 2001 and serve half of the country's newspaper readers by 2010 with highly readable multimedia, digital displays."

In hindsight, Fidler's description of his electronic tablet was remarkably like the Kindle and other e-readers available now. But he was keen to make sure the IDL tablet had a component that is missing from today's e-readers – interoperability. Fidler, said *AJR*, was urging newspaper publishers to agree on standard technical specifications so the tablet could be used anywhere, with any digital news content. Fidler also had worked out the advertising possibilities and a number of methods to deliver content to the e-reader, including wirelessly via satellite transmission. But the e-reader was only part of the work that Fidler and his team were developing in their quest to reinvent the newspaper for a new era. "The electronic tablet may deliver the newspaper of the future," *AJR* reported, "but IDL also is working on projects that will have more immediate results and expand the boundaries of newspapers, turning them into what Fidler calls 'community knowledge centers.' These projects include an experimental IDL Fax Report on new media and telecommunications to be circulated nationally; a national online daily agricultural news service (in conjunction with the *Grand Forks Herald* in North Dakota); an interactive computer software package for pro football fans in Charlotte, North Carolina (with the *Charlotte Observer*); an electronic guide to restaurants; and electronic street maps indicating real estate sales."

So whatever happened to the e-tablet and the other forward-thinking newspaper projects at Knight Ridder? The media company shut down the lab in August 1995 for reasons that were not made entirely clear. "IDL made a valuable contribution to the company's long-range vision of electronic publishing and helped to further the flat-panel newspaper concept," P. Anthony Ridder, Knight Ridder's chairman and chief executive, said in a statement. Polk Laffoon, vice president of corporate relations, told *The New York Times* that Knight Ridder planned to concentrate its electronic publishing efforts on existing technologies like the Internet and online services.

Onto the web

The *San Jose Mercury News*, the hometown newspaper for California's high-tech Silicon Valley launched into cyberspace in 1993, followed by a slew of other papers. In 1994, *The Daily Telegraph* launched the Electronic Telegraph, to become the first online paper in the UK. That year *The Sydney Morning Herald* also published Australia's first daily online newspaper site, smh.com.au. This was the start of a land grab in a place once known as "The Information Superhighway." As the number of newspapers online grew, along with other new websites by the millions of every type and description, the race was on to build readership, not sort out online payment mechanisms. A prevailing business concept at the time was the "first mover advantage." The idea was that the online winners would be those who grabbed the biggest market share of audience first. So getting online and building readership fast was a priority for many newspapers, rather than building a comprehensive business plan that determined how readers would be "monetized." Advertisers would eventually flock to the biggest, most successful websites, was the thinking. Attempts to charge for content proved fruitless. In one early and short-lived effort, *The New York Times* required overseas readers to buy a subscription to the online edition before gaining access to it. But, as it quickly became clear, online newspaper readers, unlike print readers, had a vast choice of newspapers to choose from – the geographic limitations that had given newspapers regional monopolies, or near monopolies in print, were now gone.

Another factor which deterred charging for online content was the infrastructure and technology of the web, which was not particularly conducive to online payment systems at that time. Dial-up Internet access was shaky and slow, and users were initially charged by the minute. Online security measures were in their infancy and there was a wholesale lack of trust among users who were concerned about typing their credit card details into the computer and sending them off to a vague destination. So from the beginning, online newspaper content was, in most cases, free. Today, this early decision to give away newspaper content online – to the extent that it was a decision at all – is viewed by some newspaper industry analysts as the "Original Sin." Their argument is that, had newspapers begun charging for online content from the very beginning, never allowing users to consider it a "free" product, the newspaper industry would be in fine shape today, its traditional business model of copy sales and ad revenue still in place. How realistic that might have been remains the subject of some debate. (That debate is discussed further in Chapter 5).

Dotcom boom and bust

By the late 1990s, the dotcom boom was exploding and a so-called "new economy" that wasn't measured by traditional business metrics such as profit and loss was in the ascendant. Public media companies found they could boost their share price by merely announcing how many millions they were about to spend on boosting their online presence. Creating separate online operations that were disconnected from the main newsroom became routine. Few newspapers took much advantage of the interactive possibilities the web offered. Original web site content was scarce because newspapers relied predominantly on copy pulled straight from the print newspaper, earning the online content the name "shovel-ware."The "one-to-many" centralized newspaper publishing model that had lasted centuries continued. While the online versions of newspapers did attract advertising, the revenue was relatively insubstantial. The Newspaper Association of America did not even begin keeping track of online advertising revenue until 2003, when it had crossed the $1 billion mark, to $1.2 billion – a significant figure, but still a tiny fraction of the nearly $45 billion the print side attracted that year.

Publishers and editors, charting new journalism territory, were confronted by new issues such as whether to publish stories on the web site before they appeared in print and to provide links to information that appeared on other websites, sending readers elsewhere. These were difficult concepts for newspaper executives to accept. "The definition of what a media site is has to change," media critic and author Jon Katz told the *AJR* in a September 2000 story called "Surviving in cyberspace." "The model of a bunch of people called journalists collecting information, packaging it and selling it is in trouble." Calling the then-current online newspaper model "closed," he argued for sites to be "open" like Yahoo! and CNET which carried news but also sent their readers elsewhere for additional news and information. "It's not telling people what they should think. It's pointing them to the information and services they tell you they want. The best way to keep people is to allow them to go elsewhere, because then they'll come right back to you. You'll become their home base."

But for all the excitement and hoopla at newspapers about their online operations during the dotcom boom years, there wasn't actually that much innovation. "Newspapers embraced the new platform when it arrived in the mid-1990s, but they weren't very inventive," wrote *Slate's* Jack Shafer in a December 2008 article called "Digital slay-ride." "All the great innovations in advertising, search, and social networking have come from outside the newspaper industry, which, given its 20 percent margins, it could have afforded to fund. Today, with the web beating

newsprint as a distribution platform and gaining on it as advertising destination, the odds are against conventional newspapers."

The emergence of websites devoted to classified listings for jobs, property, cars and all sorts of sundry items began eating into newspapers' traditional revenue sources, slowly at first and then building dramatically along with the increase in Internet penetration. Portals like Yahoo! and dedicated job boards like Monster offered a fast, efficient way for employers to list vacancies cheaply. eBay harnessed the possibilities of the web to create a new market for goods via online auctions that no longer confined buyers and sellers to a particular time and place. The arrival of the mostly-free classifieds site Craigslist, which launched in San Francisco in 1995 and began rolling out across the rest of the US and the world in 2000, would mark a particularly brutal blow to newspaper classified ad revenue. Each of its city-specific sites offers a wide range of classified ad categories where sellers can post their ads for free – and free is a difficult price point to compete against. Craigslist, which is a for-profit company despite its overwhelmingly "free" offering, makes money by charging below-market rates for job listings in 18 cities of the 500 where it has operations (currently $25 for recruitment ads in 17 cities and $75 in San Francisco) and for brokered property listing in New York City). Craigslist users self-publish more than 40 million classified advertisements each month and more than one million new job listings are posted each month, the company said.

Another blow to newspaper advertising came from the arrival of search engine Google and its contextual and pay-per-click online advertising models. Google developed a highly efficient system in which advertisers could bid to have their ads shows up every time a Google user typed in a specific keyword. That way, web users would see ads specifically related to the subject they were searching for. And advertisers did not have to pay for the ads unless a user clicked on it (hence, pay-per-click). Multiple advertisers could secure the same search keyword – but the top listing would go to the highest bidder and so on down the line. Keyword search advertising was seen as dramatically more efficient because advertisers could reach their target audience and only pay when a user clicked on the ad. By comparison, most advertising on the newspaper websites is charged on a cost-per-thousand (cpm) basis in which advertisers pay a set amount for every thousand times the page containing the ad is viewed, with no indicator that the user saw the ad, unless they click it for more information.

Google also developed a contextual advertising system, using computer algorithms to display ads on the pages of others' websites. The system determined the content of the page and displayed relevant ads, with Google and the site owner splitting the revenue when the ads are clicked. When the dotcom boom started

crashing down in 2000, sending share prices tumbling and new media workers onto the streets, newspapers had to rethink their online strategies. Gone was the giddiness and sense of impending riches. In its place was a time for taking stock and devising a way forward – one that would have to include profits.

Rupert Murdoch had been criticized during the dotcom boom of the late 1990s for not investing quickly enough and heavily enough in new media. He did eventually jump into the digital world, spending hundreds of millions of dollars on existing websites and adding new digital services to his newspapers. But when the value of those investments soon plummeted as the dotcom party came to an end, Murdoch famously proclaimed that he could not see how he was going to make money from the Internet. As the Industry Standard reported in 2000 "We have not spent a fraction of what all our competitors have lost in this area,"[Murdoch] bragged to reporters in Adelaide, Australia, a few weeks ago at the annual meeting for his global media empire, News Corp. "We have slowed down and are slowing down," he said. "We have been very tentative and careful. In retrospect, we would have liked to have been even more so." In March 2000 Murdoch's UK newspaper company, News International, began a retreat from the web, first selling its Internet Service Provider operation and main portal, Bun.com. (Like other UK newspapers in the late 1990s, Murdoch's tabloid, *The Sun* – or, "The Current Bun" in Cockney rhyming slang – had positioned itself as an ISP, providing it with revenue from customers spending time online, a direct customer relationship with its users and its name in widespread circulation on the Internet as hundreds of thousands of readers signed up for "Bun" email addresses.)

Soon after selling the ISP business, News International also closed its Firedup online auction site and Revolver jobs site, both of which had just been launched amid great fanfare. "In 2001, we had to decide whether we should close [the online operations] or come up with a business model to make money," recalled Annelies van den Belt, a senior News international digital executive during that time. They chose to stay in the online business and prioritize finding a sustainable business model. Across the US and Europe, and in the Asia-Pacific region, newspapers pushed forward to find viable models for their online operations. But a lack of clarity or agreement prevailed over what the exact role of the online newspaper should be. Protecting the classified advertising business was a must – online newcomers were already eating into print newspaper profits. On the editorial side, newspapers had an online tipping point moment when people rushed to the web to find out the up-to-the-minute developments during the September 11, 2001 terrorist attack on the World Trade Center in New York. The importance of the web as a news source was never clearer.

Reasons to be cheerful

In January 2003, the Swiss-based communications group Interactive Publishing brought together a group of 20 top digital news executives to "aggregate an industry-wide view on the perceived realities and potentials of online publishing today and tomorrow." In others words, what was the state of the online news industry and where was it going. The group, mostly European but including former *Wall Street Journal* publisher Neil Budde, found much to be optimistic amount – but plenty of problems and hurdles to contend with as well. A key weakness they found, post-dotcom boom and bust, was that the content of online newspapers was usually the same as the content in the newspaper. A lack of "entertainment factor" was also cited.

Another problem was thought to be that "leadership in media companies is still holding on to its old business models and is not flexible enough to change the overall strategy to a much more integrated approach." Executives expressed concern that the advertising revenue model would not be sufficient to sustain papers in the future, and a belief that revenue would have to come from somewhere else. Meanwhile, "the majority of all participants were convinced that only 20 percent to 30 percent of the revenue potential for their companies has been realized in the online environment," said IP chief Norbert Specker in a summation. "Or, to put the positive aspect in the forefront, more than 70 percent of online potential has not yet been realized."

Crunch year: 2004

Keith Perch gave a surprising answer when asked in 2004 who he thought his biggest competitor would be in the future. He was the editor and managing director of Northcliffe Electronic Publishing, overseeing 22 regional newspaper websites across Great Britain (representing more than 100 regional and local print papers) and a handful of national, themed websites for one of the country's largest national and regional publishers, Daily Mail and General Trust. It was his job to peer into the future and determine the strategy and tactics that would guide Northcliffe profitably through the rapidly-expanding digital age. So who did he foresee as his biggest competitive threat? "A guy with a video camera attending his son's football match," he said.

As Perch explained, presciently, during a pre-YouTube-era interview in his Derby office, in the north of England, technology was advancing so rapidly, that

it would soon be easy for any parent to shoot video of their child's organized sports activities, write up a report and post the video and story to a web site. The problem was going to be, he said, not just one mom or dad but hundreds or thousands of them. And it would not just be coverage of junior football league matches. There would be written, audio and video reports online from all kinds of people on everything affecting the towns and cities his local papers covered.

Newspapers could not compete with that depth and breadth of coverage of so many activities. "I think that's where the danger is," he said. "Not that someone will come along and take it all, but that someone will come along and take a little bit. And someone else will come along and take another little bit." From this nondescript office in the north of England, Perch and his team had hoped to solve a problem that many of his contemporaries had not even recognized yet.

Across Great Britain, the US and the world, the year 2004 saw Internet usage continue to explode. The recent arrival of broadband as a mass market product in developed countries meant consumers could stay online longer without racking up additional charges or tying up their home phone lines. Bandwidth-heavy multimedia content – video, music and other bulky files – long promised but difficult to obtain with dial-up access, was now widely available and could be downloaded quickly. Significantly, the year 2004 also saw the emergence of the concept of "Web 2.0."

Though it always defied an exact definition, Web 2.0 was the term applied to the fast-evolving software and applications that were allowing users to interact, communicate, collaborate and share with websites and with each other. Gone was the voice of one-to-many. In its place was "The Conversation." As new, free technologies made online publishing easier for individuals, a new environment called "the blogosphere" filled with the personal comments of bloggers, first by the hundreds of thousands, and then by the millions. Citizen journalism arose as an alternative news medium. Inexpensive digital video equipment and cell phone cameras brought a visual component to the "User Generated Content" that was becoming pervasive on the web. Terrifying video footage of the December 2004 Asian tsunami shot by locals and tourists at the scene brought home the catastrophe to viewers around the world in a way traditional new providers, scrambling to get to the scene after the fact, could not. Suddenly, everyone had the potential to be a journalist.

And just as email had been the first "killer app" on the Internet, new technologies allowing more complex methods of social interaction gained massive followings. From the early days of AOL's Chat Rooms and Instant Messaging came the arrival in 2004 of "social network" websites MySpace and Facebook. A year

later, YouTube arrived, creating a mass market entertainment and news channel that completely bypassed the traditional media filters. Content consumers were now content producers as well.

But content that was disintermediated – that is, not filtered through traditional media – was only part of the radical shift in the new media equation. The business model that had sustained news providers for centuries was under threat as never before with vast numbers of competitors soaking up users and ad revenue. Advertising income was still on the rise at American newspapers in 2004. Print ads brought in $46.7 billion that year – a 3.9 percent rise over 2003, according to figures from the Newspaper Association of America. While online advertising only brought in a fraction of that figure – $1.54 billion – newspaper executives were pleased that web advertising income had grown 26.7 percent over the previous year, pushing overall ad revenue for the year up by 4.5 percent to $48.2 billion.

But other forces were in play. Newspapers across the US, and many regional papers in the UK had long enjoyed monopolies on print advertising in their regions and had enjoyed profit margins of 20 percent and more, making them a hugely lucrative business. The rise of new "pure-play" websites that could grab readers and ad revenue created a widespread "defensive" mindset among newspaper publishers.

Defense of the realm

"The primary purpose of our websites, whatever the readers might think, is about protecting the classifieds in the newspapers – particularly recruitment," said Northcliffe's Perch, during a 2004 interview. "But also motors and property. It's a massive amount of money for the newspapers. Most of the papers in the UK – that's regional newspapers – the amount of money they take in on recruitment advertising will be equivalent to how much profit they make. So that was the starting point for the site. What we're trying to do is keep the cost of the sites down while protecting that revenue."

He also recognized that print advertising revenue at Northcliffe, as well as other newspaper groups, would soon start falling as competition from the Internet increased. More visionary than many other regional newspaper executives at the time, Perch created an atmosphere within Northcliffe of "let's try anything and see if it works." Notably, the initiatives were mostly about saving money and building revenue, rather than focusing on the editorial product.

Among the online initiatives launched under Perch around 2004:

- Joining the "Fish 4" group of classified ad websites (jobs, homes and cars) along with other major regional newspaper groups to combat the growing number of web-only sites. Pooling together to run national classified advertising sites was actually common in both the UK and the US.
- Toowrite.com – Northcliffe newspapers had been spending substantial sums buying first person stories from freelancers. Toowrite allowed anyone in the country to submit a first person story and possibly win a cash prize. The proviso was that all submitted stories could be used for free by any Northcliffe newspaper.
- Hold the Front Page – Like other newspaper groups, Northcliffe had been spending a fortune placing recruitment ads in the industry trade paper the *Press Gazette*. To cut the high cost of attracting job applicants, Northcliffe created a web site that published news about the regional press in Britain – attracting everyone in the industry – and then placed their own recruitment ads on it. The initiative was so successful, other newspaper groups paid to place their ads on it, with some later buying an ownership stake in the site. It was a huge blow to the *Press Gazette*.
- Source Derbyshire – This was a partnership between Derbyshire County Council and Northcliffe Electronic Publishing to connect government buyers and contract tenders with local suppliers.The site was created after NEP executives learned that the overwhelming majority of public contracts in Derbyshire were awarded to companies from outside the region – despite the fact that Derbyshire spent millions of pounds promoting inward investment. The site lists contracts being put out to tender and publishes directories of suppliers. The commercial concept: NEP publishes the contract listings for free but charges suppliers to appear in an on-site directory and offers another paid service in which they send email alerts to suppliers notifying them of any new contracts in a particular category (i.e. flooring or air conditioning).
- Web Services– NEP also had a team of web designers and developers who built websites for clients. When Northcliffe began trying to sell Internet advertising to its print newspaper customers, many were reluctant because they did not have a web site for online users to click onto. So NEP began building sites for them. That side of the business mushroomed and NEP built about 5,000 websites for clients in the three years up to 2004 – accounting for about one-third of the group's

revenue. NEP also had a contract at that time with Lloyds TSB bank, in which the bank referred its business customers to NEP for web services. NEP had built about 2,000 websites as a result of referrals through that partnership by early 2004, according to Perch.

Although some of these experiments ultimately were more successful than others, it did show that there were attempts by newspapers to find new ways to bring in revenue.

The newspaper industry continued to seek ways to monetize its websites. Debates raged over whether it would ever be possible to charge for news online. Perhaps the best known attempt to charge for content was the move by *The New York Times* in 2005 to put its top op-ed columnists behind a pay wall under the banner TimesSelect. The experiment lasted two years before the *Times* relented and dropped the pay barrier.

Vivian Schiller, general manager of NY Times.com at the time, told online site paidContent that the TimesSelect model was a success, bringing in $10 million in subscriptions. But she said the decision to drop the pay wall was "because of what's happened in the Internet in the past two years – particularly the power of search," referring to the increase in traffic to newspapers that stemmed from searches on Google or other search engines. TimesSelect closed down with roughly 787,400 active subscribers: approximately 471,200 home delivery subscribers, 227,000 online-only paid subs, and 89,200 free academic subscriptions through TimesSelect University, the *Times* reported. But Schiller said the *Times* had determined that it would attract more revenue from advertising with free content that it would attract subscription revenue with a closed model.

Murdoch again

Advertising revenue for American newspapers hit its highest point ever in 2005, with print revenue hitting $47.4 billion and online ads reaching $2.02 billion. But disaster was looming.

The precise role of newspapers' online operations was still subject to debate within the industry. Talk of "web-first" publishing policies (as opposed to holding stories to run in the print edition first) and newsroom convergence (having print and online teams sitting near each and working together as a single unit) was still hazy and abstract. Writing about the state of digital journalism in the *British Journalism Review* in early 2005, Emily Bell, digital director of Guardian

Media, said, "My original brief for this piece was to explore the question: 'Is the writing on the wall for online newspapers?' I wondered for a minute whether I had misheard and the actual question was: 'Is the writing on the wall for printed newspapers?' "

But Rupert Murdoch had undergone a change of heart since he said in 2000 that he could not see how he could make money from the Internet. Five years after that declaration, in April 2005, Murdoch gave his "Digital Natives" speech to the American Society of Newspaper Editors, a speech now seen as a watershed for pushing newspaper publishers to recognize that online journalism was the key to the future.

"Scarcely a day goes by without some claim that new technologies are fast writing newsprint's obituary," Murdoch told the editors assembled in Washington. "Yet, as an industry, most of us have been remarkably, unaccountably complacent. Certainly, I didn't do as much as I should have after all the excitement of the late 1990s. I suspect many of you in this room did the same, quietly hoping that this thing called the digital revolution would just limp along. Well it hasn't … it won't …. And it's a fast developing reality we should grasp as a huge opportunity to improve our journalism and expand our reach.

"I come to this discussion not as an expert with all the answers, but as someone searching for answers to an emerging medium that is not my native language. Like many of you in this room, I'm a digital immigrant. I wasn't weaned on the web, nor coddled on a computer. Instead, I grew up in a highly centralized world where news and information were tightly controlled by a few editors, who deemed to tell us what we could and should know. My two young daughters, on the other hand, will be digital natives. They'll never know a world without ubiquitous broadband Internet access.

"The peculiar challenge then, is for us digital immigrants – many of whom are in positions to determine how news is assembled and disseminated – to apply a digital mindset to a new set of challenges. We need to realize that the next generation of people accessing news and information, whether from newspapers or any other source, have a different set of expectations about the kind of news they will get, including when and how they will get it, where they will get it from, and who they will get it from."

Murdoch then highlighted why he and other industry leaders had been so slow to react. "There are a number of reasons for our inertia in the face of this advance. First, newspapers as a medium for centuries enjoyed a virtual information monopoly – roughly from the birth of the printing press to the rise of radio.

We never had a reason to second-guess what we were doing. Second, even after the advent of television, a slow but steady decline in readership was masked by population growth that kept circulations reasonably intact. Third, even after absolute circulations started to decline in the 1990s, profitability did not. But those days are gone," he said. "The trends are against us."

The next chapter moves the story forward by looking at current news industry business models.

Current journalism business models – new ways to support traditional revenue streams

Summary

This chapter sets the scene before we explore new business model options in later chapters. It describes a range of models that media companies have employed with varying degrees of success. It begins by exploring paid content, and then looks in detail at aggregation, search engine optimization, hyperlocal and dayparting strategies. The chapter concludes with an analysis of what happened with classified advertising and examines the emerging model of distributed media.

The realization that traditional business models and strategies to support journalism will no longer be sufficient in the digital age has resulted in new, increasingly desperate, attempts to find extra revenue streams. Gathering, packaging and disseminating the news is expensive. Some strategies, such as Search Engine Optimization (SEO) and premium content creation, have been aimed at finding new ways to bolster the longtime mainstays of advertising and subscriptions. Other efforts have involved creating new products that readers will be willing to pay for, such as personalized information created through database manipulation.

The Holy Grail for online news providers is the elusive paid content model – getting readers to pay for news online as they have for print. But that has proved difficult, if not impossible. Online readers have made it clear – so far, anyway, that they will not pay for information they are accustomed to getting for free. Surveys and marketplace experimentation have borne this out.

Consumers are not entirely averse to paying for content. As *Slate* editor-at-large Jack Shafer pointed out in a February 2009 article entitled "Not all

information wants to be free," all sorts of content exists online for which people are willing to pay. He cites examples such as ConsumerReports.org and Major League Baseball's MLB.tv where baseball fans pay to watch games live. Among newspapers, specialized business publications *The Wall Street Journal* and the *Financial Times* offer a hybrid model of some free content combined with a pay wall for other types of information. Entertainment trade publication *The Hollywood Reporter* also offers a hybrid model, with much of its content provided free, while other types of information, such as its detailed charts of television shows and films currently in production, require a subscription (currently $27.95 a month). Both *The New York Times* and *The Times* in the UK are able to charge for their famous and addictive crossword puzzles. The *Sun* newspaper in the UK charges users for sending text messages to them, at 25p per text, with updated information about general news, celebrity gossip, and sports news. Users can also subscribe to receive texts about their favorite soccer teams. The *Sun* also offers texts with betting tips on horseracing. That costs £1 per text. Some of these sites and services are successful, such as MLB.com. Others not so much – *The Hollywood Reporter* is struggling through the recession just like general circulation newspapers and has seen sweeping layoffs.

Nonetheless, all these sites have traits in common. Some have specialized information or services that cannot be obtained elsewhere easily, if at all. Others have information that may be found elsewhere, but is delivered in a particularly timely or convenient way. What they also have in common is being targeted at specific, niche audiences. In the case of text alerts at *The Sun*, the niche group is not those who value that particular information, but those who value the timing and mobility. But finding content readers will pay for, or shaping existing content into conveniently distributed and timely products, is still out of reach for most publications – especially when their main product is general news.

Here are examples of a few attempts to create new paid content sources:

- *The New York Times* began charging for its news tracker email alerts in May 2003 after having offered the service for free. The alert system enabled users to list specific topics or keywords that might appear in stories in which they were interested – say, airlines or Bruce Springsteen. Whenever one of those terms appeared in a *Times* story, it would send an email, at pre-selected intervals such as once a day, to the user. Though the charge was a modest $19.95 a year, it was still an increase from being free. As a bonus, the *Times* expanded the number of keywords users could track from three to 10. But within months Google launched its own news alert system, following on from its launch of Google News in September 2002. The Google service offered

unlimited alerts, for free, and drew from the thousands of news websites it monitored. *The New York Times* eventually reverted to a free model.

- In July 2003 *The Guardian*, the UK paper which has been a consistent leader in digital thinking and innovation, announced it would begin charging for "an improved version" of its email services. The Wrap, a daily summary of the news in other newspapers was offered for £12.50 per year as was The Informer, an afternoon email following the day's breaking news and offering a preview of the next day's *Guardian*. Also on offer was an advertising-free version of *The Guardian* for £20. Although none of these services offered any information that readers could not obtain themselves, they offered convenience, time-saving, previews of information not yet released to the wider public and relief from advertising, for those willing to pay for an ad-free edition. "We have always said that paid-for content is a part of our future, but it is no panacea: it needs to be seen as part of a balanced business with a mix of revenues," *Guardian* director of digital publishing Simon Waldman said at the time. Today, The Wrap is free, The Informer has been closed and the ad-free edition disappeared quietly, sometime after Emily Bell, then editor-in-chief of *Guardian* websites, noted in a 2006 column that the response was "small."

- The *Sacramento Bee*, the hometown paper of California's capitol, launched a niche political news site in January 2007 targeting lobbyists and political insiders with expanded political coverage and an early peek at political stories going into the general newspaper – all for $499 a year. Before the end of that year, the paper dropped the charges and converted the site to a free, advertising-supported model. Although the paper never revealed how many subscribers it had, a spokesman told Reuters at the time, "It's fair to say that it did not meet expectations." Whether Capitol Alerts could have survived as a paid service with higher quality content, or distributed in a more convenient and timely way or at a lower price point remains unknown.

- The *Los Angeles Times'* web site had a popular entertainment, culture and listings section called CalendarLive. To exploit its popularity, the paper placed the section behind a pay wall, charging $4.95 a month or $39.95 for the year, with print subscribers getting free access. Take-up was not impressive. In the first six months, wrote Tim Windsor on the Nieman Journalism Lab blog, 15,000 print subscribers registered and 3,674 online-only users paid the fee and signed up, for total revenue of about $63,000. During those six months, Windsor reported, visits to the site dropped from 1.4 million a month to 540,000 a month, a 61 percent fall. Most of those were

"visitors who turned away at the wall." The number who actually made it past the pay wall fell from 729,000 the month before the pay wall went up, to about 19,000 registered users – a drop of 97 percent. The pay wall was taken down 21 months after it went up.

- In probably the most watched paid content experiment in the newspaper industry, *The New York Times* put its top op-ed columnists behind a $49.95 a year pay wall in September 2005, under the banner TimesSelect. Print subscribers could register to get the service free. *The Times* said it was targeting the one million online readers it had designated as heavy users. Besides gaining access to the columnists, subscribers were given a few extra features and services such as free archive access and an early look at the Sunday paper's non-news sections. *Times* columnists, for their part, were rumored to be fuming at the arrangement, which left them with reduced readership and influence. Another consequence of the *Times'* move was that copies of the *Times* pay-only columns were widely copied and disseminated across the blogosphere, so that anyone typing the name of a *Times* columnist into a blog search engine such as Technorati would find numerous sites where they could read the writer's work for free – and without *The Times* getting the traffic. *The Times* dropped the pay wall two years later, in September 2007, despite making $10 million from 227,000 online-only subscribers on top of an audience of 471,200 registrants who were print subscribers and nearly 90,000 free academic subscriptions. *Times* executives said the paid service had been a success, but had determined that the rewards would be even greater with free access supported by advertising.

The demise of TimesSelect in 2007 quelled the paid newspaper content debate for a while. Newspapers continued to slash costs with staff buyouts and layoffs becoming increasingly commonplace as publishers tried cutting their way back to health. Industry analyst John Morton noted in the *AJR* that in 2007 "the average operating profit margin of the publicly owned companies' newspaper operations [in the US] was 17 percent. Most non-media businesses couldn't hope to achieve even half that in the best of times." But he added a "good chunk of those profits came, you guessed it, from cost-cutting, with inevitable damage to newspapers' standing in the markets." He called on newspaper publishers to "stop the ax-wielding and accept that the era of exceptional profitability is over."

But at the start of 2009, the roof was caving in. Staff layoffs were not the big industry story – it was newspaper closures. Print advertising revenues for 2008

had plummeted by 17.7 percent from 2007, which itself had seen record-breaking drop of 9.4 percent. And while the industry had hoped that online ad revenue would keep climbing and eventually offset print losses, 2008 saw the first fall in newspaper web advertising with a drop of 1.8 percent.

Paid content suddenly became a top talking point again. Walter Isaacson, former managing editor of *Time* magazine, kicked off the resurrection with a February 2009 *Time* cover story calling for news providers to create a system to enable – or is it force? – online readers to pay small amounts of money (micropayments) for various levels of content. "The key to attracting online revenue, I think, is to come up with an iTunes-easy method of micropayment," he wrote. "We need something like digital coins or an E-Z Pass digital wallet – a one-click system with a really simple interface that will permit impulse purchases of a newspaper, magazine, article, blog or video for a penny, nickel, dime or whatever the creator chooses to charge." As he envisioned the process "a newspaper might decide to charge a nickel for an article or a dime for that day's full edition or $2 for a month's worth of web access. Some surfers would balk, but I suspect most would merrily click through if it were cheap and easy enough."

The concept Isaacson proposed, a sort of pay-as-you-go subset of the paid content model, has been around as long as online content, but has never taken off. Critics have pointed to multiple problems with the model such as the fact it was unlikely someone reading a newspaper online would want to constantly stop and make a decision about whether to buy the next article. Online readers would also face a dilemma with buying news articles that they would not face buying most other products. Namely, they would have to decide to purchase the product before they knew what they were getting. Industry analysts, such as Alan Mutter, also pointed out that a micropayment could not work for one news outlet if others were providing the same, or similar, content for free. So they would need to band together.

Digital media consultant Clay Shirky dismisses the whole idea of micropayments as a last gasp effort by traditional news media to hang onto their news monopoly. "Even if most traditional publishers formed a 'cartel of news' tomorrow, all retiring behind a pay-wall on the same day," he wrote in *The New York Times*, "many net-native publishers, from ProPublica to Spot.us to Off the Bus, would see their competitive advantage in attacking that cartel rather than joining it." Writing about micropayments on his own blog, Shirky was even harsher. "The threat from micropayments isn't that they will come to pass," he said. "The threat is that talking about them will waste our time, and now is not the time to be wasting time."

But micropayments are only part of the macro issue of paid content. Consensus is forming – among traditional publishers, not pure-play websites, as Shirky would point out – that some form of payment plan needs to be enacted. But what form should it take? And who will jump in next?

Tom Curley, CEO of the Associated Press, said in a *Business Week* story about paid content that the business needed to shift to "some sort of user payment model" because there would be "less and less advertising for some number of years." Industry analyst John Morton only half-jokingly suggested "the Morton Plan" under which all newspapers would simultaneously place their content behind pay walls. He acknowledged, as had others, that any newspaper acting alone was likely to face fast ruin because of the vast choices available to audiences. Ultimately the newspaper industry must act in concert – most likely with permission from government anti-monopoly regulators.

However, publishers may not have considered that this plan, and all other plans that put news content behind a pay wall, create an unintended consequence that undermines the core mission of newspapers to keep the public informed. One of the great features that online news has opened up to readers is the ability to compare various accounts of the same story by clicking through to a variety of news sources, usually via a search engine such as Google. What's more, if an event is happening in a particular city, say, Dallas, Texas, users around the world can go straight to the *Dallas Morning News*, believing they are likely to have the best resources to cover the story. Putting individual online newspapers behind a pay wall would immediately kill that freedom and opportunity for users. And while a return to enclosed "walled garden" news provision could benefit newspaper publishers, it would be seen elsewhere as an attempt to go back in time, to a period when information was not so easily (let alone freely) available to the masses.

So how to resolve the balance between freedom for audiences and the need for news providers to get paid for their costs and work? One potential, and partial, resolution to that problem would be to create a system under which online users could make a payment to a single operator, which would then give them access to a wide range of online news sources. Jon Stewart, host of cable TV's *The Daily Show*, suggested such a system – like a cable TV model – while interviewing Isaacson on his show, and he is now sometimes credited with the concept (though it was one of many models discussed previously.) The problem for users of course, is that even the cable model still places limits on their travels across the web. Another way of looking at the online paid content issue is to consider whether it is an extension or a corruption of the print paid content model. Consider this passage from Poynter Biz Blog editor Rick Edmonds, writing about McClatchy

CEO Gary Pruitt in a column called "Paid online content? Not so fast, says McClatchy's Pruitt."

> With light prompting from an analyst's question during this morning's quarterly earnings call, Pruitt, also current chairman of the Newspaper Association of America, indicated he didn't much agree with the chorus of outside critics saying the industry's decision to make Web site content free was a big mistake. "Value propositions are complicated," he said. "In print, people pay a nominal amount to have the paper delivered to their doorstep every day." In practice that roughly covers the cost of paper and delivery. The revenue to support a news effort and everything else the company does comes from advertising. Online content is free to the user, he continued, but there is no paper or delivery cost. So the model (also shared with broadcasting) is that advertising is the sole revenue stream. In short, he said, the distinction between the two "is not as great as most people think." McClatchy will continue to experiment with specialized paid content at its Web sites, he added, and has enough papers to do many different modest-sized trials.

Edmonds said he "took Pruitt to be saying a little more by way of implication. Though we newsroom types think of readers as paying for their sparkling content when they buy the paper, maybe in the Internet age, it is more precise to say that they are paying for the luxury and convenience of the paper format (ads and inserts included) and home delivery."

So, as of this writing, finding a way to get online readers to pay directly for news content, whether via micropayments, by the traditional newspaper subscription route, or by a cable TV style model, remains a hot button topic. Despite the urgent calls for action, no one has taken the plunge so far beyond the few general circulation news providers and specialized information publications that already have a pay wall. But that could change quickly. Meanwhile, in the absence of getting users to open their wallets before clicking onto stories, news providers are attempting other strategies to build revenue. Most, but not all, of the strategies are about finding ways to grab a larger share of the advertising market. Here are some of the key business models that are being tried or considered.

Aggregation

Just as news publishers are desperately seeking ways to get online users to pay for news, many are also seeking a way to get news aggregators such as Google to pay for the right to provide a news link service with links to news media websites. For newspapers and other online news providers it is complicated territory for which

the term "frenemy" – meaning, someone who is both a friend and an enemy – could have been invented. In the wake of newspaper closures and threats of closure across the US and UK, Google is becoming increasingly demonized for its practice of organizing headlines and links to news stories and then sending users back to the originating news source to read the full story. Despite the huge levels of traffic sent to news providers via Google – often more traffic than arrives directly at their websites – some news executives are calling it theft and demanding payment. "We can no longer stand by and watch others walk off with our work under misguided legal theories," said William Dean Singleton, head of MediaNews and chairman of the Associated Press in 2009, in a speech to news executives. Rupert Murdoch asked rhetorically, "Should we be allowing Google to steal our copyrights?"

Flipping the argument around, Danny Sullivan, editor-in-chief of Search Engine Land, noted that Google sends newspapers much of their online traffic for free and that newspapers earn money from all those page views. Google, for its part, has said providing headlines and links is perfectly legal under "fair use" regulations. And Google executives have reminded news publishers that they are free to stop Google's spiders from indexing their pages and providing links to them. Despite all the harsh words against Google, no newspaper is known to have taken that step as of this writing. Google CEO Eric Schmidt, at a gathering of the Newspaper Association of America in April 2009, told assembled news executives that they needed to "try to figure out what your consumer wants." Silicon Valley Insider covered the speech under the headline "Google's Schmidt tells newspapers to quit whining and create a product readers want." The Insider's Eric Krangel wrote "Mr. Schmidt called on the industry to join with Google to create products that would entice readers to go beyond headlines listed on search engine pages. He said Google envisions a layered approach to information that was personalized, to draw in readers. "We think we can build a business with you," Schmidt told the group. "That is the only solution we can see."

Writing on the same issue, MarketWatch columnist Adam L. Penenberg said, "What's the solution? There isn't one. We are in the midst of a paradigm shift. The big media companies with huge legacy costs pertaining to gathering, printing and distributing information either will adapt or die."

Search engine optimization

One of the key survival tactics for news providers is to make sure their stories are picked up by search engines, aggregators, bloggers and anyone else who can send traffic back to them. Traffic equals page views and page views equal advertising

revenue. Search engine optimization (SEO), as it is called, is a multi-billion dollar, and constantly evolving, business on the web. It is fundamentally changing the way journalism is practiced both commercially and editorially. The situation is more than a little ironic, in light of the news industry's complaints about Google and other search engines and aggregators that organize news headlines and link to them. As newspapers and other online news providers become more sophisticated at utilizing SEO to attract users to their stories and sites, they can increase their audience dramatically. But chasing web traffic can also have editorial consequences as writers and editors adjust their headlines and writing – and even the topics they write about – to be search engine friendly. Search engines will give higher rankings to online content that has, for example, a user's search terms in the headline or high up in the story. The search engine also will give priority to stories that have embedded keyword tags that match the search terms people are typing into the search engine. And Google also factors in how many other websites have linked to a particular story or page and give that story greater prominence, under the theory that it must be more valuable to users if more sites have linked to it.

To use this to their advantage, online news providers are using a number of SEO tricks. Headline writers ensure they include the keywords that web users are most likely to use for their search, and stories will contain important keywords up high in the story. This can lead to online news stories sacrificing individual writing flair for the sake of search engine visibility. More controversial is the growing trend among news organizations to track the most popular search terms at any given time and then create content that uses those search terms.

At a March 2009 seminar hosted by the Association of Online Publishers in the UK, the executives in charge of search at Telegraph.co.uk (*Daily Telegraph*) and *The Sunday Telegraph* and Times Online (*The Times* and *The Sunday Times*) attributed their increasingly sophisticated and aggressive use of SEO to the huge year-on-year growth in the number of unique users coming to their sites. Julian Sambles, head of audience development at *The Telegraph*, told the seminar that SEO considerations should be a part of writing and publishing every story, according to the web site journalism.co.uk, which covered the event. Sambles said all journalists at the paper are given SEO training and that an SEO support team has been set up to advise journalists on a story-by-story basis. Tasks that improved an article for search engines, such as drafting web headlines or adding tags, were being integrated into journalists' roles to help streamline the production process, he told the seminar. Drew Broomhall, head of search at *The Times*, told the event his team monitored the popularity of search terms to note the gaps between what people were seeking and what the *Times* was writing about. In one

case, he noted, he found a growing number of searches for the terms "recession" and "calculator." So the *Times* built an online "Recession Calculator." Built for free by one of the site's advertising partners, reported journalism.co.uk, the calculator rose to number three in Google UK's search results for the term "recession." The project was not about gaining one click from users, but providing them with sufficient relevant content to refer them around the site, Broomhall said.

Other techniques used to increase web traffic from search engines include providing users with the ability to share stories either with links to blogs or content aggregation sites as Digg, or social networking sites such as Facebook. Some news providers have been accused of including the names of celebrities gratuitously so search engines will pick them up. News providers also use paid search advertising to attract users to stories. That is, they buy certain popular keyword search terms, so that every time an online user types that search term into a search engine, users will see a small contextual ad notifying them of coverage about that topic in the newspaper, and a link to the story.

Hyperlocal

This is the strategy and practice through which news organizations cover communities at a much more local, granular level than previously conducted. From an editorial point of view, hyperlocal coverage means news reporting that more closely reflects the everyday lives of residents in a particular community – things like the opening of a new grocery store, a minor car crash or kids' football league results. Hyperlocal news coverage has become fertile territory for citizen journalist projects, with sites popping up by the hundreds. For mainstream news providers, the evolution has been slower, with the innovative *Lawrence (Kansas) Journal World* an early entrant to the field, followed by such big names as Gannett, the *Chicago Tribune*, *The Washington Post* and somewhat later, *The New York Times*. In the UK, major newspaper publishing company Trinity Mirror began experimenting with hyperlocal sites in communities in the Northeast of England, with each site covering a separate postcode area.

From a commercial point of view, the hyperlocal strategy represents an attempt by news organizations to attract new sources of advertising revenue. While regional newspapers once enjoyed near monopolies in attracting advertising, the rise of the web has resulted in unprecedented competition. Publishing a web site is relatively easy compared with the vast cost of printing a newspaper or magazine. So news organizations have decided that their competitive advantage might be to drill down

to the smallest segments of a community, places that receive little news coverage, and build an audience within those segmented zones. Then, by attracting that very local readership, which is not being served by a competing news provider, they could offer low-cost advertising space to small businesses and individuals with something to sell or promote to that specific group. Suddenly, businesses that were too small or local to advertise previously would have an affordable outlet to promote themselves.

That's the theory. While the editorial results of the hyperlocal movement have added a new, and largely welcomed, impetus to local journalism, the commercial results have been, at best, mixed. An early hyperlocal startup called Backfence, funded with millions in venture capital, rolled out across major metropolitan areas of the US starting in 2005, fueled by citizen-journalists' news reports and local ads. But by late 2007, Backfence's hyperlocal sites were drying up, short of news, advertisements and readers. It never really caught on. Today, the Backfence web site is just a vehicle for displaying localized Google ads.

The *Washington Post* also has floundered after its dive into the hyperlocal arena. The newspaper created a hyperlocal web site called LoudounExtra, zeroing in on Loudoun County, Virginia, one of the most affluent counties in the US. Leading the development of the site was Rob Curley, one of the leading lights of the hyperlocal movement, who had developed such sites at the *Lawrence Journal World* and elsewhere. Despite the backing of one of the top newspapers in the US, Curley's guidance and a potential readership of big spenders, the site fizzled. Why? According to a June 2008 story in the *Wall Street Journal*, several factors contributed. One was an apparent lack of coordination that meant that stories about Loudoun County in the *Washington Post* main web site were not linked to LoudounExtra. But more importantly, the *Journal* reported, "Mr. Curley's crew was trying to reach a much different audience than they were used to. Unlike Lawrence, Kan., which had a small populace linked by an easily identifiable set of interests, Loudoun County is a 520 square-mile area with seven towns whose residents share little else besides a county government. To penetrate those communities requires a more dedicated effort than the LoudounExtra.com team was putting forth. Mr. Curley himself acknowledged he spent too much time talking to other newspaper publishers about the hyperlocal strategy and too little time introducing his team and the site to Loudoun County." Curley and his team have since moved on to the *Las Vegas Sun*.

A hyperlocal site that remains promising is EveryBlock, a project that coordinates coverage of neighborhoods within big cities by providing, as EveryBlock puts it, "recent public records, news articles and other web content that's geographically

relevant to you. To our knowledge, it's the most granular approach to local news ever attempted." Noted journalism technologist Adrian Holovaty oversees the project. It was funded by a two-year grant from the Knight News Challenge, but then acquired by MSNBC in August 2009 when the Knight funding expired.

The hyperlocal movement has shown the value of mixing local reporting and citizen journalism with database manipulation of maps, public records and other types of online content to create highly relevant local news for residents in small, specific geographical areas. But whether the hyperlocal business model will sustain the editorial model remains unproven. Richard M. Anderson, who publishes four hyperlocal sites in Maine under the umbrella title Village Soup says he has found a sustainable model that both serves the community editorially and is viable commercially. Among the features of the Village Soup sites is a reverse publishing aspect that sees some of the online content published in a weekly print newspaper and blogs sponsored by local advertisers, who are able to maintain online display advertisements for their business, while updating news about themselves, such as sales, new services and the like. Writing as a guest blogger on the journalism blog Reflections of a Newsosaur, Anderson said: "In the two most mature of the four markets we serve, the sponsored blogs help generate a large portion of the online sales that collectively generate 19 percent of our $2.5 million in annual advertising revenues. So far as I know, no other newspaper, not even *The New York Times* has been able to do this."

Dayparting

In the fast moving online world, a promising idea can quickly become obsolete. That seems to have been the case with a business model called dayparting that enjoyed some popularity among online newspapers between 2003 and 2007. MORI Research, on behalf of the Newspaper Association of America, published an influential report in January 2003 titled "Online Dayparting: Claiming the Days, Seizing the Night." The findings were generally backed by a similar study released later that year by the Online Publishers Association. The concept was fairly simple and had been a traditional part of television and radio broadcasting programming. MORI Research found that, as in broadcasting, different sections of each day, or "dayparts" in broadcast-speak, drew distinct audiences. Web audiences had their own distinct uses for the Internet at various times of the day.

What MORI found was that online users in their study had a huge appetite for news between 8 a.m. and 11 a.m. every weekday morning, with news web site usage

trailing off after that, aside from a mild blip around lunchtime. On the weekends, online newspaper usage plummeted. But notably, these same users still accessed the Internet in significant numbers at evenings and weekends – they just did not go to news sites. Instead, as they day went on they went online for other services such as email, entertainment and entertainment listings and research. The study also found that, by significant percentages, Internet users conducted their online commerce – buying travel tickets, books, clothing, electronics and the like – between 6 p.m. and 10 p.m. So MORI concluded that online newspapers should adjust the emphasis of their content, particularly on the homepage, to reflect the needs and habits of online users, rather than see their websites become ghost towns by early afternoon.

MORI gave these specific "Daypart" recommendations: **Early Day** (6 a.m. to 2 p.m.) news heavy homepage, with sports and entertainment on the page, but with a lower priority. **Afternoon Drive** (2 p.m. to 6 p.m.) breaking news emphasized with a rise in entertainment news and services such as "movie times, maps and directions, events and calendars – all searchable from the homepage." **Night** (6 p.m. to 6 a.m.) "a four-pronged homepage" consisting of breaking news; entertainment and hobby content; classifieds ("that gives the homepage user more ready access to the wealth of classified ad content inside") and retail shopping ("a searchable database of retail ads imported from the printed newspaper and a local calendar of shopping events").

Among the newspapers that decided to try dayparting were the *Lawrence (Kansas) Journal World*, which was closely observed within the newspaper industry because of its reputation for digital innovation, along with papers such as the *Milwaukee Journal, Arizona Republic* and the *San Jose Mercury News*. Former *Mercury News* executive Stephen Wright recalled shifting to a dayparting strategy as one of the byproducts of an overall attempt to add new content to the web site as the day progressed. Web editors noticed that starting at about 2 p.m. and building until about 6 p.m. *Mercury News* online users began combing the site looking for film and restaurant reviews, live music listings and TV schedules. Giving greater emphasis on the homepage to leisure activities simultaneously solved another problem – the lack of fresh content to post on the web site, Wright recalled in an interview. "Remember, this was a time when newspapers were finally getting serious about their websites," he said. "But it was hard to get fresh news updates in the afternoon because the reporters were all hard at work for the next day's paper. So some of these decisions were solutions to the problem of not having new content toward the end of the day." That problem began to dissipate about 2005, Wright said. "There began to be much less resistance in the newsroom to posting first drafts of stories or the top six paragraphs."

But, as other newspapers discovered, the *Mercury News* found that a substantial percentage of their online audience was neither local nor arriving via the homepage. "We did have stats at one point," said Wright, "that something like two-thirds of our visitors were from outside our circulation area, mostly looking for Silicon Valley news or ads from the early technology retailer Fry's. So freshening up the homepage with local news was an attempt to get subscribers and other local folks to come to their site more often. This was important to local advertisers on the site." Attempts to reshape newspapers as different things to different people at different times never did take off. In a 2006 column in the *Seattle Post-Intelligencer* announcing the end of its two-year dayparting experiment, senior online producer Brian Chin wrote: "SeattlePI.com is, first and foremost, a news site. That's how people see us, that's what they expect of us and that's what brings them to us in the first place." (Although SeattlePI.com remains active, its print counterpart was shut down by its owners, the Hearst Corporation, in March 2009, after prolonged financial problems.)

Perhaps more significant to the dissolution of the dayparting movement was the surge in online newspaper traffic that comes via search engines and aggregators to specific, individual stories rather than through the front door of the homepage. "Coming in through the home page is an old model," former *Washington Post* online executive Caroline Little was widely quoted as saying. "And coming in sideways is the new method of arrival for most users."

Reclaiming the classifieds

Commercial success for newspapers has always been, with few exceptions, based on the strength of classified advertising sales. Between 25 and 50 percent of a newspaper's revenue, and in some cases more, used to stem from the small ads for jobs, cars, property and other categories. No other medium was as well suited to providing ads that were brief, time-dated, geographically defined and relatively cheap. Newspapers had a virtual monopoly on the multi-billion dollar industry. In 2000, US newspapers earned $19.6 billion from classified ads out of their total advertising revenue of $48.6 billion for the year. That was the peak year for newspaper classifieds and it has been downhill ever since. In 2008, when a global recession made already bleak conditions for newspapers disastrous, classified ad revenue at American newspapers fell to $9.97 billion on total ad revenue of $34.74 billion for print and another $3.1 billion for all categories of online advertising, meaning total ad revenue of $37.85 billion for the year.

The newly arrived web proved to be a highly efficient way to connect buyers and sellers. Yahoo, Monster, Craigslist and other websites produced innovative advertising platforms and services that made it fast, easy and cheap to post ads (see the previous chapter). The web also made it easy for employers to post their own job listings, cutting out the middleman and creating an entirely new layer of competition for the newspaper industry. The National Health Service in the UK, for example, by far the country's biggest employer with 1.3 million workers, has run its own recruitment web site for years, with thousands of job openings listed at any given time.

Though the threat to this vital revenue stream was clear enough, the industry's response was neither fast nor decisive enough to see off the challenge to its long-held monopoly. As classified revenue began to decline, big newspaper groups banded together to create their own national classified sites. In the UK, for example, six regional newspaper groups – Newsquest Media Group, Northcliffe Newspapers Group, Trinity Mirror, Regional Independent Media, Bristol United Press and Guardian Media Group Regional Newspapers – created the "Fish4" brand of sites for cars, jobs and homes. Fish4 also provided services to, and from, nine additional subscriber newspaper groups. In the US, the country's second and third largest chains at the time, Knight Ridder and Tribune Company, joined forces to operate recruitment site CareerBuilder. (Today, only Newsquest and Trinity Mirror remain in Fish4. CareerBuilder is now owned by Gannett, McClatchy Co., Tribune and Microsoft. Knight Ridder was taken over my McClatchy newspapers in 2006 and no longer exists. Tribune Company filed for bankruptcy in 2008). Gannett, McClatchy and Tribune, along with the Belo Corporation and the Washington Post Company also hold joint ownership in Classified Ventures, which describes itself as designed to "collectively capitalize on the revenue growth in the online classified advertising categories of automotive, apartments, and real estate."

Despite these efforts, classified revenue continued to drop and the explosive growth of the classified ads site Craigslist pits newspapers against a business model and price point that is tough to compete against – free. In a move that created great controversy within the industry, newspaper groups began signing up with Google and Yahoo in ad partnership deals. In the case of Google, about 800 newspapers joined an initiative launched in 2006 called Google Print Ads, through which Google would automate the sale of advertising to print papers. Some news industry leaders decried the partnerships as giving even more power to companies that were already draining revenues from newspapers. But in January 2009 Google dropped the program saying "the product has not created the impact that we – or our partners – wanted." Yahoo, however, was still going strong in 2009 with nearly

800 newspapers signed up to its advertising partnership initiative. Unlike Google, Yahoo never became involved on the print side. Instead, it works with online news sites in a variety of ways, from displaying partner sites' headlines on Yahoo sites as a way to increase newspaper traffic, to incorporating its HotJobs recruitment site into newspaper sites to using its software to help newspapers with online ad management.

The perilous drop in newspaper revenue in 2008 and 2009 brought renewed and urgent efforts to reinvent and reclaim the classified ad business. These efforts can be seen in websites such as ReinventingClassifieds.com, produced by longtime news industry pundit Steve Outing, and RevenueTwoPointZero, a site dedicated to finding better ways to increase advertising at news organizations, including classified advertising. Outing offers a manifesto that includes suggestions ranging from redesigning the classified ad pages and making the rate structure simpler to becoming more involved in the sale of goods and services, beyond merely listing them. RevenueTwoPointZero offers similar basic suggestions, with both sites building on these core ideas in their blogs.

Distributed Media

Google's dominance of the digital world is attributable to a great many factors, but one of the most important is that its services are distributed across the web, rather than only available on a solitary web site. In other words, Google's search functions and ads and email go to the users – users do not need to go to Google. Anyone who goes online and clicks onto a few websites will probably see Google contextual ads on those sites, or some other reminder of Google's near omnipresence. What Google realized, and what other media organizations are learning, is that in the crowded, interactive digital space, it is no longer enough to sit back and wait for online users to find your web site and come to you. That model, which worked well for print newspapers and TV and radio broadcasters, will not suffice in the digital world. True, big portals dominated the early years of the web with their strategy of serving as an online entry point for users and then holding onto their audience with a smorgasbord of content. And two of the original mega-portals, Yahoo! and MSN, are still among the most popular sites in the world. But even they are working to refocus their strategy toward a more distributed model. News organizations have had to come to grips with no longer being "destination" sites. They have seen an increasing percentage of their online traffic arrive from search engines and links from other sites, such as news aggregators. Rather than land on

the homepage of a news site and start browsing as they would in a print newspaper, users frequently click onto a particular news story – and may well leave that news site with the next click.

As a result of these fundamental changes in audience viewing habits, news organizations are now experimenting with distribution models that send their content to where users are, rather than just publishing material on their sites and waiting for audiences to find it. Digital news pundit and academic Jeff Jarvis, one of the most vocal advocates for developing distributed news platforms, highlighted three main methods on his blog in May 2008:

- *Widgets that enable people to embed your news (and links and brand) anywhere.*
- *A platform strategy enabling people to build on your content, data, and functionality.*
- *A network strategy that includes blog networks (a la Glam).*

The method Jarvis first suggests – widgets – are small applications that can be embedded onto a webpage. News organizations are able to increase their distribution and visibility by offering users widgets they can download and keep on their computer desktops or embed in their own websites, blogs or Facebook pages. The widget will automatically update itself to display the latest headlines, videos or any other kind of news from that news organization. Reuters, for example, offers widgets on a range of topics, including Top News, Politics, Entertainment and Business Data.

Jarvis also is among those who believe that news organizations should create platforms that enable anyone to take their content and build on it to create something new. This is generally done by offering an Application Programming Interface (API) which allows access to the material, or open databases. Projects offering free access to news content already have been launched by some of the biggest news brands including The *New York Times*, the BBC, Reuters and *The Guardian*. *The Guardian* launched its "Open Platform" project in March 2009 with two main parts – a "Content API" and a "Data Store" both of which are freely available for approved users to develop. "By opening out our content to external developers and offering them an API," said *Guardian* Newspapers Managing Director Tim Brooks in a July 2009 article in *The Guardian*, "we are harnessing not just the creativity and imagination of our own team of developers but of the entire global web development community and we hope to get some extraordinary and unforeseen uses of our data."

News organizations clearly have an opportunity to extend the reach of their content and their brand by opening it to outside developers and having them redistribute it in new forms. There also are commercial opportunities, although this aspect has been largely undeveloped so far. Most of the media companies that have opened their content to developers have required that any new projects that emerge must be non-commercial. The *Guardian* has gone a step further than most, writing in its Open Platform terms and conditions that it has the right to place ads on sites using its content and that, conversely, developers can also sell ads themselves on the sites they develop using *Guardian* content. The *Guardian* also notes that it has the right to begin charging for access to its content in the future.

News organizations also can extend their reach, and send their content to where users are, by networking with other websites and blogs to share articles, videos and links. Jarvis cites as an example Glam Media and its biggest property, Glam.com, which bills itself as the "largest online women's network in the world" and claimed in August 2009 that it had 54 million unique users monthly in the US and 115 million globally and had signed 1,400 online publishers to its network. Glam Media owns and operates a few websites devoted to traditional women's interests such as beauty, fashion and entertainment. But the key to Glam.com's business model is that it signs up independent websites and blogs that publish content for women, and serves ads across those sites. On its own main site, it also promotes and provides links to some of the content offered by third-party sites in its network. Conversely, all sites in the network display a Glam button that links back to the main site. While this structure can be seen in some ways as a positive model for distributed media, Glam also has attracted some controversy. Critics complain it is really an advertizing network not a content network and that the way it counts its unique users is deceptive because it counts the users of third-party sites as its own. Nonetheless, the Glam model provides a starting point to look at how a distributed, networked news content model might look.

The quest continues for new ways to make media companies viable. The next chapter looks at experiments with sponsorship as an alternative to advertising.

Sponsorship and philanthropy

Summary

One method of funding journalism that is drawing increased attention is the sponsorship model. Traditionally advertising has subsidized newsgathering. With sponsorship the idea is to transfer the subsidy to wealthy individuals and foundations. These donors want to see quality journalism survive, and are willing to fund it. The chapter focuses on the example of ProPublica, which received a subsidy of $10 million a year for at least three years from mid-2008. It also looks at a range of smaller operations. ProPublica employs a relatively small number of journalists, even if they are the largest single grouping of investigative reporters in the US. The key issue is whether the small-scale funding examples that have arisen in recent years can be extrapolated to major newspapers.

In sixteenth-century Europe business people employed letter-writers in cities where those business people traded but did not live. The letters carried the same news that a trader or merchant would need today: prices, economic conditions and news of disasters, along with rumors of war and other forms of gossip. The letters were valuable because they were current, reliable, relevant to decision-makers' needs, and because they were not widely circulated. Those letter-writers were well paid and respected. Quality and accuracy were vital, along with an ability to interpret.

Professor Jay Rosen of New York University noted in his PressThink blog that this business model exists today in the form of expensive specialty newsletters. But only big firms and rich people can afford them. "If you make your money in the oil industry you need good information from around the globe and

will pay a lot for it." In a limited sense, Rosen said, society would always need quality news – and paid professionals to research, write and package it. The key question for journalism was whether the public could continue to be informed by paid correspondents "trying to figure out what's going on and tell the voters about it." The world had reached a new point in history, Rosen said, where it was difficult to know how a public that wanted informed opinions would continue to be informed. Humanity had reached an era which faced "new economies of news" that proposed to transfer the subsidy for news from advertisements in newspapers to wealthy individuals and foundation donors who wanted to see quality journalism, especially investigative journalism, survive.

This introduces the non-profit model for journalism. Professor Todd Gitlin of Columbia University notes that the very existence of non-profit foundations rests on tax policies that advantage their creation. "So in the end, it is public policy and only public policy that will determine what kind of journalism survives" if groups follow a non-profit model.

Probably the best-known example in the US is ProPublica, which launched in mid-2008. It represents one new business model that might save modern journalism, though at the elite end in terms of audience. But it has attracted controversy as well as publicity. ProPublica is funded entirely through philanthropy. Its operating budget is about $10 million a year, and it has money for at least three years. The Sandler Foundation, the Atlantic Philanthropies, the JEHT Foundation, and the John D. and Catherine T. MacArthur Foundation supplied the money. Chairman Herbert Sandler and his wife Marion founded Golden West Financial Corporation in 1963. They were Golden West's chief executive officers and chairmen of the board from 1963 until 2006 when the company was sold to Wachovia Corporation. The Sandlers are currently presidents of the Sandler Foundation and chairmen emeriti of Golden West Financial Corporation. In early 2009 *Forbes* estimated their worth at $1.2 billion.

About two-thirds of ProPublica's funds are devoted to news, according to the organization. To put that into context: Many major newspapers spend a mere 15 to 20 percent of their budgets on news. ProPublica uses the elite press as its distribution channel, rather than creating a new channel. It gives its stories free to quality news organizations like *The New York Times* and *The Wall Street Journal* and web sites of leading news organizations "selected with an eye toward maximizing the impact of each article," the web site said. These papers accept the stories because of the reputation of Paul Steiger, ProPublica's president and editor-in-chief.

Prior to ProPublica, Steiger was editor at large for *The Wall Street Journal* and a vice president of Dow Jones & Company, the *Journal's* publisher. He is also the chairman of the Committee to Protect Journalists and a trustee of the John S. and

James L. Knight Foundation. After 25 years at the *Journal* and the *Los Angeles Times*, Steiger was appointed managing editor of the *Journal* in 1991 and served in that role until May of 2008. During that time *The Wall Street Journal* won 16 Pulitzer Prizes. Steiger was a member of the Pulitzer Prize Board from 1998 to 2007, serving as chairman in his final year. Steiger won two John Hancock awards and three Gerald Loeb Awards for his economics and business coverage, as well as the 2002 Loeb Award for lifetime achievement.

ProPublica's birth was announced in October 2007. Its web site described it as a new, non-partisan, non-profit newsroom producing journalism in the public interest. As of early 2009 it had 24 full-time reporters and editors, the largest staff in American journalism devoted solely to investigative reporting, plus a handful of administrators. Steiger cited a 2005 survey by Arizona State University of the 100 largest American daily newspapers. It showed more than a third (37 percent) had no full-time investigative reporters and most had two or fewer such reporters. Only 10 percent had four or more. Television networks and national magazines have similarly been shedding or shrinking investigative units.

Steiger said creation of ProPublica occurred at a difficult moment in American journalism: "The number and variety of publishing platforms are exploding in the Internet age. But very few of these new entities are engaged in original, in-depth reporting. Sources of opinion are proliferating, but sources of facts on which those opinions are based are shrinking." Steiger said investigative journalism was particularly at risk. "Many news organizations have increasingly come to see investigative journalism as a luxury that can be put aside in tough economic times."

Steiger said ProPublica focused exclusively on journalism that shone a light on exploitation of the weak by the strong and on the failures of powerful people to vindicate the trust placed in them. "We will look hard at the critical functions of business and of government, the two biggest centers of power. But we will also focus on such institutions as unions, universities, hospitals, foundations and the media when they appear to be exploiting or oppressing those weaker than they, or when there is evidence that they are abusing the public trust." ProPublica paid salaries and benefits comparable to the biggest newspapers, Steiger said. "I won't be offering somebody 50 grand or 100 grand more than they're making to jump ship, nor will I ask them to take a pay cut," he told *The New York Times* in October 2007 when the project was announced. (Steiger was paid $570,000 by ProPublica in 2008, which was slightly higher than the base salary of $547,692 he earned at the *Journal* in 2006. The salary revelation raised eyebrows among some media pundits. But a ProPublica spokesman responded that Steiger was worth the money

and that the salary was far less than what he made at the *Journal*, where additional forms of compensation took his 2006 earnings to $1.38 million.)

Writing in the online magazine *Slate*, Jack Shafer noted that non-profit organizations such as the Center for Investigative Reporting and the Center for Public Integrity had been muckraking for decades. "Non-profits already publish investigative magazines such as *Mother Jones*. Some newspaper owners have given their properties to non-profits to maintain independence and quality, such as the *St. Petersburg Times*, the *Anniston Star* and the *Union Leader*." But nothing on the scale of ProPublica with its investigative focus had been attempted before in journalism, he wrote.

Wall Street Journal reporters Sue Schmidt and Glenn Simpson left the paper in March 2009 to launch a new company, SNS Global. It will do investigative work for private clients. The journalists will also be affiliated with the International Assessment and Strategy Center, a non-profit foundation focused on security issues. They joined former *Washington Post* investigative reporter Douglas Farah. Schmidt said the group would continue to investigate areas they covered while doing traditional journalism, from counter-terrorism to international organized crime. Schmidt said the whole newspaper industry was in a state of turmoil. "Everyone is thinking about plan B all the time." ProPublica's Steiger described the departures as a "loss" for the *Journal*, noting newspaper cutbacks were forcing reporters to start looking for alternatives. "Still, I would expect that investigative reporting will remain part of the DNA of the *Wall Street Journal*," Steiger said.

Another example of investigative journalism under the aegis of a non-profit is *Mother Jones*. The bimonthly magazine, founded in San Francisco in 1976, sees itself as a defender of journalism and is proudly independent of any corporation. *Mother Jones* is named after the labor organizer Mary Harris "Mother" Jones, who helped found the Social Democratic Party in the early twentieth century.

The magazine suffered financially in 2008, with advertising down 23 percent. About half of the magazine's annual revenue comes from major grants and donations. Jay Harris, the magazine's publisher, said he was looking at "belt-tightening." Some of the big donations the magazine relied on disappeared, Clara Jeffery, a co-editor of the magazine, said in an interview published in *The New York Times* in March 2009. The *Times* reporter, Tim Arango, noted that endowed journalism as a cure for the print industry's economic problems had engendered a "lively debate" among journalists and bloggers in recent months, and in articles in *The New Yorker* and on the Op-Ed page of *The New York Times*. Arango interviewed Rick Melcher, a former *BusinessWeek* bureau chief who runs a consulting business in Chicago and sits on the board of *Mother Jones*: "We are clearly out there talking

to donors and subscribers about this model, and how it could be a way forward for journalism." Melcher said non-profit publications "still need an earned revenue base" as a business model. "You need advertising," he said. "And you need good journalism to draw a fan base."

Non-profit publications are initially more durable in a recession but they are far from impervious to market forces. The non-profit model had shown serious flaws in the midst of recession and fundamental changes in the economics of journalism, Arango said. He cited the example of *The Christian Science Monitor*, a non-profit newspaper financed through contributions and an endowment, which adopted a mostly digital format because of heavy losses. The *Monitor* is owned by the First Church of Christ, Scientist, in Boston.

In 2009 businessman Mark Cuban funded Sharesleuth (http://sharesleuth. com/) as an independent web-based journalism site aimed at exposing securities fraud and corporate chicanery. The site's "about" section points out that more than 13,000 companies are listed on U.S. stock exchanges. But analysts for brokerage houses and independent research firms track fewer than half of them. And examiners at the Securities and Exchange Commission review only a fraction of the filings that come their way. "If you've spent any time digging through muck and rot in the lower reaches of the stock market, you know that many investment opportunities are not what they seem, and that some companies are the creation of predators and pretenders," the site says. Sharesleuth.com aims to create a new line of defense by using investigative journalism techniques and a worldwide network of amateur and professional stock detectives to identify suspect companies.

Christopher Carey is editor and president of Sharesleuth. He was a business reporter for more than two decades, most recently at the *St. Louis Post-Dispatch*. There he produced a series of articles on global stock fraud. He specializes in digging through SEC filings, court records and other documents to find information that companies try to bury, and in tracking the activities of known securities-law violators, the site says. The other journalist is Justin McLachlan, formerly a television and print reporter in and around Pittsburgh and in West Virginia. Mark Cuban is described as the majority partner. He is co-founder of Broadcast. com (which was sold to Yahoo! in 1999 for about $6 billion) and owner of the NBA's Dallas Mavericks. His other holdings include HDNet, a high-definition television network and a range of other web ventures. The "disclosures" section of Sharesleuth said Cuban would "periodically" make personal investments based on information the site uncovered. "Those investments will be fully disclosed, so that readers can evaluate any potential conflicts of interest." Carey said he (Carey) did not buy or sell individual securities.

Slate's Shafer said philanthropists, especially those who earned the fortune they were giving away, tended to monitor how their money was spent. The Sandlers had donated large amounts to the Democratic Party. "How happy will they be if ProPublica gores their sacred Democratic cows? Or takes the 'wrong' position on their pet projects: health, the environment, and civil liberties?" Shafer called for a firewall to stop the Sandlers and other funders from selecting or rejecting the targets of any investigations. "And if I were an editorial writer, I'd call upon Herbert Sandler to provide ProPublica with 10 years of funding ($100 million), and then resign from his post as the organization's chairman so he'll never be tempted to bollix up what might turn out to be a good thing," Shafer wrote.

A serious television program or newspaper's power and value are derived from trust, credibility and authority. Thus it becomes important to consider whether funding sources could dilute this authority. Professor Lowell Bergman of the graduate school of journalism at UC Berkeley said a perception existed that non-profits were liberal or further left in the political sphere. "You have to be willing to do stories about your donors and be more transparent than corporate-owned newspapers." Steiger told the Editors Weblog, an online publication of the World Association of Newspapers, that ProPublica's board and he had agreed the board would get no advance knowledge of what ProPublica decided to cover. "They will see it on the day of publication." Board members are invited to offer story ideas, but Steiger emphasized these ideas were funneled through him or managing editor Stephen Engelberg "so reporters won't feel pressured by getting a call from a director."

Editors and reporters decide the stories they want to pursue. After starting an investigation into the issue, they offer the story to a relevant publication. As of February 2009, Steiger said, ProPublica articles had appeared in about 20 newspapers including *The New York Times* and the *Los Angeles Times*, several websites and television news outlets such as CNN or CNBC. Stories also appear on the ProPublica web site soon after publication by the chosen partner. The site links to the partner, which is good publicity for the partner.

Reporters cover broad beats such as the effectiveness of government spending, health care, energy and the environment, voting rights or the impact of the legal system on the poor. These national issues sometimes veer into international territory, but can also have a local focus, Steiger said. He described one of the most important projects in 2008: an investigation of the impact of deep drilling for gas on the water supply. Because reporters discovered a crucial government decision pending in New York state which would have put legislative and regulatory protocols into place to give the industry carte blanche to drill wherever

it chose, ProPublica offered the story to the local paper, the *Albany Times Union*. Government policy was consequently changed, Steiger said.

Steiger said he was enthusiastic about the multimedia advantages of online reporting: "The awareness of how online graphics and online interactive elements can enhance a story and enhance its impact is penetrating through the entire group," he said. Older journalists with print backgrounds were learning from younger reporters with online backgrounds "because that's where so much of the energy and the growth is." Steiger said the newsroom had a "huge" online focus that was much larger than he expected when he first took the job.

In March 2009 the Huffington Post blog launched an investigative journalism fund with an initial budget of $1.75 million. The money came from the Huff Post and The Atlantic Philanthropies. Nick Penniman, founder of The American News Project, ran the initiative as executive director, and said his project would be folded into the Investigative Fund. Arianna Huffington, editor-in-chief of the Huffington Post, identified good journalism's role in preserving democracy. "The Huffington Post Investigative Fund is one of the ways we are addressing that need, while also providing work and a platform for seasoned journalists downsized by major media outlets." Kenneth Lerer, chairman of the Huffington Post, said non-profit investigative journalism was a logical next step for the Huffington Post. The fund's independent journalism would be supplied free to all news outlets. The headquarters would be in Washington, DC, and the fund's journalism would range from long-form investigations to short breaking news stories.

The fund plans to hire editors in different topic areas who can commission pieces in those areas from freelance reporters. Penniman said he looked forward to producing journalism that would have an impact, and incorporated the "best of traditional journalism and the tools of new media and distributed journalism." Jay Rosen of New York University would be a senior advisor to the project. Rosen previously collaborated with the Huffington Post on OffTheBus, an experiment in citizen journalism that attracted 12,000 contributors and gained widespread media attention for its coverage of the 2008 campaign. Rosen said he had been writing for years about the possibility of distributed reporting projects that coordinated the efforts of teams of professionals and amateurs working together. "I think the Huffington Post Investigative Fund is the next logical step." The fund would provide a higher profile for the work of existing investigative reporting partners such as Spot.us, the Center for Public Integrity, the Institute for Justice and Journalism, the Center for Investigative Reporting, and the European Fund for Investigative Journalism. The Huffington Post attracts up to 24 million unique users a month and is the most linked-to blog on the Internet, according to Technorati. Rosen

said the fund's operating principle was "report once, run anywhere" because work it produced would be available for any publication or web site to publish at the same time it is posted on the Huffington Post. Huffington will help raise money for the fund, and find partners for it.

In June 2009 the Associated Press (AP) announced it would distribute the work of four non-profit groups devoted to investigative journalism to AP's 1500 newspaper members. Work by the Center for Public Integrity, the Investigative Reporting Workshop at American University, the Center for Investigative Reporting and ProPublica was provided free for a six-month trial from 1 July 2009, said Sue Cross, a senior vice president. AP said the "six-month experiment" could later include other investigative non-profits. "It's something we've talked about for a long time, since part of our mission is to enable our members to share material with each other," said Cross.

A group of journalists in London agreed to sponsor Britain's first major not-for-profit initiative to fund public interest investigative journalism, the Bureau of Investigative Journalism in July 2009. Major support came from a $3.27 million grant from the David and Elaine Potter Foundation. Elaine Potter, a former *Sunday Times* journalist, was chair of the board of the Centre for Investigative Journalism. "Our goal in helping establish this project is to support investigative journalism of the highest ethical standards and to search for sustainable models for its long-term future," she said. Google have agreed to support the bureau with technical expertise, software tools and training. Patron Sir Harold Evans, former editor of *The Times* and *The Sunday Times*, described the bureau as an important venture at a time when public trust in corporations and politicians was at an all-time low, particularly in the UK. "I am supporting the Bureau of Investigative Journalism because without someone championing investigative journalism, the meltdown of conventional media means that further abuse of power will go unmonitored and unchecked." Gavin Macfadyen, director of the Centre for Investigative Journalism, and one of the founders of the bureau, said the bureau would experiment with "all the techniques available to us from 'crowdfunding' to 'crowdsourcing' and provide content across the media spectrum."

Sponsorship works at a much smaller scale at the SiliconValleyWatcher blog, based in San Francisco. Tom Foremski, a former Silicon Valley reporter with the UK's *Financial Times*, established the site in 2006. Foremski was adamant he was "still a journalist" who was "simply using a new platform." "We are not bloggers, we are journalists." He said society would always need journalism though he had concerns about the viability of old media companies. Tibco and Intel sponsor Foremski's blog. "My business model is sponsorship. Intel pay me regardless of

whether I get two page views or 200,000." Foremski believes tomorrow's media industry will be technology-enabled and community-powered.

The New York Times reported on its front page of November 18, 2008 that investigative journalists in San Diego had exposed city officials with conflicts of interest and hidden pay raises, and forced the bosses of two redevelopment agencies to resign. Reporter Richard Pérez-Peña noted the revelations came not from any of San Diego's broadcast stations or its dominant newspaper, *The San Diego Union-Tribune*, but from a handful of young journalists at a non-profit web site, VoiceofSanDiego.org.

Similar operations had arisen in New Haven in Connecticut, the Twin Cities of Minnesota, and in Seattle, St. Louis and Chicago. "The fledgling movement has reached a sufficient critical mass, its founders think, so they plan to form an association, angling for national advertising and foundation grants that they could not compete for singly. And hardly a week goes by without a call from journalists around the country seeking advice about starting their own online news outlets," Pérez-Peña wrote. VoiceofSanDiego.org and its peers embraced the business model of public broadcasting, not newspapers: "They are non-profit corporations supported by foundations, wealthy donors, audience contributions and a little advertising."

Dean Nelson, director of the journalism program at Point Loma Nazarene University in San Diego, said he cited Voice of SanDiego to his classes as "the future of journalism," the article said. The people who run these local news sites believe the decline of traditional media created an opening for new sources of news, as well as a surplus of unemployed journalists for them to hire.

This new breed of news sites had a "whiff of scruffy insurgency," Pérez-Peña wrote, apart from the MinnPost, based in Minneapolis. Its founder and chief executive, Joel Kramer, had been the editor and publisher of *The Star Tribune* in Minneapolis. Kramer started MinnPost with $1.5 million in 2007, and its annual budget is $1.3 million. Top editors came from *The Star Tribune* or its rival, *The Pioneer Press* in St. Paul. Full-time editors and reporters earned $50,000 to $60,000 a year, Kramer said, though he admitted it was less than what they could earn at competing papers. As of early 2009 MinnPost had five full-time employees, but employed more than 40 paid freelance contributors.

VoiceofSanDiego took another approach, Pérez-Peña said, hiring young and hungry journalists, and paying them salaries comparable to what they would make at large newspapers. It relies less on freelancers than other web sites mentioned in this chapter. Editors typically earned $60,000 to $70,000. The site was growing said Buzz Woolley, a member of the board of directors. He said he was convinced

the non-profit model offered community news the best chance of survival. The site's "about" section describes VoiceofSanDiego.org as a 501(c)(3) non-profit organization. "We are the only professionally staffed, non-profit online news site in the state focused on local news and issues. We will continue to operate with the support of individuals, foundations and businesses which, like you, recognize the importance of local news from an independent perspective."

Could the non-profit model be implemented more widely? David Swensen and Michael Schmidt, in an opinion piece in *The New York Times* in January 2009 headlined "News You Can Endow," suggested the non-profit approach was an option that could save newspapers as well as make them stronger. Newspapers could become non-profit, endowed institutions like universities. "Endowments would enhance newspapers' autonomy while shielding them from the economic forces that are now tearing them down," the pair wrote. Swensen is the chief investment officer at Yale, and Schmidt is a financial analyst at the university. "As long as newspapers remain for-profit enterprises, they will find no refuge from their financial problems," they wrote. "By endowing our most valued sources of news we would free them from the strictures of an obsolete business model and offer them a permanent place in society, like that of America's colleges and universities." *The Guardian* in the UK is an example of a newspaper not obligated to make money for shareholders. It is owned by a trust, and has been subsequently less affected by the financial downturn. The paper's web site attracts a bigger audience than NYTimes.com. It is discussed in Chapter 7.

Non-profits need a plan to ensure long-term survival, such as a large endowment, because having to scrabble for funds every year puts a non-profit under the same pressures as a for-profit organization. An obvious issue is continuing costs: huge endowments would be needed to fund a national newspaper. To support a daily such as *The New York Times* would require an endowment of $5 billion, Swenson and Schmidt wrote. *The Washington Post* would need an endowment of $2 billion. Finding people to fund an entire newspaper, especially non-news soft sections such as entertainment or sport, would be difficult. Steiger believes it possible for non-profits to play an expanded role and "fill in some of the gaps." Non-profit journalism offers a way to bolster existing structures. But a sponsored newspaper also risks becoming dependent on donations rather than finding new ways to survive on its own. Another issue is how to sustain the business model beyond the initial funding. What are the strategies for sustainability? Once journalists get money for a one-off project, for example, how can they keep further projects going?

In an October 2007 *Slate* article ("What do Herbert and Marion Sandler want?"), Jack Shafer noted that the capitalist system had allowed America's great

newspapers to succeed. "*The Times*, the *Post*, and The *Wall Street Journal* earned their reputations by competing in the marketplace, not by stroking philanthropic billionaires or foundations," he wrote. "Their dynamism and adaptability allowed them to gain their dominant positions in the market; to remove the financial impetus for such growth could have a detrimental effect on their innovation and efficacy in news distribution. It would also, crucially, change the way that they measure their success: an increased focus on story impact could be a positive outcome but this is not relevant for many types of news."

If newspapers are to function as a crucial part of the democratic process they need to find a way to maintain staff and resources. A non-profit model offers a way to provide the kind of journalism a democracy needs, such as deep investigative forms of reporting. This means newspapers need to find other forms of revenue for other types of reporting. Meanwhile, sites like ProPublica will continue to do investigative journalism in the public interest.

Columbia University's graduate school of journalism hosted a two-day conference in March 2009 on the future of investigative journalism. Bevis Longstreth of the Fund for Independence in Journalism, a conference sponsor, proposed inviting a group of America's major private universities and colleges to create, fund and operate a "non-profit demonstration model for investigative journalism." Chapter 9 offers a case study of a partnership between a university and major news organizations as one possible option. Longstreth rejected proposals for a government-funded media bailout, because one of the chief roles of an independent media was to report on government abuse. "Being fed by the hand one is trained to bite won't work," he said.

Lucy Dalglish, executive director of the Reporters Committee on Freedom of the Press, agreed that relying on a non-profit model might expose journalists to government meddling. Dalglish said it was not possible to "insulate" media outlets from the government under a non-profit model. Professor Todd Gitlin of Columbia University said journalism was too important to be left to business interests or the market. "Leaving it to the myopic, inept, greedy, unlucky, and floundering managers of the nation's newspapers to rescue journalism on their own would be like leaving it to the investment wizards at the American International Group (AIG), Citibank, and Goldman Sachs, to create a workable, just global credit system on the strength of their good will, their hard-earned knowledge, and their fidelity to the public good," he said in a speech at the University of Westminster in London in May 2009.

Perhaps one way to avoid the influence of business would be to consider city government support. In July 2009 the mayor of New York, Michael Bloomberg,

outlined plans for a stimulus package to help the city's media industries. The initiatives focus on technological innovation, training and research, and are expected to create 8,000 extra media jobs in the city over the next decade. "New York City is the media capital of the world … but with the industry undergoing profound changes it's incumbent on us to take steps now to capitalize on growth opportunities and ensure we remain an industry leader," Bloomberg said in a statement. The stimulus plans include the establishment of a New York City Media Lab for collaborative research and education programs, a fellowship scheme to facilitate media start-ups and other entrepreneurial activity, and a tax exemption bond program to allow companies to buy research and equipment. Media Tech Bonds will be used to finance projects costing $1 million to $10 million.

While some news providers are turning to the single-donor, non-profit model for financial support, others are looking to raise money in small amounts from lots of individuals. This form of income, via microfunding, is the topic of the next chapter.

Microfunding and micropayments

Summary

The world's appetite for news and information remains ravenous. Each day millions of people worldwide read free content in the online edition of quality papers like *The Guardian* and *The New York Times* – many times more than the number who read the print edition. The Pew Research Center found a tipping point occurred in 2008: More people in the US got their news online for free than paid for it by buying newspapers and magazines. News organizations are now urgently looking at ways to get people paying again – either by charging for online content or by less direct ways such as crowd-funding, in which they receive small amounts of money from a large number of contributors. The money allows those organizations to produce quality journalism, and re-invest the profits into the next project.

Crowd-funding is a form of micro-financing. In the context of journalism it is deceptively simple: A broker, which might be a media organization, gathers contributions from a large number of small investors. It uses that money to produce a specific form of reportage, such as a documentary or a piece of investigation journalism. Once the story is sold, the investors get their money back or it is re-invested to fund another piece of journalism.

The financial model takes its name from crowd-sourcing: a way to use a large public, via the Internet, as an information resource. Many enterprises have used crowd-sourcing for research and development to design T-shirts, or supply stock photographs, or write software. With crowd-sourcing the people supply the content and expertise. With crowd-funding they supply the cash.

One of the best examples of crowd-funding as of early 2009 was Spot.Us (http://spot.us/), which was founded by David Cohn in San Francisco in late 2008. Cohn received a grant of $340,000 from the Knight News Challenge, funded by the Knight Foundation for his proposal. Cohn used much of the funding, which is considered seed money and does not have to be repaid, to write the code for the web site. He has since shared the code with similar ventures around the world.

The premise of Spot.Us is simple. It is based on what Cohn calls "community-funded reporting." A journalist posts an idea for an investigation on the Spot.Us web site along with a project cost, and the site accepts micro-donations associated with the story idea. Progress towards reaching the financial goal is charted on the site. All individual donations go only to the targeted project that spurred the donation. "In some respect, our pitch to potential donors is as simple as this: 'Upset that your local news organization isn't covering an issue you're passionate about? Donate $25 to a reporter who will'," Cohn said.

Late in September 2009 Spot.Us announced it was expanding to Los Angeles in collaboration with the journalism school at the University of Southern California. The web site for the Los Angeles outlet is http://la.spot.us

Both Spot.Us sites have rules that limit the percentage of donations from any individual to stop advocates or lobbyists becoming primary funders of a project. The finished content is licensed under a Creative Commons agreement, and Spot.Us aims to get the project published in as many places as possible. If a news organization wants exclusive rights to the story, it needs to pay half the total budget. Supporters later get their money back to invest in a new story. "My sole and motivating mission is to figure out how reporting can thrive as we witness the death of the institutional model that traditionally supported it," Cohn said.

Journalism professor Jay Rosen of New York University advised Cohn when he was establishing Spot.Us. Professor Rosen is direct about journalism's problems: "The [advertising-subsidized] business model is broken," he said. "We're at a point now where nobody actually knows where the money is going to come from for editorial goods in the future. My own feeling is that we need to try lots of things. Most of them won't work. You'll have a lot of failure. But we need to launch a lot of boats." Spot.Us is one of those boats beating on against the current.

Despite his love for journalism, David Cohn emphasized that Spot.Us was not a news organization and he was not an editor. "Spot.Us is a platform and I, along with others who have worked with me on this project, am its creator." Spot.Us was intended as a "collaborative marketplace" for public participation in the process of producing quality journalism. Cohn's blog, DigiDave, is a useful resource for background material and updates about the project: http://www.digidave.org/.

Cohn believes success in the digital age will happen for people who create platforms on which acts of journalism can be performed. YouTube and WordPress blazed large trails in creating such platforms, Cohn said, but plenty of unexplored side trails were available that could lead to much larger areas where journalists could make their mark. "Right now," he said in early 2009, "journalists are fleeing newsrooms – either being pushed out through buyouts or choosing to strike out in new directions – and by doing so creating a diaspora, of sorts, as they search for a new home." The key question was whether a viable platform could be found to offer journalists "a modicum of job security" so they could resume doing what they believed in: keeping the public well informed.

Some critics suggest that using crowd-funding to finance journalism raises prickly questions. For example, how are members of a neighborhood with an agenda, and willing to pay for an article, different from a public relations company trying to place a positive article about their client? Or publicists who buy favorable coverage by taking a journalist to lunch? Cohn said Spot.Us controlled this by limiting the amount any one individual can give to a maximum of 20 percent of the cost of the story.

One key issue with crowd-funding is the public's mindset: getting people accustomed to contributing for a service like news. Americans tip waiters almost without thinking, and sometimes for mediocre service, often for 20 percent of the bill. How do we teach audiences to compensate the news media for service? Is it possible to create such a mindset among news consumers? News organizations need to use their considerable creative talents to inculcate a new "social norm" whereby readers feel a responsibility to make voluntary payments to news media in the same way they tip waiters.

Version 1.0 of Spot.Us went live in October 2008. Cohn spent many hours working with lawyers on the terms of the service agreements. "The payment gateway I constructed had to meet my hosting requirements and build an audience around the concept of community-funded reporting." Cohn said these and other tasks were not "shoe-leather reporting," but he never lost the sense of himself as a journalist.

The idea for Spot.Us came from Cohn's work in citizen journalism, which started in 2005. He was involved with projects like NewAssignment.Net, Assignment Zero, Beat Blogging and OffTheBus. He also co-organized the first and second Networked Journalism Summits held at the City University of New York's graduate school of journalism in 2007 and 2008 (see http://newsinnovation.com). "Spot. Us is informed by the citizen journalism movement. It is an attempt to ensure that journalism remains a strong and vital part of local democracies as a participatory process, not just a product," Cohn said. The idea came in an "aha" moment Cohn had while working as a research assistant on Jeff Howe's book *Crowdsourcing: Why*

the *Power of the Crowd Is Driving the Future of Business.* Howe writes for *Wired* magazine. "When I was working on background research for the chapter on 'crowd-funding'," Cohn said, "I learned about web-based micro-philanthropy sites such as Kiva, DonorsChoose and others, which have been incredibly successful in targeting contributions to specific projects in their respective fields."

Prior to its October 2008 launch Spot.Us funded three investigative reporting projects in the San Francisco Bay area using only a wiki and a blog. The most successful of these projects was a series of articles to fact-check political advertising for the November 2008 San Francisco election. To support this reporting 74 people each contributed an average of $33. Funds totalled $2,500: the target amount the reporter needed to do the work.

An example from early 2009 demonstrates how Spot.Us works. A Bay Area Rapid Transit police officer shot dead a young man, Oscar Grant, in the city of Oakland, California. The entire event, caught on camera, brought up deep issues about class and racism, Cohn said. Subsequent protests turned into civil unrest and the city of Oakland continued to deal with the emotional aftershocks. All this came four days after Spot.Us had successfully funded an investigation into the Oakland police department (see http://spot.us/pitches/35). The Spot.Us platform performed beautifully through a specific call to action, Cohn said. An independent journalist uploaded a pitch describing the work he wanted to do. Internet leaders passionate about the story, such as the Huffington Post, spread details and donated. The Spot.Us team did some pre-reporting to show it was an important topic that would benefit from deep storytelling. And an independent news organization, Raw Story, supplied 50 percent of the cost in exchange for the right to publish the story first, though it also appeared on the Spot.Us web site. "So the finished content gets seen by more people and the initial donors are validated in their early support," Cohn noted. These simple steps meant Spot.Us funded a documentary about Oscar Grant in 11 days, Cohn said.

News organizations can get first publication rights in two ways. The first is through early involvement and payment of half the costs, as with Raw Story. The second is through a late pitch which requires the news organization to refund 100 percent of the story costs, as *On Earth* magazine did in March 2009. Reporter Aaron Crowe turned in a finished story to Spot.Us, headlined "Solar power: When will it be affordable for Bay Area homeowners?" Instead of publishing it immediately, Spot.Us contacted news organizations in its database. *On Earth* magazine showed interest so Cohn sent them a copy of the story. The magazine asked for a rewrite to give the story more of a narrative flow. Crowe obliged and the finished story appeared on *On Earth*'s web site (see http://www.onearth.org).

Some weeks Spot.Us removes pitches because they do not get enough donations. Other factors also influence coverage, such as when a reporter withdraws because of their poor health. In January 2009 Spot.Us removed two pitches – with the titles "How prepared is the city of Oakland for an earthquake" and "Where Bay Area neighborhoods get their electricity." Both were great story ideas, Cohn said, but for some reason they did not connect with potential donors/readers. "We simply couldn't get the traction for them. One thought is that they were both too broad. I suppose that is the classic problem in preparing for an earthquake. It will affect everybody – but nobody thinks it'll happen to them."

Cohn said his organization was "learning more and more" about how to present pitches to garner public support. "We've also started making some decisions that originally I wanted to avoid. I often refer to Spot.Us as a platform not a news organization, and while I stay committed to that notion, in the future we are going to make more editorial decisions about what pitches we will and won't take on. We are going to hold reporters responsible for certain actions and we will strongly suggest pricing for their work." Spot.Us subsequently published a Reporter Agreement and recommended costs. See http://spot.us/pages/reporter_agreement

Thomas Jefferson said a well-informed citizenry was the foundation of democracy. And traditionally newspapers have been one of the main stones in that foundation, supplying information with which citizens make informed decisions. In the future print newspapers might not be how citizens receive information. But something will take their place. Cohn said he had never tried to promote Spot.Us as a "silver bullet" for journalism's future. "There is no such thing. But Spot.Us should give us a way to find out whether people are willing to put a direct monetary value on what journalism provides."

By tracking what happens on Spot.Us, Cohn said he might find apathy among a public that prefers "free" reporting – the kind supported by advertisements, donated by citizen journalists, or paid for by a non-profit organization. "If Spot.Us reveals this, I will feel that we will have learned what the marketplace will – and will not – support. If this enterprise fails, then it might be possible to conclude that direct micro-philanthropy is not among the feasible options for enabling journalists to keep doing their work." Cohn said he would do journalism "a great disservice" if he failed to find out whether the public was willing to support this approach. "While Spot.Us might not provide the answers, I am confident it will assist in our search for new ways to enable journalism to thrive."

All donations to Spot.Us are tax deductible. Spot.Us is a non-profit project of the Center for Media Change. Another of the center's projects is Reel Changes (http://www.reelchanges.org/). Like Spot.Us it seeks financial support from

individuals, groups, corporations and foundations to help democratize journalism. Reel Changes produces high-quality documentaries. Contributions that sup- port the operations of the site and to promote the documentary projects are tax deductible under US federal law. Taxation laws vary from country to country, and individual states within those countries, so this funding option should be explored in the context of specific cultures. The question needs to be asked: What changes in tax laws might be possible to facilitate these transactions?

Two other issues need to be considered in relation to micropayments and crowd-funding. The first is how to sustain the organizations once they have been around for a while and once the first blush of publicity wears off. The second concerns legal constraints: Some countries have laws that prohibit organizations from trying to influence legislation or that stop media organizations funded by public money from campaigning for or against political candidates. It comes down to semantics: A crowd-funded newspaper would need to avoid endorsing candidates for public office. But it would be able to participate in the debate over issues of public importance.

The micropayments debate

Walter Isaacson, a former managing editor of *TIME* magazine who was president and CEO of the Aspen Institute, wrote a much-publicized *TIME* cover story in February 2009 calling for new forms of micropayments online. One of history's ironies, Isaacson wrote, was the fact that Ted Nelson had invented hypertext in the early 1960s with the goal of enabling micropayments for content. "He wanted to make sure that the people who created good stuff got rewarded for it. In his vision, all links on a page would facilitate the accrual of small, automatic payments for whatever content was accessed. Instead, the web got caught up in the ethos that information wants to be free."

A micropayment system, Isaacson wrote, could be used for all forms of media including blogs, television newscasts and amateur videos, porn pictures and policy monographs, citizen journalists' reports, games, recipes of great cooks and songs of garage bands. "This would not only offer a lifeline to traditional media outlets but also nourish citizen journalists and bloggers. They have vastly enriched our realms of information and ideas, but most can't make much money. As a result, they tend to do it for the ego kick or as a civic contribution. A micropayment system would allow regular folks, the types who have to worry about feeding their families, to supplement their income by doing citizen journalism that is of value to their community."

Isaacson said he advocated micropayments because he loved journalism, and believed it was valuable and should be valued by its consumers. "Charging for content forces discipline on journalists: they must produce things that people actually value." The need to be valued by readers, to serve them first and foremost rather than relying solely on advertising revenue, would allow the media "to set their compass true to what journalism should always be about."

Isaacson's article attracted a volley of debate. This is understandable when an existing business model begins to collapse. Alternative models are offered, debated and rejected, and some consensus arises from the ashes. Alan Mutter writes the Reflections of a Newsosaur blog, as well as being an adjunct professor in the Graduate School of Journalism at the University of California, Berkeley. Mutter said micropayments could work. "It's a journey publishers absolutely have to begin. After years of giving everything away for free on the web, it won't be easy for them to start charging for at least some of the content they spend small fortunes to produce. But there is no other choice."

Consumers would use their credit cards to fund accounts that would enable them to purchase online content through a system deployed at the largest possible number of participating websites. "One problem with this solution is that it wouldn't work for one publisher if a competing publisher decided to provide the same, or nearly identical, content for free. The other gotcha is that content would have to be secured so that someone who bought it could not turn around and provide it to a friend or, worse, publish it on the web for free. Although protecting content for unauthorized use is a formidable technical problem, it has already been solved reasonably well by a number of companies," Mutter wrote in his blog.

Very few publishers have tried to sell articles one at a time, Mutter said. Most had declined to invest in the implementation of micropayment systems. With micropayments the amount charged per article would be up to individual publishers, but should be kept to cents, or fractions of cents, to encourage maximum readership. "Consumers might not like being micro-nickeled and nano-dimed for every article, but they would get over it if the content were sufficiently unique and compelling. Remember, this works only if the content is unique and compelling."

Indeed, audiences appear most willing to pay for content that is unique and not readily available elsewhere (unlike news agency stories which are everywhere); is fresh and frequently updated; is authoritative and comes from a trusted source in a relevant niche area; and is actionable. With the last point, the story must help the reader make or save money, improve their professional career or health, or develop a personal interest such as a hobby. Some newspapers can match some but not all of these four criteria. They need to create more content that

satisfies all four characteristics. The companies that exist through subscriptions such as *Consumer Reports* and *Congressional Quarterly* have built loyal audiences and revenues. Specialized newspapers like the UK's *Financial Times* and *The Wall Street Journal* also managed to charge for content, Mutter said. But widespread adoption of paid content among general-interest media would require a critical mass of publishers to agree to collaborate more earnestly, more broadly, and more smoothly than any group of humans in history. "Could it happen? Theoretically. But don't hold your breath." Publishers could require advertisers to pay premium rates to pitch their wares to this valuable, loyal audience.

Mutter said sales of print advertising generated the bulk of revenues for most publications, and those sales subsidized the content of most newspapers and magazines published online. "Because online ad sales produce only about 10 percent of ad revenues at the average newspaper, it would make sense for newspapers to try to get paid something for the content they publish on the web." Newspapers charged for copies of the print edition though this did not cover the full costs of production and delivery. "With ad revenues falling by double-digit rates at most publishing companies [in 2009], every little bit of new revenue would help."

William Baker, a former CEO of the Educational Broadcasting Corporation in America, spent 2008 investigating new media business models as an executive-in-residence at Columbia University in New York. Saving America's distressed newspapers is critical for a free society because newspapers do most of the serious reporting, Baker said. But he did not believe endowments would maintain major papers because those endowments would involve tens of billions of dollars. It was an "unthinkable Apollo project" even before the economic meltdown.

Baker advocated for a combination of advertising, subscription, philanthropy and micropayments. "It will take all of these as one segment grows and another shrinks to get us through this dry desert." Micropayment models had not been thoroughly tested. Baker suggested Skype as a workable model. Audiences would load their account and the system would automatically charge them a certain amount per click or story. "For good information to flow from journalists to readers, proportional revenue must flow the other way. Consumers must learn to associate costs, even small ones, with regular access to reliable news."

Isaacson wrote that the key to attracting online revenue was to come up with an easy method of micropayment like iTunes. A pay-per-view model could work if it were made easy enough, he said. "Steve Jobs got music consumers (of all people) comfortable with the concept of paying 99 cents for a tune instead of Napsterizing an entire industry, and Jeff Bezos with his Kindle showed that consumers would buy electronic versions of books, magazines and newspapers if purchases could be done

simply." What Internet payment options existed today, Isaacson asked? PayPal was best known but its transaction costs were too high for impulse buys of less than a dollar. Facebookers were using systems like Spare Change that allowed them to charge their PayPal accounts or credit cards to get digital currency to spend in small amounts. "Similar services include Bee-Tokens and Tipjoy. Twitter users have Twitpay, which is a micro-payment service for the micro-messaging set. Gamers have their own digital currencies that can be used for impulse buys during online role-playing games. And real-world commuters are used to gizmos like E-ZPass, which deducts automatically from their prepaid account as they glide through a highway tollbooth."

Newspapers needed something like digital coins or an E-ZPass digital wallet – a simple system that would permit impulse purchases of a newspaper, magazine, article, blog or video "for a penny, nickel, dime or whatever the creator chooses to charge."

But it is not possible to apply micropayments to the bulk of online content because it is not possible to establish a monopoly for news. Laws prevent people from sharing iTunes content. Baker suggested this was not likely with news unless traditional publishers formed a news cartel behind a paywall, and the process had to happen at the same time. He cited *Consumer Reports* magazine as the most successful subscription model. It refuses all forms of advertising and has about four million paying online subscribers and another four million print subscribers. "The magazine succeeds because its cost is trivial compared with the potential direct benefits to consumers. For example, the magazine's content helps readers find an excellent product and saves them money."

Isaacson said Henry Luce, a co-founder of *TIME*, rejected the notion of give-away publications that relied solely on advertising revenue. He called that formula "morally abhorrent" as well as "economically self-defeating." He believed a publication's primary duty was to its readers, not to its advertisers. In an advertising-only revenue model, the incentive was perverse, Isaacson said. "It is also self-defeating, because eventually you will weaken your bond with your readers if you do not feel directly dependent on them for your revenue."

In Minneapolis, the non-profit news startup MinnPost has reported modest success in getting readers to "micro-sponsor" the site's most popular blog with donations of between $10 and $25. In one week in March 2009 more than 130 people donated $2,575. The Harnisch Foundation matched the amount with a donation. The foundation described itself on its web site as a "catalyst for sustainable social change ... in the fields of philanthropy, coaching and journalism." The appeal focused on the blog of reporter David Brauer, BrauBlog, a blend of local media news and Minnesota politics. Readers who gave $10 became LowBrau micro-sponsors, while a $25 donation was rated as HighBrau. The Harnisch Foundation said it

would match up to $10,000 raised within three months. Joel Kramer, editor and publisher of MinnPost, said he chose BrauBlog for the fundraising drive because Brauer had an audience of about 1,000 readers for an average post. Brauer requested he not be told the names of his micro-sponsors. Kramer said "micro-funding a beat" would not replace traditional fundraising focused on memberships and large donations, but would be an adjunct. "The thing I keep reminding people is that it's all experimental," Kramer said, "and we're going to try whatever seems promising."

Professor Rosen of New York University established NewAssignment.Net (NEN), a research project based at his university's Arthur L. Carter Journalism Institute. NEN's mission is to spark innovation in "open platform" journalism, distributed reporting and crowd-sourcing. Rosen said the web made these forms of collaborative journalism possible and kept costs low. He launched NewAssignment. Net in July 2006, and has raised money from generosity groups and individuals like the MacArthur Foundation, Craig Newmark of Craigslist, the Sunlight Foundation, Reuters Media and Cambrian House (a software company). The McCormick Tribune Foundation also contributed funding.

NewAssignment.Net conducts pro-am, open-source reporting projects with media partners such as Assignment Zero with Wired.com, Off The Bus with the Huffington Post and Beatblogging.org with various newsroom partners. Beatblogging.org is an initiative of NEN. It looks at how journalists can use social networks and other web tools to improve beat reporting. Beatblogging.org highlighted innovative beat reporters, Rosen said. "We look at the latest tools and trends and how they can help reporters do a better job tracking their beat. We find real-world examples of social media helping journalists improve their beat reporting. Our podcast interviews feature journalists who are pushing the practice. We ask them what works and what doesn't. We are constantly trying to determine what is the return on investment for putting time into social media." As of early 2009 BeatBlogging.org also produced the journalism blog, The Journalism Iconoclast.

At the time of NEN's launch Rosen said he believed a hybrid content model – mixing professional journalists and amateur contributors – would produce the most sustainable form of journalism. His projects were attempts "to show they have potential." The next chapter explores that professional-amateur (pro-am) model.

Collaboration between mainstream media and citizen journalists

Summary

Pro-am is the term we use to describe partnerships between traditional newspapers and/or broadcasters, and contributions from the audience (the amateurs). The amateurs often contribute content for free. With a pro-am model, professionals use a well-established brand to distribute that content. The professionals understand concepts like news values, the importance of ethics, and how to edit content to ensure quality. They generally produce a better product than amateurs working alone. A pro-am partnership is a classic win-win situation: both parties benefit from the partnership. This chapter highlights two of the most successful pro-am partnerships in Asia, OhmyNews in South Korea and STOMP in Singapore, and touches on others in the US and Europe. This chapter shows that people will contribute for free if they receive rewards beyond money, and that involving the audience helps lower operating costs for traditional media as well as producing varied perspectives from news coverage.

OhmyNews in South Korea is the world's best-known example of a news organization that embraces the audience. In December 2004 *The Guardian* named OhmyNews one of its top five news sites for its role as a "hybrid between weblog and pro news site." On a typical day about 70,000 citizen reporters submit about 200 stories for the Korean-language site. Another 6,000 international citizen reporters submit content for the English-language site. Jean Min runs the English-language arm, called OhmyNews International. OhmyNews had a different kind of economic model compared with traditional media – "more like wiki-nomics," he explained. "Everyone is a stakeholder. You cannot just treat audiences as a

bunch of eyeballs." OhmyNews' culture had been very mindful of this: "Without the participation of our audiences we cannot survive."

Min said it was important to understand why people donated their time and energy to the site. What was the motivation in becoming a citizen journalist? Citizen reporters believed they were part of a family. Being associated with a well-known brand like OhmyNews had more prestige and impact that writing a solitary blog. "People also want the approval of their peers. That is one of the most precious rewards you can get on the web. There are other motivations apart from money."

OhmyNews launched on a shoestring budget of about $100,000 in February 2000. It broke even in 2003 and remained profitable until 2008 when the global financial crisis struck. OhmyNews makes about 70 percent of its revenues from advertising. Online advertising spend in South Korea rose from $150 million in 2002 to about $1 billion in 2008, though the figure was expected to stay flat in 2009. The other 30 percent comes from news content sales and other sources. The company aims to diversify into other types of revenue streams apart from banner advertisements on the web, and move more to a 50–50 mix of advertising and content sales to provide more stability. OhmyNews employs a form of sophisticated automated advertisement placements similar to Google's Adsense.

When the global financial crisis hit, many advertisers cut their spending. This had a major impact on OhmyNews. Founder Oh Yeon-ho published an open letter on the site in July 2009 to say the organization had lost about $400,000. He appealed to readers to support the site, suggesting that if readers joined OhmyNews as supporters, and paid 10,000 Korean won a month (about $7.80), the site would gain financial independence without relying on advertising dollars. "For a news media to remain healthy, it will have to earn at least 50 percent of its income from the sales of content or paid subscriptions. Despite our best effort, OhmyNews still relies on advertisers for more than 70 percent of its revenue." The goal was 100,000 supporters. Within two weeks about 3,000 people signed up as paid subscribers, along with another 1,000 existing contributors who had been paying the same amount to subscribe to a weekend print edition. It will be an experiment worth watching.

About a third of the 200 stories that arrive for the Korean-language site each day are rejected for various reasons such as poor sentence construction, factual errors or lack of news. Editors in Seoul fact check and polish each accepted piece, and decide where it will appear on the site. Potentially defamatory stories receive more thorough fact-checking . Sometimes this involves on-site visits. OhmyNews can also revoke the membership of any citizen reporter who violates the agreement and code of ethics they signed when they joined. Details are linked to the home

page at http://english.ohmynews.com/ The positioning of a story on the home page reflects the editors' view of its significance or newsworthiness. The higher up a story appears on the main page, the more important the story and the more money it earns.

Contributors' payments reflect how the editors perceive each story. The site uses cybercash to pay for published articles. The base payment is the Korean equivalent of $2 for an entry-level "Ingul" story and payments rise to $50 for a main story. Min said "ingul" was a Korean word meaning "fresh fire." When founder Dr Oh Yeon-ho was developing his business plan for OhmyNews, he imagined that when a citizen reporter submitted a raw story, and it was accepted and edited, it was like a stick of wood that had just caught fire. The site's editors monitor each story to see if that fresh fire will explode to a full blaze and advance to become the site's top story.

Min admitted the payments offered were "not a lot of money" for Westerners. "But for someone in parts of the world like Africa it's good money. We have Cameroon citizen reporters who are excellent writers. Some earn $1,300 in half a year, more than their annual salary [at home]." After stories are published, they often draw scores of reader comments. Controversial stories attract thousands of comments. Reporters are free to write about any subject. Min said the only exceptions were explicit sexual descriptions, pornography, profanity and swearing. "Other than that we are pretty liberal." OhmyNews also publishes a weekly broadsheet newspaper in Korean (circulation about 150,000) where the best of the web makes it into print.

OhmyNews maintains its editorial integrity through an ombudsman committee comprised of citizen reporters and outside observers. They monitor the site each day and submit a monthly report that is published on OhmyNews. Min said the "millions of watchful eyes" of the readers and citizen reporters was the most effective way to preserve the site's editorial integrity. "Independence from everything, including even OhmyNews, is the underlying guideline when it comes to editorial independence. Political power is not exerting as big an influence on the Korean media as it used to."

An increasingly serious concern among Korean journalists is the "pressure from advertisers," Min wrote in an article published on the web site of the Center for Citizen Media at Harvard University in 2006. "OhmyNews strives to listen to the voices of no one but our readers and citizen reporters. OhmyNews, by design, cannot bend its editorial integrity because of illicit pressure from anybody. Our citizen reporters will submit whatever story they deem newsworthy and worth attention, and OhmyNews cannot reject them without first offering them justifiable reasons publicly. Should anyone find that we are rejecting some critical

stories out of external pressure, OhmyNews will instantly come under great fire and public scrutiny by our own citizen reporters."

OhmyNews is proud of its record of accuracy and credibility. Of the hundreds of thousands of stories that have appeared since February 2000, only five by citizen reporters had been involved in legal disputes. OhmyNews editors verify reporters' identities through a government-sponsored authentication process before they grant membership. Citizen reporters also sign a code of ethics. Min said OhmyNews was trying to combine traditional journalism with citizen journalism. "Our model of community journalism and web sites is unique." The number of Korean citizen reporters reached 70,000 by mid-2009. When the site launched in February 2000 it had 727. The English-language site OhmyNews International (OMNI) started in May 2004. By March 2009 OMNI had 6,000 citizen reporters from more than 130 countries. The number of in-house editorial staff in mid-2009 totaled 46 in the Seoul headquarters, plus another 30 software developers and engineers, and other support staff.

Min explained that OhmyNews was aiming to combine traditional journalism with citizen journalism. This required good communication skills to maintain a community of citizen reporters. "Our model of community journalism and web sites is a unique model that no-one has done before." OhmyNews emphasized the importance of communication, and insisted that most editors had been a citizen journalist before taking on their new role so they knew what was involved. "It is important to understand the psychology and expectation of citizen journalists," Min said. Most of the staff are aged in their 20s and 30s. Min said in such a small company, everyone was required to have multiple roles. "That is actually better because of the nature of our business," he said. "The role of the office-based jour-nalists was more like that of an editor than a reporter." The gender balance in the newsroom is split almost evenly between men and women, unusual in South Korea where the bulk of journalists are men.

Excellent broadband links are part of the reason for OhmyNews's success. At the time of going to press South Korea had the highest broadband penetration in the world. In 2005 three-quarters of households had broadband. By early 2009 the percentage had jumped to more than 80 percent of households. South Korea was an early adopter of "triple play" models that bundled cable television, broadband Internet and voice telephony as a package from a single provider. South Korea was also a world leader in third generation (3G) mobile phone technology. It has the world's highest percentage of mobile users with 3G phones. Because of the wide range of telephone and digital technology, South Korea has become a hothouse for infrastructure developments. It is at the "bleeding edge" of the digital revolution,

acting as a trailblazer for high-speed and wireless Internet services. The country has also pioneered the distribution of television via mobile devices.

One critical measure of any news medium's success is influence among opinion leaders. Each year the *Sisa Journal* rates the influence of Korea's media by asking about 2,000 key opinion leaders what media they consider the most influential. Since 2003 *Sisa Journal* has ranked OhmyNews as high as the sixth most influential media outlet. This is a remarkable achievement given its relative youth and competition from almost 120 daily newspapers and about the same number of television channels. Traditionally television has held the most influence in South Korea. *Sisa Journal* regularly places the Korean Broadcasting Service at the top of its most influential list. Interestingly, *BusinessWeek* in an article published July 14, 2009 quoted marketing expert Shane Park at Cheil Worldwide, Korea's largest advertising agency, as saying OhmyNews was no longer a "novelty." South Korea had many blogs and social media catering to a wide variety of viewpoints and values. Park said OhmyNews' citizen journalism had emerged as a significant media outlet earlier in the decade, when it served as a "rare alternative" to conventional news organizations that largely reflected conservative views and portrayed then president Roh as a "dangerous leftist." "We live in a different environment now," said Park.

History of OhmyNews

Dr. Oh Yeon-ho is the founder and CEO of OhmyNews. He started work as a reporter for a small liberal magazine called *Mahl* in 1988. His surname and the name of the web site are not related. Dr. Oh encountered numerous frustrations while trying to access major news sources. As a taxpayer, he believed he had a right to the vast reservoirs of public information in government agencies. The idea that "every citizen is a reporter" came to him about that time and stayed with him for several years until he began post-graduate journalism study at Regent University in Virginia in the US almost a decade later. One of his professors asked the class to draft a plan for an imaginary new media start-up. Dr. Oh's business model was based on his long-cherished idea. After returning to Korea in 1998, Dr. Oh persuaded five businessmen to help him. They were part of the generation who participated in the student movement of the 1980s that helped topple the country's military dictatorship. With investors' money and some of his own, Dr. Oh launched a beta, or test, version in December 1999. At the time OhmyNews had a staff of four and had received 20 articles

from citizen reporters. By the official launch date, at 2:22 p.m. on February 22, 2002 when the incorporation papers were signed, OhmyNews had 727 citizen reporters.

In his autobiography *OhmyNews Story*, published in Korean in August 2004, Dr. Oh wrote that he wanted to start a journalism tradition free of newspaper company elitism. "So I decided to make the plunge into the sea of the Internet, even though I feared things that I was not accustomed to." (OhmyNews supplied an English translation.) OhmyNews was the first citizen journalism site to challenge Korea's mainstream media's ability to set the national agenda. The OhmyNews web site attracts more than one million repeat visitors each day. It once recorded more than 25 million page views in a single day during an election.

The form of journalism that OhmyNews pioneered gained mainstream recognition during the country's 2002 presidential election. During the election, OhmyNews received 20 million page views a day, which is remarkable given the country's adult population totalled about 40 million at the time. Imitation is the sincerest form of flattery goes the saying, and Korea's mainstream media have adopted some of the features of citizen participation. For example, *Chosun Ilbo*, one of the leading conservative dailies, started allowing its readers to leave comments at the end of articles. Daum, the second-largest portal in Korea, began encouraging "blogger reporters" to submit news to a dedicated site named "Media Daum." And the Seoul Broadcasting System, a leading television broadcaster, started to accept video news from citizen reporters.

OhmyNews introduced the online-only model to South Korea. Before that, Korean newspapers used to shovel content onto their web sites. In January 2005 Dr. Oh Yeon-ho presented his ideas at Davos as a panelist in a World Editors' Forum seminar entitled "Welcome to the Blogopolis." In November 2005 *Time* described Dr. Oh as "very much of his generation: the anti-government student protestors of the mid-1980s who managed to rid South Korea of its dictatorship." Dr. Oh spent a year in prison in 1988–89 after being charged with violating the country's infamous National Security Law. Some years later he realized the establishment could not control the Internet. "OhmyNews wasn't created just for money," he said in his autobiography, "it was created to change society." Dr. Oh realized the Internet encouraged interaction, and he wanted to make the most out of this new medium. "Every citizen can be a reporter. Journalists aren't some exotic species, they're everyone who seeks to take new developments, put them into writing, and share them with others."

At the end of 2006 *TIME* chose Kim Hye Won, a Korean housewife and OhmyNews citizen reporter, as one of the 15 Netizens who exemplified "YOU,

Person of the Year." Each year since 2005 reporters from more than 50 nations have gathered in Seoul in June or July for the annual citizen journalists' forum.

Jean Min said it was vital to remember that the audience "is the content." The nature of the content would be decided by the nature of the audience. "It is really up to the audience as to what kind of content you will have, what kind of brand you will have, what kind of structure." When it considered partners in other countries OhmyNews always looked for a local group with a good understanding of their own market and audiences. Min also acknowledged that user-generated content was the new industry buzzword, noting that many media organizations saw the commercial possibilities of user-generated content because they expected to receive free content. "All the conversations focus on business applications and exploiting audiences. But nobody talks about empowering audiences. That is the key."

Min said all citizens were stakeholders in OhmyNews. Users or participants needed a chance to be empowered. "We are thinking about how to empower citizen journalists." All three stakeholders – audiences, citizen journalists and media companies – need to be involved. "The web is a community space. Without contributions from the community, web-based media organizations cannot do anything." Nobody should be allowed to dominate the media environment, Min said. "Nobody has the right to exploit people without giving something back. That is [our] basic philosophy."

Citizen journalism in Singapore

Another well-known pro-am site in Asia is Singapore's Stomp (an anagram formed from Straits Times Online Mobile Print). It is the country's most popular social networking and citizen media web site and is owned by media conglomerate Singapore Press Holdings (SPH). In January 2009 Stomp received its highest audience numbers to date, with 10.5 million page views. This was a leap of 30 percent from September 2008. Three-quarters of the site's content comes from citizens. They send it via SMS, MMS and email. This user-generated content also finds its way into SPH dailies such as *The Straits Times* and Chinese-language newspapers *Shin Min Daily News* and *Lianhe Wanbao*.

Video content, both entertainment and news, is produced by Stomp's multimedia producers and videographers as well as by people in the street, often using the cameras on their mobile phones. By early 2009, Stomp was getting about 1,000 photographs a day, compared with one a day when Stomp launched in June 2006. Almost all are published on the web site at http://www.stomp.com.

sg. Only poor-quality or offensive images are rejected. Newsworthy photographs are shared with SPH's newspapers. Most weeks, citizens' photographs make it into the pages of *The Straits Times*, including a handful on page 1.

Felix Soh, digital media editor for English and Malay newspapers at SPH, oversees Stomp. He believes it is the only platform in Asia that focuses on social networking. Stomp caters for a different market compared with *The Straits Times*, whose online site, ST Interactive, effectively mirrors the print edition and contains mostly serious journalism. Stomp is alternative journalism. "It is not serious journalism in the form that *The Straits Times* offers," Soh said, "though Stomp does deal with journalism that affects people's lives."

He cited an example: Every three months Roger Sim, a cleaner aged in his 60s, takes his mother-in-law to one of Singapore's 18 health clinics. There he found long queues. "I was so tired of seeing snaking queues outside Geylang Polyclinic. They start forming at about 5am, and old aunties and uncles have to wait outside for their turn." Sim sent a photograph of the queue to Stomp. A reporter from *The Straits Times* visited several clinics and discovered that early-morning queues were a nationwide problem in the island state. After the paper ran an article, health minister Khaw Boon Wan instructed health chiefs to fix the problem. Today, all 18 polyclinics open at 7 a.m., allowing patients to wait indoors for an hour until 8 a.m., the official opening time.

Social networks and news

In 2009 Dr. Tony Tan, chairman of SPH, opened the Multimedia Center in the company's news centre, describing it as the company's "base of operations" to tackle the digital challenges ahead. The center houses Stomp, AsiaOne and a new project, The Straits Times Razor TV. AsiaOne describes itself as a "free-access, one-stop information mall" which incorporates information from SPH newspapers. Razor TV is an online television service that broadcasts live from SPH's web studio. It offers video-on-demand for people who want to control what they want to watch and when. It includes real-time interactivity between the web studio and the audience, and amongst members of the audience. The site exploits Web 2.0 technologies. Think of it as an interactive YouTube combined with Facebook, Soh said. Razor TV's presenters are all new faces. It delivers content that is young and hip, with an informal tone. "News and views are raw and edgy," Soh said. Unlike traditional television broadcasts, which had yet to adapt to the Web 2.0 paradigm, Razor engaged in real-time social interactivity to "capture new eyeballs and better engage audiences."

Even though the public has embraced social networks, news organizations have been slow to wade into Web 2.0 waters. Publishers and editors tend to see themselves as curators of content – commissioning, selecting, massaging and presenting material for their perceived audiences. But they do not network with their audiences except in rudimentary ways like comments and letters to the editor. A Bivings Group report published in December 2008, *The Use of the Internet by America's Largest Newspapers,* found that while individual journalists had adopted tools like social bookmarking, blogs and RSS, only 10 newspapers had built social networking into their sites.

While some newspapers in the US were filing for bankruptcy in 2009, the *Bakersfield Californian* was expanding. One reason was the paper's launch of an online social network in 2005, Bakotopia.com, designed to reach newspaper non-readers, especially young people aged 18–34. Twice a month the newspaper publishes 20,000 copies of a free magazine with content from Bakotopia, *Business Week* magazine reported in March 2009. Dan Pacheco, senior manager of digital products at the company, said because the magazine's audience was young, hip, and hard to reach "advertisers pay full rates."

The *Bakersfield Californian* is independent and family-owned. In March 2009, using an $837,000 grant from the Knight News Challenge and about $200,000 of its own money, the company launched a site called Printcasting.com that allowed individuals, schools and groups such as local associations and clubs to create their own digital magazines. The idea was to reach new audiences, cut costs, and attract new kinds of advertisers. Pacheco said the future for newspapers could be very different from how they started, adding, "We are the network that allows people to communicate among themselves."

In Singapore, Razor TV aimed to attract viewers between the ages of 18 and 40, Dr. Tan said. New streams of revenue would come from television commercials, online banners and advertorials. Other aims included promoting *The Straits Times* brand name and building an online presence. Users create content and share that personalized content with the Razor TV community. Meanwhile, developers created third-party applications for the online site. A suite of Application Programming Interfaces (APIs) were being developed to allow third-party developers to build applications to offer a more engaging Web 2.0 user experience. Another key differentiator was emphasis on the hyper-local, aimed at specific local audiences, Soh said. Dr. Tan said delivery of videos over the Internet had been one of the most significant features of the Web 2.0 evolution. "The explosion of video sites such as YouTube has led to a rapidly growing demand for video content. Large-scale social networking platforms like Facebook also offer a high level of

interactivity and open interfaces for third-party applications. Not surprisingly, these sites have enjoyed an explosion in the number of active users." Traditional media companies worldwide had yet to adopt new-media paradigms, Dr. Tan said. Many news portals had adopted technologies like podcasts, vodcasts and RSS syndication but had not engaged audiences through real-time interactivity. SPH intended to be among the first media companies to do so, Dr. Tan said. In late 2009 an Innovation Laboratory would be added to the Multimedia Centre so that the latest, cutting-edge ideas could be nurtured and developed. The laboratory will become a showcase of how news will be delivered and consumed in the future. "It promises to be an exciting ride," Dr. Tan said.

Meanwhile, Stomp has achieved recognition internationally. Its chief architect Felix Soh and his staff have been invited to speak at numerous international media conferences. The site is actively involved in national campaigns, partnering various government agencies such as the Promote Mandarin Council and the Speak Good English Movement. The site's "English as it is broken" feature, created in conjunction with the Speak Good English Movement, has been so successful its content has been published in a book by the same name. It remained on Singapore's best-selling list for more than six months and has been reprinted four times.

Founding editor Jennifer Lewis described Stomp as a bridge between traditional newspapers and young readers. Editorial managers decided that the future had to be online because that was the way to reach young readers. The focus would be on involving readers and interacting with them through user-generated content. "It's rare within an established media group to be so involved with user-generated content," Lewis said. "From what we can see we have a fair number of young people and students. But at the same time we also see an older demographic aged in their 40s who are very active in what we call Singapore Scene, which is our citizen journalism section. We know about them because a fair number of older people have called us on our hot line to ask us about how to send pictures by mobile."

People send an email or SMS about an issue or story. Stomp producers interview the senders and rewrite the story for them. "Singapore academics think it's a cultural thing unique to Singapore where citizen reporters would rather talk to a reporter," Lewis said. When the story is put online Stomp staff tell the person who provided the information. Then they read the story and check it for accuracy. "We ask them are you happy with it? If it doesn't reflect what you meant to say, call us back and we'll adjust it. This is different from how citizen journalism works in other countries like South Korea," Lewis said. "Much of what we are doing is new to everybody and given some of the cultural preferences in Singapore our audiences would rather relate their story. We are very meticulous. We take copious notes.

And often they send us long emails that we rewrite. Because we have their contact numbers and email addresses we can contact them for clarification, and they certainly know they can get back to us," Lewis said.

Mobile phone and broadband Internet penetration in Singapore are very high by world standards. Mobile phone penetration was already 103.2 percent by 2006. Almost every household has an Internet connection and most are broadband. The Infocomm Development Authority (IDA), the body that oversees and regulates telecommunications in Singapore, announced the Next Generation National Broadband Network in 2007. By 2010 it was expected to provide broadband speeds of at least 100 Mbps to 60 percent of homes and offices via an all-fiber network.

For SPH's Soh, breaking news online was not new. "I get breaking news on my mobile phone. Mobile is big for breaking news." The Internet was no longer text-focused. The future focus should be multimedia. "It is not new media," Soh said. "It is now media."

Meanwhile in Europe and the US, the morphing of citizen journalism into something more recognizable as "public engagement with the media" has attracted interest from major media companies such as CNN, Yahoo! and Reuters. These mainstream media have provided ways to let people submit video, still images and text via their mobile phone. CNN introduced its iReport section for audience-submitted material (http://www.cnn.com/exchange/) in August 2007. Some submissions are included in mainstream news broadcasts. Within months CNN was forced to expand the site to accommodate the volume of material submitted. The iReport site offers a range of tools for helping novice reporters, called the Toolkit. Mitch Gelman, executive producer of CNN.com, said observers could offer their perspectives on a story from the inside. "Even the best reporters in most cases are approaching the story from the outside in. We feel as a news organization we need to provide both to offer full coverage to our audience." Reuters also established a site for accepting content from audiences, along with Yahoo! News, CBSeyemobile.com and the Fox network in the US. The last is called UReport. Yahoo! News has built a training site for its audience-generated contributions called YouWitness News (see http://news.yahoo.com/you-witness-news).

In France, the Observers launched in December 2007 and combines citizen journalism with professional editing. Julien Pain, founder and editor of the site, described the Observers as "collaboration with professional content and an international scope." The project has only three full time staff in Paris yet it operates English and French versions of its site. About 12 freelancers work as "regional editors." They are paid for their time but only work when required. Most of the stories on the sites

come from about 700 "observers" around the world. Early in 2009 the site started a weekly radio show and was considering a weekly television slot.

Pain said the idea was to receive information from people on the scene of whatever story was current. The site uses the expertise of local sources, Pain said, but did not try to make them reporters. "We use their expertise and local knowledge." The editors in Paris provide background information on each story while expert "observers" from the country under discussion comment on the event. "The idea is to zoom in on a small anecdote and then zoom out, placing it within a wider context. The stories picked to follow might be connected to well-known breaking news items, or might be about something relatively unknown to readers," Pain said. He always looked for local contacts: "I'm not going to get somebody in Beijing to comment on something that happened 3,000 km away in the Sichuan province," he told the Editors' Weblog run by the World Association of Newspapers. Pain said he aimed to get people native to the country to "observe," rather than French or English people living abroad, because locals tended to have a better knowledge of local culture and language. Anybody who goes to the Observers site can register as a "friend" and comment or contact the site. Those "friends" who provide useful information over time will be invited to become Observers. Pain said he hoped the "already substantial network" would grow further.

The site had the informal tone of a blog and was easy to read, Pain said. But it also maintained a professional approach. Blogs had broken down the barrier between journalists and readers. The Observers intended to be part of a dialogue, allowing comments on all stories and responding to reader reactions. As with OhmyNews, though amateurs produce much of the content, professional check and edit everything. "Amateur content is far more valuable if edited by professional journalists," Pain said. The Observers aimed to be a trusted source, and he was keen only verified information was associate with the Observers' parent brand, France24.

Early in 2009 the Observers started a weekly 15-minute radio show in partnership with Radio France Internationale. The idea was to take a document and employ an expert on the subject matter to analyze it. Pain said the Observers' work would not replace professional journalism. But it hoped to provide an alternative voice in the news media world. The site is innovative, with an impressive output considering its tiny number of full time staff. The Observers has found a way to validate citizen journalism and turn amateur content into something more valuable. This could offer a model for the future as news outlets struggle with limited resources.

ProPublica in the US (see Chapter 4) launched the ProPublica Reporting Network in May 2009 to organize readers to commit "acts of journalism." Amanda Michel, who edits the network, said that by collaborating directly with the public ProPublica aimed to deliver a greater range of information. This type of reporting would also extend ProPublica's reach. "We have three strategies for building a corps of pro-am journalists and integrating them into ProPublica's mission. Everything will be done under the auspices of the ProPublica Reporting Network, our pro-am journalism initiative. First, we'll coordinate collaborative reporting projects. Like major metro dailies that often publish stories drawing from reporting by a half-dozen or so reporters and stringers around the country, we'll manage assignments that draw on the insight and experiences of many people. I call them assignments because we're not inadvertently scooping up old news – we're intentionally organizing people to report. Second, we're going to make available data and documents hidden from public view and hold them up to public review." Michel acknowledged that Talking Points Memo had pioneered this technique. "Even in a newsroom as young as ProPublica's, reporters are sitting atop massive stacks of documents. We won't just cherry-pick from documents sitting around the office – we also plan to ask our readers what documents they'd like us to FOIA on their behalf."

Michel said the third strategy was to create resources that citizens could use to assess what was happening in their towns and cities. The site published guides to help people perform background checks on companies on its blog. "Our suggestions aren't exhaustive, but they are tools available to anyone who wants or needs them. Most of the time these resources will accompany an assignment, but they'll live in perpetuity online, too." Michel said citizen reporters would not be paid. "We're running the program much like CNN's iReport, HuffPost's Eyes & Ears, the Talking Points Memo community, and others."

Citizen journalism site AllVoices (http://www.allvoices.com/) launched in April 2007 and by January 2009 had attracted one million unique visitors a month. The site started with $4.5 million of equity funding and hoped to make enough money from advertising to cover costs and become profitable. But it needs seven or eight million unique visitors a month to become profitable from advertising. Meanwhile, AllVoices was keeping costs as low as possible, and only had six fulltime staff. Founder Amra Tareen hopes that once the site becomes big "monetizing it will not be a problem."

The site relies on proprietary algorithms and its community for selection of content. The web site said AllVoices took a contributed news event and created context by "bringing together relevant news stories, blogs, images and videos."

It was a place for the community to share and discuss news. Tareen described this as the "YouTube principle" and emphasized that producing an edited product was not the aim of the site. The goal was to publish what people wanted to create and "provide multiple points of view." Tareen was confident that the site's users were capable of "making their own decisions as to what they want to believe in."

AllVoices staff did not edit the site. Staff only checked content if a community member flagged it. Selecting articles for the front page was based on a variety of criteria – popularity, credibility, and whether the news was breaking – all assessed by algorithms. The algorithms identified a contributor's location based on the computer's IP address or mobile phone network. Algorithms also assessed a report's credibility based on whether other people were reporting on similar issues, or adding to it, plus other users' ratings. Tareen said the algorithms were only 80 percent accurate: "You need some human interaction and this is what we are trying to get the community to do." Stories ranked highly by both the algorithms and the community were more prominent. Stories started on a city page, chosen based on geo-coding technology, and then moved to regional and global pages if they caught "momentum" – that is they received many hits and high rankings.

All contributors had to create a profile, which also was the basis for the community's social networking feature. A personal messaging system for communication between members was available to help form a community. A recommendation engine showed users what mainstream media and other bloggers said about the news they were writing. An incentive program allowed contributors to earn cash once they reached a certain number of readers and a high level of credibility. Users kept track of their earnings on their profile page.

By building pro-am social networks around news, media organizations can stimulate conversations about their content, which should help them grow and keep users loyal. But networked journalism is a process not a product. When the process is shared the networked journalist changes from being a gatekeeper to a facilitator, because the web, as Min from OhmyNews has noted, is a community space.

In the next chapter we look at how media companies working within a framework of family holdings, trusts or government charter avoid some of the financial pressures that publicly-listed news organizations face – and how they face other pressures related to their private status.

Family ownership and trusts

Summary

In Greek mythology Zeus, the king of the gods, had a goatskin shield or a goatskin slung over his shoulder as a piece of armor. This gives us the concept of the aegis, from the Greek word for goatskin, meaning a protector or patron. Some of the biggest and most prestigious titles and brands in journalism have thrived because they are protected by family trusts. They enjoy more freedom to innovate and remain truer to journalistic ideals than corporate entities beholden to shareholders and quarterly results. But this unique form of ownership has not made media houses any less vulnerable to recession. Some of the family trusts that succeed financially employ some kind of revenue-generating mechanism outside of their prestige journalism title. This chapter describes the structure of media trusts at some well-known media organizations and outlines how they operate. It also acknowledges that some family trust titles have gone into decline under the control of more recent generations of the family who have neither the interest nor the smarts to keep the company going, or simply want to cash out.

The essence of this chapter is simple: In tough economic times dedicated media companies do whatever is needed to protect the core journalism. Sometimes it is not about having a better or smarter business model than anyone else. It is about being willing to focus on the long term – keeping one's eye on the prize – and appreciating the influence of structures on how a company works. One of the authors of this book learned a lot from Ikujiro Nonaka, the Japanese father of knowledge management. In a lecture in 2001 Nonaka displayed images of the skeletons of a human and a great ape. Nonaka pointed out that the two creatures shared 99.99 percent similar

DNA. But they operated differently in the world because of their skeletal structure. In other words, structures dictate what is possible. Family trusts represent the kinds of structures that allow quality journalism to prosper. This chapter proposes to describe operations at the *New York Times* Company in the US, The Scott Trust Limited in the UK (which runs among other newspapers, *The Guardian*), and the Schibsted Trust in the Nordic nations, plus the world's best-known public broadcaster, the BBC.

Around the world, too often the market makes decisions about the fate of media companies rather than individuals with a commitment to quality journalism. In 2001 Gibert Cranberg, Randall Bezanson and John Solosoki published an important book *Taking Stock: Journalism and the Publicly Traded Newspaper Company*. They argued that decisions made in the boardrooms of publicly traded newspaper companies were largely dictated by the opinions of media analysts in the financial sector "whose interests are strictly financial and whose expectations are by definition short term because of easy access to alternative investments at a moment's notice." News was a business. The newspaper chains the academics studies in the mid-1990s were subject to the "unceasing demands of the investment marketplace, populated by individuals, corporations, institutional investors and other passive investors, large and small, whose interest is profits and margins and yields and share value; whose interests, in short, is business and not news."And they published this book in 2001, before the upheaval in the American newspaper market had really begun to bite.

Jump forward eight years. To save money, media managers have cut costs. The easiest cuts are in editorial numbers. Thousands of journalism jobs disappeared from the world's media in 2008 and 2009: almost 6,000 in the US alone in 2008. Managers are being forced to cut costs to protect their margins, but they are cutting the people who create the content. When does this directly affect the quality of the content and hasten a decline as audiences start to look elsewhere in an information-saturated world? And when do advertisers stop valuing that content as highly. In Australia in May 2009, media analyst Christian Guerra of Goldman Sachs JB Were wrote that a cost-cutting strategy was "driving decay in content quality." He concluded "this must harm audiences." "The question we do not know the answer to is: Are audiences noticing the decay in quality? If the answer to this question is 'yes,' which we suspect it is, traditional media companies face the prospect of the current challenges (cyclical and structural) actually driving further audience migration away from traditional media," Guerra wrote. Do traditional media companies appreciate the irony in the fact they could be contributing to their own death by pushing audiences away?

Because of their structures, publicly traded media companies can do little to stop this decline. They are doing what the market forces them to do.

This chapter aims to consider the question: Do family trusts produce better journalism? The best-known examples of media houses protected by some form of private control at the end of 2009 were the BBC and *The Guardian* in the UK, *The New York Times* in the US, and newspapers in the Schibsted Trust in Norway. Other family-owned trusts have been sold off in the past decade. These include *The Wall Street Journal*, which the Bancroft family sold in 2007, the *San Francisco Chronicle* which the de Young family cashed out of in 2000 and the *Los Angeles Times*. The last went from being a prestige paper under the Chandler family, to a lesser publication under a series of corporate owners, culminating in the bankruptcy of parent company Tribune and mass layoffs that appear to have diminished the paper.

As of mid-2009 even trust-protected newspapers were struggling, but they looked more likely to survive and flourish than newspapers owned by corporations. *The New York Times* continues to be a bastion of quality journalism and continues to repel potential boarders, aided by family ownership. This newspaper has won more Pulitzer Prizes for journalism than any publication in the world. *The Guardian* loses money but is not under the same commercial pressures as other British newspapers because of the commercial activities of parent GMG that underwrite the newspaper's activities. The BBC – a shining example of quality journalism – receives £3 billion ($4.8 billion) of public money every year.

Under family ownership, journalism has more security than at media houses owned by corporations. Trust-owned media houses have the freedom to find outside revenue sources to subsidize journalism, and they know their owners will not close the company if profits are not high enough. Family-owned newspapers appear able to resist the market's call for higher profit margins. Family-owned newspapers are also willing to accept lower margins. News Corporation under Rupert Murdoch runs like a cross between a public company and a family company. When the recession started to bite in Australia most of the media companies started laying off journalists. Initially Murdoch did not, and the managing director of the Australian Broadcasting Corporation, Mark Scott, in a major speech to the National Press Club in September 2008, described Murdoch as the "last best hope for newspapers." Scott was a newspaper executive before he joined the ABC. Murdoch has been prepared to sustain losses at his newspapers, such as *The Times*, when it suits his larger purposes. He genuinely appears to care about newspapers.

Thomas Kunkel, dean of the Philip Merrill College of Journalism at the University of Maryland, said the twentieth century was not kind to family newspaper ownership in the US: "While some 1,650 dailies were family-owned in 1900, the number plunged to 850 by 1960, 350 by 1990, and about 250

now," he wrote in early 2009. Many family-owned newspapers went to corporate chains in the 1960s. Most of the largest chains, which included Gannett, Knight Ridder, Tribune and Times Mirror, started out as family run enterprises. But as they expanded the family stake became diluted, and Wall Street entered the fray. Sometimes this was a good thing because some family-owned newspapers were poorly managed. Knight Ridder in particular gained a reputation for improving the properties it bought. But with profits under severe pressure from the recession and the flow of advertising to the Internet, Wall Street turned the screws. KnightRidder was sold off in 2006. Tribune bought *Times* Mirror in 2000 and Sam Zell acquired Tribune in April 2007 before it went bankrupt in 2008. And Murdoch purchased the Dow Jones Company in 2007 to obtain control of *The Wall Street Journal*. This leaves America with only two family-owned major newspaper companies, the Washington Post Company and the *New York Times* Company.

Newspaper executive and blogger Steve Yelvington described the four cycles in the life of an American family newspaper business in March 2009. A pioneer founder usually appeared in the late nineteenth century. That founder either started the business or sometimes stepped in to buy one or two poorly run newspapers. "The founder was unabashedly a booster, a city builder, [or] a civic leader," Yelvington wrote on his blog. The next generation was the empire builder. This generation took risks to grow the business, sometimes acquiring other newspapers, and perhaps starting related businesses. Many of this generation purchased broadcast licenses as they became available in the twentieth century, Yelvington said. The third generation tended to focus on "cleaning up the wonderful mess created by the previous one" – turning chaos into a focused, professionally operated enterprise. MBAs are brought in. Yelvington described the fourth generation as "the wastrel." "It's a cruel label, but how often have you seen it happen," Yelvington asked rhetorically. "Unlike the previous generations, this one didn't grow up working in the family business, but rather grew up spending the family money. By the time you get to four generations, there are too many heirs to coordinate, to manage, to employ. Most have little or no real interest in the business itself." This was the generation that typically sold to a corporate buyer, he said.

In the cover story for its January 2009 edition, *The Atlantic* magazine predicted the death of the print edition of *The New York Times*, possibly by May that year. The newspaper was still publishing as we went to press. Why? Partly because the more than one million people who pay to receive the print edition each day are worth far more than the 20 million visitors to the web site each month, in the sense that advertisers want to reach those affluent readers, the

so-called AB demographics. (Revenue from a web-based version of *The Times* would pay for about a fifth of the current staff of more than 1,200 journalists at *The New York Times*.) But other factors come into play: Choice and heritage. Editors and managers at *The New York Times* believe they have almost a sacred trust to maintain. Without the protection of the structure of *The New York Times* this situation would not continue. Its two-tier stock arrangement, designed to preserve control within the Sulzberger family, has protected the newspaper to a major degree. The Sulzbergers own 19 percent of the company but control 70 percent of the voting power. At the Washington Post Company, the Graham family own almost 40 percent of the company but control about three quarters of the votes. When David Kirk became CEO of Fairfax Media in 2005, he pointed out Fairfax's Achilles heel: the fact that its capital structure did not separate voting shares from ordinary shares in the way that this structure benefitted the *New York Times* Company, the Washington Post Company and News Corporation. An earlier section of this chapter details the challenges associated with being buffeted by market forces.

Donald E. Graham, chairman of the Washington Post Company, rebranded it as an "education and media company" at a meeting with Wall Street analysts and shareholders on December 5, 2007. This was designed to reflect the rise of the education arm, Kaplan Inc. It also reflected the decline of its flagship newspaper. The company bought Kaplan in 1984. By 2007 Kaplan accounted for 50 cents in every dollar of company revenue. Graham said he had waited until Kaplan passed the 50 percent threshold to announce the change in emphasis. The newspaper division, primarily *The Washington Post,* accounts for 21 cents of every dollar. At the time newspaper industry analyst John Morton said the company should probably be identified as an education company and "get *The Washington Post* name out of the title." In 2008 almost 70 percent of the company's profits came from Kaplan and Cable One. The 2008 annual report predicted: "The newspaper will lose substantial money in 2009. Some will be non-cash accelerated depreciation because we will be closing a printing plant. Most will be real losses. Post management knows that losses must diminish in 2010," chairman Donald E. Graham wrote in the annual report. "Today, it isn't obvious that even the best-run, most successful newspaper can be consistently profitable. But *The Post* will get every chance." The question arises: Would this high level of support happen if Wall Street were in control? If newspapers are considered a public good, then media trusts serve a vial purpose for society.

Another newspaper that benefits from a trust structure is *The Guardian*. The CP Scott Trust was created in 1936 to protect the legacy of the longstanding

editor and former owner of *The Guardian*, CP Scott. In October 2008 that trust was replaced by The Scott Trust Limited. This placed the independence of *The Guardian* on a "very secure footing for the future," Scott Trust chair Dame Liz Forgan said. "Over the 72 years of its existence the Scott Trust has periodically re-examined its structure to make sure it is in the best possible shape to guarantee the ongoing independence of *The Guardian* – the core purpose of the trust," Forgan said. The change occurred because the Scott Trust had a finite lifespan, unlike limited companies. The trust transferred ownership of the Guardian Media Group (GMG), which controls Guardian News & Media, publisher of the *Guardian* and *Observer* newspapers, GMG Regional Media, GMG Radio, GMG Property Services and Apax Partner joint ventures Emap and Trader Media Group, to the new parent, The Scott Trust Limited. Forgan assured staff that the core purpose of the Scott Trust had been enshrined in the new company. The core purpose of the trust was "To secure the financial and editorial independence of *The Guardian* in perpetuity: as a quality national newspaper without party affiliation; remaining faithful to its liberal tradition; as a profit-seeking enterprise managed in an efficient and cost-effective manner."

To ensure the group's financial security Guardian Media Group went into partnership with a venture capital firm, Apax Partners, in two key deals in March 2008. In the first, GMG sold 49 percent of its profitable Auto Trader business to Apax. Soon after, the trust and Apax acquired business publisher Emap Communications for $1.8 billion. *Guardian* Blogger Roy Greenslade wrote that to survive it was necessity for newspapers, including liberal and left-of-center papers, to get into bed with capitalists. "However painful it may be for old Marxists like me to admit it, there is no way to buck the market. If we want to preserve journalism and, most importantly, ensure diverse media ownership and a consequent plurality of viewpoints, there is no alternative." Greenslade also noted that several newspaper companies relied on allied businesses that once were "marginal add-ons," such as organizing events, staging exhibitions, and education and training, for revenues. He suggested this diversification could give journalism a "wonderful new lease of life" free from a continual worry about advertising.

The Guardian and its web sites have become a global brand. Its online sites flourished in the early decade of the twenty-first century. Fully 40 percent of its traffic came from the US as of mid-2009, as Americans looked for global perspectives beyond those offered by parochial American media. Carolyn McCall, CEO of the Guardian Media Group, said GMG's national newspaper business Guardian News & Media, which also published Guardian.co.uk, generated nearly 30 percent

of its advertising revenue online. This figure was high compared with the company's competitors, McCall said.

She acknowledged the print edition of *The Guardian* would be around for a long time because the UK's population was ageing, and that demographic wanted print. Much of the group's revenues came from *Auto Trader* magazine. McCall said the parent company Trader Media Group's revenues were 50–50 from print and online in 2009 but more than 70 percent of profits came from online. The Guardian company was preparing for the future by developing extra revenue streams, such as building on the success of online classified businesses such as recruitment site Guardian Jobs and dating site Soulmates, McCall said. The company was also developing video and audio advertising and building communities with its Comment is Free site and via blogs.

The BBC

The BBC is the largest broadcasting corporation in the world. Its mission is to enrich people's lives with programs that inform, educate and entertain. It is a public service broadcaster funded by a license fee paid by UK households. The BBC is constitutionally established by a Royal Charter. An accompanying Agreement recognizes its editorial independence and sets out its public obligations in detail. The current Royal Charter was granted on September 19, 2006 and took effect from January 1, 2007. The Charter sets out the Public Purposes of the BBC and guarantees its editorial independence. It prescribes the constitution of the BBC, the relationship between the Trust and the executive board which runs the BBC, and the duties and functions of both bodies. The Agreement complements the Charter. It goes into more detail on many of the subjects mentioned in the Charter and also covers such things as the BBC's regulatory obligations and funding arrangements. The Agreement was made between the BBC and the UK's Secretary of State for Culture Media and Sport, and approved after a debate in Parliament in July 2006.

The BBC uses income from the license fee to provide eight national television channels plus regional programming, 10 national radio stations, 40 local radio stations and an extensive web site, bbc.co.uk. BBC World Service broadcasts to the world on radio, on television and online, providing news and information in 32 languages. It is funded by a government grant, not from the license fee. The BBC has a commercial arm, BBC Worldwide, which operates a range of businesses including selling programs around the world and publishing books, DVDs and merchandise.

Its profits are returned to the BBC for investment in new programming and services. The BBC is governed by the BBC Trust, which represents the interests of license fee payers and sets the overall strategy. The Trust's Chairman as of mid-2009 was Sir Michael Lyons. The BBC's executive board, chaired by the director-general Mark Thompson, manages the day-to-day operations of the corporation.

The BBC's mission is simple and elegant: To enrich people's lives with programs and services that inform, educate and entertain. The vision statement is also elegant and ambitious. "Our vision: To be the most creative organization in the world." The BBC outlined its values on its web site:

- Trust is the foundation of the BBC: we are independent, impartial and honest.
- Audiences are at the heart of everything we do.
- We take pride in delivering quality and value for money.
- Creativity is the lifeblood of our organization.
- We respect each other and celebrate our diversity so that everyone can give their best.
- We are one BBC: great things happen when we work together.

The Royal Charter and Agreement also establishes six public purposes for the BBC to fulfill its mission to inform, educate and entertain:

1. Sustaining citizenship and civil society
2. Promoting education and learning
3. Stimulating creativity and cultural excellence
4. Representing the UK, its nations, regions and communities
5. Bringing the UK to the world and the world to the UK
6. Delivering to the public the benefit of emerging communications technologies and services.

However, all is not as rosy as it might seem. Commercial media companies in the UK say the presence of the BBC distorts the market and makes fair competition against it impossible. The BBC does not suffer the commercial constraints of other media companies, collecting $4.8 billion a year from public money no matter what the economic conditions or how well or poorly its programming is faring. There also are complaints that the BBC sometimes seems beholden to the British government in corporate and programming decisions. Although the media giant is supposed to be free of government influence or interference, it still depends on Parliament to decide how much public money it will receive.

Schibsted

Schibsted is a Scandinavian media group that reaches around the world. As of mid-2009 it had about 8,100 employees and operations in 22 countries. Its domestic markets were Norway and Sweden, but the group also had companies in Denmark, Finland, France, Spain, Estonia, Latvia, Lithuania, Austria, Italy, Belgium, Portugal, Russia, Slovenia, Singapore, Malaysia, the Philippines and four countries in Latin America. Schibsted operated across a range of media platforms: newspapers, television, film, online, mobile-phone, book and magazine media. The company's turnover in 2007 was NOK 13.61 billion, and NOK 13.74 billion in 2008 ($2.13 billion and $2.15 billion). The 2008 annual report noted the "crucial" role of innovation. "We aim to influence the development of the media of the future, so we are completely focused on constantly improving our understanding of how media habits change and using this knowledge to develop better and better products. The further development of our established brands is just as important as innovation. By combining tradition and innovation, we will face the challenges that the rate of change in the media landscape poses and start to achieve our new ambition to become Europe's most attractive media group."

Schibsted described itself as a knowledge-based company. "In addition to strong brands," the annual report said, "highly qualified employees and the right expertise are our most important resources." A greater focus would be placed in the future on recruiting talented people, the company said. "The aim is to allow talented people to learn more and have more exciting career opportunities. If we do not improve greatly in these areas, we will not achieve the ambitious business goals we have set for ourselves. Attracting talent, developing good leaders and creating competent organizations will be regarded as a strategic area at Schibsted that requires time, resources and prioritization by top management."

After a visit to Schibsted in June 2009, Earl Wilkinson, executive director and CEO of the International Newsmedia Marketing Association (INMA), described it as one of the "most progressive newsmedia companies in the world." He concluded Schibsted had a hidden asset: multiple cultures. "Most media companies operate singularly when it comes to culture, and that is often their Achilles heel. Usually, there is a dominant culture – entrepreneurialism, mindless template execution, conservatism, risk-aversion, top-down, Balkanized – that is prevalent at the business unit level." Executives had realized that managing a multimedia company was not about pasting a print newspaper culture onto online assets. "They especially don't want to tie an anchor onto the tail of digital operations." Wilkinson said it

was refreshing to see Schibsted run on a set of principles, yet business units were allowed to flourish "without the baggage of the one-size-fits-all print culture" that had dragged down less formidable companies.

Schibsted was structured to protect freedom of expression. Schibsted's former largest owner, Tinius Nagell-Erichsen, established the Tinius Trust in 1996 to ensure that Schibsted's newspapers and other media could continue in the future to maintain their position as free, independent bodies. "Editorial independence, credibility and quality are to be the norm for all the Schibsted Group's Norwegian and foreign operations," he wrote in 1996. Tinius Nagell-Erichsen transferred the only voting share in Blommenholm Industrier to the Trust in May 2006 before he died in November 2007. Blommenholm Industrier owns 26.1 percent of Schibsted ASA shares and is the group's largest shareholder. Amendments to Schibsted ASA's articles of association require a 75 percent majority and no shareholder is allowed to own or vote for more than 30 percent of the shares. Provided the trust's 26.1 percent shareholding is not split up, these provisions allow a considerable influence over the ownership of Schibsted.

At Schibsted's general meeting in 1996, Nagell-Erichsen told those present why he established the trust: "Ownership is much more significant to a newspaper than a normal industrial company. A newspaper is not a standard product, but rather a forum for essential social information and debate, on which our democratic society rests. In addition to its long-term nature, newspaper ownership should openly pledge itself to the values which the newspaper represents. At times it may be called upon to defend these values so that the newspaper can retain its freedom and independence. This is when it is an advantage to own a large share."

The Tinius Trust's articles of association stipulate that the trust shall make efforts to ensure that the Schibsted Group continues as a media group, run according to the same main editorial and business guidelines as at present. Editorial independence, credibility and quality should govern all media and publications, owned by the Schibsted Group. The trust must also work to ensure the long-term, healthy financial development of the Group. The trust's board consisted of three members in mid-2009. Chairman Ole Jacob Sunde was also the chairman of the Board of Schibsted ASA. The two other members were Per Egil Hegge and John A. Rein.

Schibsted's annual report for 2008 noted: "The Tinius Trust has been a very effective obstacle against financially-strong players who would otherwise have tried to take over the group. Without the trust, Schibsted would probably not have existed in its current form, nor would we have had the same opportunity

to further develop the company. The trust has effectively limited any interest in taking over the company. When media companies in other countries have wanted to have Schibsted as owner, we have noticed how the trust has contributed to us being viewed positively as a business partner."

The next chapter considers ways journalism can focus on developing niche content and use the power of "passion publishing" to build new revenue sources.

8

Narrowing the focus with niche and passion content

Summary

Some news organizations are using niche content and passion power to build new revenue sources for journalism. Niche content is narrowly-focused, deep and highly-targeted. Broad and popular content should be offered free to build online traffic. But hard-to-find niche material has high value to specific groups and they are willing to pay for it. At the same time niches can be built around communities engaged intensely in an activity or special interest. This is known as "passion publishing."

In April 2008 the owner of niche-content website Pizza.com sold the domain name to an unnamed buyer for a staggering $2.6 million. That's what news organizations all over the world reported, including the BBC, *Washington Post*, CNET and the *New Zealand Herald*. Many publications couldn't help but note that $2.6 million for site about pizza was "a lot of dough." But those publications failed to report the follow-up – that the $2.6 million deal never actually took place. A few months after the initial publicity hoopla, it turned out, the domain name Pizza. com was quietly sold to a small Philadelphia domain-name exchange company called National A-1 Advertising for a more modest sum. To find that out, news consumers had to click onto one of the narrowly-focused news websites that covered the domain name industry, such as dnexpert.com. They had the story.

The story of Pizza.com and the multi-million dollar sale that never took place offers a lesson in the prevalence and importance of niche news sites that cover a very thin slice of the world, but cover it in great depth for a committed audience that

places a high value on the information. The publishers of dnexpert.com can't beat the *Washington Post* and the BBC for broad coverage of the world. But they routinely beat the biggest global news organizations on stories – and follow-up stories – about the sale of domain names. Their low-cost web site (it looks close to no-cost) is filled with advertisements for domain name companies, which can target the exact readership they seek. Some niche blogs and sites can turn a profit because their overhead is so low they do not require a huge readership, while big metro papers such as the *San Francisco Chronicle* and *Boston Globe* have been losing millions of dollars.

As news organizations struggle to find ways to build new revenue sources for content, they are increasingly focus on developing niche content – narrowly-focused, deep, highly-targeted, exclusive or difficult-to-find information that will hold great importance with a specific group of news consumers. In the past, traditional mainstream newspapers were able to generate huge profits by offering general news that appealed to a mass audience. Mass readership brought revenue from single copy and subscription sales of the paper. But even more importantly, it attracted advertisers who paid to get their message to that wide audience. But as noted in previous chapters that long-standing business model is breaking down. Prior to the arrival of the digital age, news consumers had limited access to multiple news sources. Regional, metro and local newspapers benefitted from monopoly or near-monopoly conditions. Even in the UK, where news consumers have a choice of more than a dozen national newspapers, loyalty to one newspaper has been commonplace for reasons that include the cost of having to pay for any extra publications. But the transformation of news to digital platforms has changed that equation dramatically. News consumers can access information from all over the world with a single click, which means general news has become highly commoditized. The same or similar news stories can easily be found at hundreds of online sites. Stories about the Obama family puppy might enthrall the world and attract millions of readers – and can still please those advertisers looking to get their message to the widest possible audience. But commoditized news no longer holds the commercial value it once had. That is why some news organizations are looking to develop differentiated niche content that will provide added value and attract a loyal and committed readership. But identifying, creating and publishing specialized content that consumers will pay for – or that advertisers will pay premium rates for – will not be easy. And questions arise over whether mainstream news providers should reallocate resources toward creating content for a small segment of readers.

Niche-content publications, covering narrowly-focused topics, have been around for ages. Think of specialty magazines on topics such as cars, sports, music,

gardening – or any of hundreds of categories. Likewise, industry newsletters and trade publications have always been able to charge premium subscription rates to a readership that has a particularly strong interest in the content, often for professional and financial reasons, because audiences cannot get it elsewhere. They also hand advertisers the narrowly targeted audience they seek.

Publishers of newsletters focusing on the latest key facts and figures and analysis about industries and markets, such as entertainment, oil and pharmaceuticals, have always been able to charge hundreds or even thousands of dollars for subscriptions that give readers must-have proprietary information. Trade publications also have provided information not found elsewhere about specific types of businesses and industries. While many of these earn revenue through both subscriptions and advertising, some give away their publications to a highly-targeted readership with a compelling interest in that topic and then sell advertising space at a premium to companies trying to target that particular group. For example, a trade publication about the computer games industry could be given away free to the managers at every computer game retail outlet in a particular region. The publisher could then sell advertising to computer game manufacturers trying to get their products onto store shelves by pointing out that they reach every computer store manager in that area.

So these business models are nothing new. But where they have changed, and had a dramatic affect on journalism, is in the opportunities afforded niche publication via digital publishing. Just like general news, niche content published online has global reach, immediacy and substantially reduced production and distribution costs. What it also means for niche content producers is low barriers to entry – that is, setting up a web site or a blog and adding content is so easy and so cheap that almost anyone can do it. And millions do. Most are never seen by anyone other than the person who created them. Research shows that 99 percent of all blogs attract an audience of fewer than 5,000 page views a month. Nonetheless, new websites and blogs devoted to any subject imaginable are competing with traditional news providers for readers. Experts in their field are cutting out the media filter and connecting directly with readers. Journalists once working at big mainstream media outlets can launch their own niche topic sites. Mainstream news outlets have come to find that no matter what they report on, it's likely a web site exists devoted to that topic, or a narrow slice of that topic. And the niche site is probably covering it in greater depth.

In a March 2009 story headlined "Niche websites buck media struggles," *The Wall Street Journal* examined a number of web content start-ups such as SB Nation, which are "recording sharp gains in visitors and in many cases revenue" by creating and aggregating content about subjects like sports, business and health. The sites,

said *The Journal*, "are outpacing other sites on similar topics through business models that allow them to create niche content with little financial investment." SB Nation, owned by SportsBlogs Inc., recruits bloggers and aggregates and organizes their blogs under the SB Nation umbrella, and pays them a percentage of the advertising revenue earned by their blog. SB Nation hosts more than 200 blogs, most of them focused on individual teams across major sports. Keeping costs to a minimum is critical to the whole concept. "This model only works if you have a cost structure to make it work," SB Nation chief executive Jim Bank told *The Journal*. Andrew Braccia, a former senior Yahoo! executive and partner at venture-capital firm Accel Partners, who sits on the board of SB Nation, told the paper: "Consumer engagement is shifting toward niche-content experiences. Three to five years from now, people will no longer be drawing a distinction between traditional forms of publishing and what we know as blogs today."

The threat created by new online niche competitors extends across every level of mainstream news organization – local, regional and national. Former Northcliffe electronic publishing chief Keith Perch saw it coming in 2004. The newspaper executive, who was in charge of regional and themed news websites across Great Britain for one of the country's largest publishers, had predicted (see Chapter 2) that his greatest competitive threat in the future would come from smaller, not larger, news providers. Asked in 2004 what he saw as the most significant threat to his operation he answered: "A guy with a video camera attending his son's football match." Perch believed that publishing content online had become so easy that the web would soon host a vast number of sites that would compete with his. They wouldn't be general news sites like newspapers, with their mix of council meetings, local crimes, movie listings and sports. Instead, each site would cover some very small, niche topic about local life – but that site would be able to cover that one narrow topic in greater depth than any of Northcliffe's regional newspapers.

And so it came to pass – for Northcliffe newspapers and many other local mainstream news providers. Regardless of whether it's kids' league football games or local planning commission issues, there is often a web site that covers it. Niche sites are changing the way consumers obtain information and transforming the economics of the news industry. The question is how mainstream news organizations can compete. News industry publishers and pundits continue to debate how to get consumers to pay for online content. New and convenient distribution models such as electronic reading devices may be part of the answer (see Chapter13). From a content point of view, producing hard-to-obtain information that some segment of the audience values highly appears to be one of the most likely routes.

But how to do it? General circulation newspapers have launched all kinds of online niche news sections about moms and schools and entertainment and sports. But aside from a few examples, such as *The Milwaukee Journal Sentinel's* niche site about the Green Bay Packers football team, "Packer Insider" ($6.95 a month or $44.95 a year), few have attracted a paying audience.

"The key is not to take your most popular stuff and put it behind a pay wall," *Wall Street Journal* online executive editor Alan Murray told the Nieman Journalism Lab in an April 2009 interview."That's been the mistake that some people have made in the past. You know, this is the story that most people want to read; therefore, that's the one we're gonna make them pay for. That's not the right answer. The broad, popular stuff is the stuff you want out in the free world because that drives traffic; that builds up your traffic, and you can, of course, serve advertising to that audience. What you have to think about is sort of narrower groups of interest where the interest might be deeper and more intense and therefore might make people willing to pay for it."

The Journal, the most successful newspaper at attracting online subscribers, offers a hybrid paid/free model online, with all users allowed free access to stories in categories such as politics, arts and opinion. But only subscribers to WSJ Online are permitted access to other stories, particularly the key financial coverage. "Look," Murray told Nieman Lab, "the truth of the matter is there are tons of people out there paying large amounts of money, billions of dollars, to buy information every day. [...] I mean, there were a couple of guys in Texas who started the ultimate news service on the oil business with oil rig counts and all that. They sell it. They're driving around in Mercedes. Well, why didn't *The Houston Chronicle* do that? Why did that have to be some outsider? So the question is to find the information that has an enormous value to not necessarily a big group of people — maybe it's a small group of people — but enough value that they're willing to pay for it. And I think those opportunities are out there for lots of newspapers."

That sentiment is shared widely. In a provocatively-entitled commentary headlined "Why journalists deserve low pay," media professor Robert Picard noted: "Across the news industry, processes and procedures for news gathering are guided by standardized news values, producing standardized stories in standardized formats that [are] presented in standardized styles. The result is extraordinary sameness and minimal differentiation." In his commentary, which appeared in the *Christian Science Monitor* in May 2009, Picard wrote that "Wages are compensation for value creation. And journalists simply aren't creating much value these days. Until they come to grips with that issue, no amount of blogging, twittering, or micropayments is going to solve their failing business models."

Picard's argument is not really that journalists should get paid less, but rather, in a digital world of commoditized news, "If the news business is to survive we must find ways to alter journalism's practice and skills to create new economic value. Journalism must innovate and create new means of gathering, processing and distributing information so it provides content and services that readers, listeners, and viewers cannot receive elsewhere. And they must provide sufficient value so audiences and users are willing to pay a reasonable price. "He lists as an example the possibility that the *Boston Globe* could become a "national leader" in education and health reporting because of the many universities and medical institutions in its coverage area. Likewise, he suggested *The Dallas Morning News* could provide specialized coverage of oil and energy, *The Des Moines Register* could become the leader in agricultural news, and the *Chicago Tribune* in airline and aircraft coverage. "Every paper will have to be the undisputed leader in terms of their quality and quantity of local news," Picard wrote. But he also warned about the pitfalls of trying to develop niche content, pointing out that "those who are most highly interested in that information and knowledge are able to harvest it themselves using increasingly common tools."

Newspapers seeking to exploit major industries in their region should consider the experiences of others who have tried. The *San Jose Mercury News*, in the heart of California's Silicon Valley, was once the go-to source for news about high-tech start-ups and the venture capital funding them. But a slew of blogs covering the same turf and written by industry insiders and former insiders, particularly start-up bible TechCrunch, became the new go-to sources for technology news, leaving the *Mercury News* to scramble to keep up with all the new competition. TechCrunch, launched by former technology lawyer Michael Arrington from his home in 2005, quickly became one of the most influential business sites on the web, with a steady stream of scoops, including Google's acquisition of YouTube. The blog was generating $200,000 a month for Arrington in 2007, according to a *Wired* profile that year. Since that article appeared, Arrington has expanded TechCrunch into an empire of related websites and industry events. For the *Mercury News*, the onslaught of nimble, niche competitors, in tandem with its own staff and budget reductions, saw the paper's reputation shrink.

Even *The Washington Post*, with its reputation for journalistic excellence and its core focus on covering the US government, may already be too late to exploit its historic market power to create revenue-generating niche sites about government activities. In a February 2009 story called "The new Washington press corps," the Project for Excellence in Journalism (PEJ) detailed how the number of main-stream news outlets and journalists covering Washington had plummeted since

the mid-1980s – with much of the reduction coming between 2007 and 2009. Yet, the PEJ said, the overall number of journalists covering DC has stayed about the same because of a dramatic rise in the number of journalists writing, not for the general public, but for "specialty audiences whose interests tend to be both narrow and deep." The PEJ noted that "as the mainstream media have shrunk, a new sector of niche media has grown in its place, offering more specialized and detailed information than the general media to smaller, elite audiences, often built around narrowly targeted financial, lobbying and political interests. Some of these niche outlets are financed by an economic model of high-priced subscriptions, others by image advertising from big companies like defense contractors, oil companies, and mobile phone alliances trying to influence policy makers."

In the past, said the PEJ report, "mainstream media journalists – and much of Washington itself – looked down upon the work of these publications as both boring and peripheral to the "real" challenge of covering Washington politics. The dream of many niche sector journalists was to land work with a major mainstream outlet. Not any more. Today, many of Washington's most experienced and talented journalists no longer explain the workings of the federal government to those in the general public, but to specialty audiences whose interests tend to be both narrow and deep. These are publications with names like *Climate Wire, Energy Trader, Traffic World, Government Executive* and *Food Chemical News*. Their audiences vary, but most readers find the content increasingly important – even crucial – for their job, their business and their industry. Because of this, readers – usually with employer support – are willing to pay significant subscription fees." Some are profitable even with small readerships and little advertising. Not all of the niche sites covering US politics and federal policy are aimed at a limited readership with deep pockets, however. *The Politico*, launched by two former Post political reporters to cover the 2008 US presidential election, had built a monthly readership of nearly four million unique users by the middle of 2009, according to Quantcast figures, with political news coverage that is an "obsessive-compulsive mix of trade journal, Twitter feed, and, quite literally, real-time chat with senior-most newsmakers and leakers," according to media critic Michael Wolff in a July 2009 *Vanity Fair* profile. Wolff noted that *Politico* was unable to support its staff of about 100 on the revenue it received for advertising on its web site (it does not charge for content.) But he said that the site's "Internet caché" had enabled it to launch a print edition with a "special-interest-size" circulation of 32,000 that has doubled *Politico*'s revenue. The print edition is published daily when Congress is in session, weekly when it is not and is available for free at locations around Washington, DC and by paid subscription for home delivery and delivery outside Washington.

Wolff quoted *Politico* CEO Fred Ryan as saying Politico was likely to break even in 2009. (Read more about *Politico* in the next chapter.)

Another good example of a niche site carving out its own place in the Washington news universe is Talking Points Memo, the popular and influential left-leaning investigative blog that uses crowd-sourcing, incremental journalism (filing short, updated reports as a story progresses), tips from the site's highly knowledgeable audience of insiders and experts and video reports, along with old-fashioned reporting techniques to keep his loyal readership engaged. Founder Joshua Micah Marshall and his team are not stereotypical bloggers commenting on what mainstream news outlets report. They won a prestigious George Polk Award in 2008 for their work uncovering the firing of eight US Attorneys by the Justice Department for apparent political purposes. The stories led to the resignation of George W. Bush-appointed US Attorney General Alberto Gonzales. Talking Points Memo relies mostly on advertising revenue for its income, but also takes donations from readers. On some occasions, Talking Points Memo asks its readers for donations to fund specific projects. At a time when mainstream news outlets have been downsizing, Talking Points Memo has boosted its staff numbers. In June 2009, the site began advertising for seven new editorial staff (reporter-bloggers, writers and editors) for its New York and Washington offices. Knowing that it reaches a highly influential readership inside Washington, TPM began geo-tagging some ads in 2008 so that advertisers willing to pay premium rates could specifically target that elite audience.

The rise of these niche Washington sites contrasts with the marked decline of mainstream news outlets covering the US capital. The PEJ report cited figures showing that a mere 32 American newspapers representing 23 states had bureaus in Washington in 2008 – fewer than half the number in the mid-1980s when 71 newspapers, representing 35 states had DC bureaus. Corporate bureaus, representing all the newspapers in a chain, also more than halved, from 551 to 262, the report said.

The ability of niche business publications to generate profits – even through the highly elusive online subscription business model that mainstream news providers so desperately crave– can also be found beyond Washington and government-focused publications. An example is Informa, the London-based specialist publishing and events company. Informa's fortunes have fluctuated over time – it was the target of a £2.15 billion takeover bid in July 2009. But a look at the way it generates substantial revenue and profits from selling subscriptions for online content is instructive. Informa publishes more than 2,500 subscription-based trade magazines, academic journals, real-time news services and databases of commercial intelligence containing – what it calls "high value content" in a wide variety of subject areas.

"At the heart of every Informa product and service is research-based, proprietary information for a targeted, expert audience," the company said. Informa's publication categories range from the "arts and humanities through social sciences to physical science and technology; from the professional domains of finance and the law through to commercial fields such as telecommunications, maritime trade, energy, commodities, and agriculture," Among the vast array of titles is the nearly 300-year-old bible of the shipping industry, *Lloyd's List*.

The company, which organizes about 10,000 conferences annually and offers consulting and training services, showed adjusted profits of £172.5 million for 2008 on revenue of £1.3 billion. Publishing accounted for almost half (48 percent) of Informa's revenues for the year and 57 percent of adjusted profits. About 30 percent of total company revenue came from subscriptions, 15 percent from copy sales and 3 percent from advertising. As a sign that Informa was adjusting its products for the digital age, 70 percent of its publishing revenue was derived from electronic formats, which made up 38 percent of the company's entire revenue for the year. *Lloyd's List* is a good example of how Informa is using online publishing to boost revenues. The venerable shipping publication, which operates in a highly competitive market of maritime publications, had seen its print subscription numbers falling since 2000 from about 11,500 to 7,500. In fact, eight editorial positions were eliminated from the newsprint edition in August 2009 amid rumors *Lloyd's* may go web-only. But the online edition experienced a steep rise in subscriptions over the decade to 2009, from negligible to around 10,000, according to a former Informa executive. Both the print and online editions cost just under £1,000 a year in the UK, with prices varying elsewhere in the world. The online edition also offers some free, advertising-supported news sections. Being able to post stories instantly around the world has created a new market for *Lloyd's List* among readers who were too far from the UK to receive the print edition in a timely and useful way."The biggest subscriber growth has come from the Asian sector and the Middle East," said the former executive, who asked not to be named.

Lloyd's List also has found ways to generate new revenue by carving the publication's content into smaller niches for specific subscribers and by selling access to continually updated online databases, he said. The publication was able to provide an extremely narrow niche service for readers only interested in topics such as maritime law, marine insurance or logistics. So the lesson here for news providers is to think in terms of unbundling and versioning (see Chapter 10). The former Informa executive gave an example of how *Lloyd's List* generated revenue from selling database access: "Imagine you're a ship owner exposed to the vagaries

of oil prices which account for up to 50 percent of the cost of running your ship. Given that ship costs, say, $60,000 a day to run, you need to identify trends in the bunker fuel market for heavy fuel oil that's running your ships. You need to know if it's cheaper to take on fuel in Rotterdam or Singapore or Alabama. There are lots of services out there tracking oil prices, but you want one that's specific to the grade of fuel you operate your ships on. Only a very specialized publication is collating this vital information, tracking it and offering you the chance to make your prediction. They're offering it continuously as part of your subscription. You need it continuously, because you have to be able to tell your ship master to soldier on to Singapore with half a tank, because it's going to be cheaper."

The lesson here is in identifying ultra-niche content that some segment of the audience finds useful, if not critical, and filling that need. And it is essential to keep the cost of producing, marketing and distributing that content aligned with realistic revenue projections. That might seem like ridiculously obvious advice, yet it often goes unheeded.

Passion play

Developing niche content sites that news consumers will value enough to pay for, or that build a desirable readership segment that advertisers will pay a premium to reach, is a productive business model. But identifying and producing that content is difficult at best, particularly for organizations accustomed to supplying general news content. While niche content abounds in print and online, the content that generates revenue is almost entirely comprised of niches related to financial and professional information. Realistically, not many news organizations will be able to allocate the resources needed to develop that kind of material.

However, it is possible to build loyal, segmented audiences without having to create resource-intensive business-related sites through a concept that could be called "passion publishing." These are consumer niches built around communities of people engaged intensely in an activity or special interest. The world of computer gaming is one of the best examples. Millions of dedicated gamers seek news and information, tips and tricks, and all the latest developments in the gaming world. But its vast and high-spending audience also makes the computer games field among the most crowded and competitive in the passion niche market.

Nonetheless, this is where Yahoo! chose to dive in when it launched a passion content initiative called "Brand Universe" in early 2007. In a move watched closely within the online content industry, Yahoo! announced that it would create at

least 100 websites in the coming year, each of which would be built around a single entertainment property that had built a loyal and passionate fan base. These sites would take advantage of all of Yahoo's disparate properties to pull together various strands of content about the subject in one place. That is, stories would be aggregated on the subject from Yahoo! News, photos from Flickr, plus bookmarks from Delicious and easy access to discussions on Yahoo!'s message boards.

The websites would be supported by advertising, which could be targeted at a very specific audience. In January 2007 *The New York Times* interviewed Vince Broady, head of games, entertainment and youth at Yahoo!, about the rationale behind Brand Universe. Broady said that while Yahoo! had a wealth of entertainment content, finding the material about a specific attraction was not always intuitive. "We don't connect the dots for our users around those brands," Broady said. "Brand Universe is designed to fix that problem. What we are really trying to do is create environments where fans of brands can hang out when they are online."

Yahoo! said it would build its Brand Universe sites without seeking permission from the creators of the brands, saying it doubted any of the content creators would object, but if they did, the sites would be taken down. The first Brand Universe site to appear was built around the Nintendo Wii and Yahoo! announced that the next six would center on Harry Potter, the video games "Halo" and "The Sims," the television programs "The Office" and "Lost" and the entertainment juggernaut "Transformers." Despite initial praise from inside the online content community for the Brand Universe concept, Yahoo! killed the project within a year for reasons that were not entirely clear. Only a handful of additional sites had been built. *Adweek* magazine reported being told by Yahoo! that the Brand Universe destinations did not fit into the broader strategy laid out by CEO Jerry Yang for Yahoo! to be the "starting point" of consumer Internet activity. Keeping with that focus, Yang had said Yahoo! would curtail projects not central to that vision or its advertisement network strategy. "We're going to focus on our core media assets at Yahoo!, which include news, finance, sports and entertainment," company spokesperson Brian Nelson said.

Future publishing: Media with passion

One of the biggest publishers of passion content is UK-based Future Publishing, which operates in the UK, US and Australia, targeting what chief executive Stevie Spring likes to call "prosumers" – professional consumers. "These are people who define themselves as a gamer or a cyclist or a guitarist," said Spring in an interview.

"We are about content that is written by and for enthusiasts." The special interest media group produces more than 180 publications, websites and events in content areas such as computer games – its dominant segment – along with film, music technology, cycling, automotive and crafts such as knitting and crocheting. The publisher lists its biggest-selling magazines as tech-focused *T3, Total Film, Digital Camera, Fast Car, Classic Rock, Guitar World, Official Xbox Magazine, Official Playstation Magazine, Nintendo Power, Maximum PC* and *MacLife*. Spring, who spent most of her career in advertising, was hired to take over Future in 2006 after the previous chief executive's ambitious expansion plans resulted in a series of profit warnings. She quickly closed or sold dozens of magazines, shut down operations in France and Italy, and began focusing on building a greater digital presence.

The company pulled out of its financial nosedive and reported increasingly stronger results until the depressed advertising climate hit. Revenue for the half year ending March 2009 was £76.6 million, down from £78.3 million the previous year, with operating profits of £2.6 million, down from £5.2 million. Nonetheless, the emphasis on digital growth produced increased digital revenues. Future's online advertising revenue comprised about 25 percent of the company's total advertising income as of mid-2009. All of Future's print magazines have companion websites, Spring said. In addition, the publisher has a portal strategy of genre-themed sites, under the "Radar" umbrella such as BikeRadar, GamesRadar, MusicRadar and TechRadar.

Spring said Future's specialist publications and websites engaged readers in ways that were difficult for competitors to replicate. First, few publications can match the depth and expertise of Future's portfolio. "We hire experts and teach them to be journalists." As a result of a high level of expertise, readers get to trust the publications and engage with them. By engagement Spring meant users trust what they are reading or viewing and are likely to act on something they have just read. This also creates another high barrier to entry for competitors. Audiences perceive that Future's publications contain expert content from "prosumers" who are passionate and extremely knowledgeable about whatever the topic. Spring also cited Future's commercial partnerships as another market power advantage. The media company works closely with many of the biggest organizations in its topic areas, including producing content and official magazines for companies such as Sony and Odeon cinemas. (Obviously, these kinds of potential conflict-of-interest relationships would need delicate handling from general news providers.)

Rather than simply wait out the economic downturn in 2008 and 2009, Future has been experimenting with new content and revenue models that tap into the passion and commitment of its audience. "In a creative organization you have to be brave," said Spring. "We're trying everything." Future has been expanding

its network of advertising-supported Radar websites, adding PhotoRadar in June 2009 to its current lineup. The Radar network of sites aggregates content from Future's own special-interest publications. Adding further to its digital portfolio, Future has launched dozens of narrowly-focused content aggregation sites it calls "Blips," which the company promotes as "the web's most popular news, rumors and videos." Those produced so far – and many more are promised – are organized into categories such as sports, entertainment, technology, business and politics, music, technology and lifestyle. Within those categories are content aggregation sites such as "WallstreetBlips," "CricketBlips," "ComicsBlips," "MensfashionBlips," and "NewYorkBlips," which, along with "LABlips," suggests an increased geographical dimension as well as a content dimension. Like the Radar network of sites, the Blips sites are advertiser-supported. But unlike the Radar sites, the Blips sites are aggregated from hundreds of external websites and blogs through a combination of search algorithms, human editors and reader input. They are then ranked by a mix of reader votes, links and age (with newer stories ranking higher). According to Future, the Radar and Blips sites were attracting 27 million unique visitors a month in mid-2009, up from 12 million a year earlier, before the Blips were launched. Those user figures compare with an average of about 30 million unique users for the UK's *Guardian* and about 20 million for *The New York Times*.

Online subscription revenue

Future also has launched initiatives designed to attract revenue from other sources besides advertising. In June 2008, the publisher launched *Qore*, an interactive online gaming magazine available only through the PlayStation Network via the broadband Internet connection on Sony PlayStations. The monthly magazine, produced by Future under license from Sony Computer Entertainment America, features news, video and interviews related to upcoming or current PlayStation game releases as well as exclusive access to game demos. As part of its deal with Sony, Future has exclusive rights to sell advertising for the magazine. Initial advertisers included Burger King, Universal Pictures (Incredible Hulk) and games companies Activision (Guitar Hero: Aerosmith) and Codemasters (Grid). But what really makes *Qore* different is the pay wall component – users are charged $2.99 per episode or $24.99 for a yearly subscription.

Chief executive Spring believes the ability to charge for *Qore*'s content is related to the mindset that enables some other digital content providers to charge – as long as the content and the distribution mechanism exist outside

web browsers such as Internet Explorer and Firefox. Examples include music sold through iTunes, iPhone apps, ringtones on cell phones and newspapers and books through Amazon's Kindle e-reader. When people view online content through a web browser, said Spring, "they think that since they've already paid for access to the Internet, they should get free access to everything online." So selling content through games consoles circumvents that mindset. "It's a different medium," says Spring. "On a console, you're used to making payments."

Despite Spring's theory about why it is so difficult to charge for digital content through a web browser, Future launched a new project in July 2009 that does just that. The "Classic Rock Club," as the new initiative is called, is designed to tap into the passion for music among the readers of Future's print magazine, *Classic Rock*. The monthly magazine, which bills itself as "The UK's High-Voltage Rock 'n' Roll Magazine," was selling for £4.50 an issue in 2009 and had about 70,000 subscribers. For £3 a month, subscribers to the music club get recommendations and reviews of upcoming albums and artists, handpicked by the magazine staff, and sent straight to their computer desktops. And – and this is the innovative part – club members also get the albums sent to their computer desktops before they are officially released and can listen to them as often as they want for up to 10 days. Then, once the albums are released for sale, subscribers will be offered the opportunity to download the albums or buy the CD. Future launched the service using proprietary software from UK online content specialists Jack Brand that can distribute content online securely for limited periods of time. "We know that *Classic Rock* readers are hungry to hear new music, said Scott Rowley, editor-in-chief of *Classic Rock*. "Now readers don't just have to take our word for it – or make judgments based on 30 second samples – we bring the album straight to their desktops and they can live with it for a week." John Hazell, commercial director of Jack Brand, continued: "Our belief is that passionate consumers are happy to pay a little to have albums recommended by editors they trust delivered directly to them. The club successfully promotes the music encouraging purchase, so everyone benefits."

For general news organizations looking to replicate the opportunities offered by niche and passion content, the trick will be to find a cost efficient way to develop content that targets specific segments of readers and engages them in ways that go beyond commoditized news provision.

The next chapter considers the benefits of partnerships between established media and university journalism programs to produce new ways to practice journalism.

Partnerships – adding value

Summary

Partnerships offer one way to share costs, if all parties win in the arrangement. This chapter begins with a study of the successful partnership between *The New York Times*, PBS and the graduate school of journalism at the University of California at Berkeley and considers if this could be replicated. The chapter also looks at other innovations such as GlobalPost and Politico, and examples of media houses that are sharing content where it is mutually beneficial.

In a widely discussed opinion piece in *The New York Times* published in January 2009, David Swensen and Michael Schmidt proposed newspapers should become endowed institutions like universities. "Endowments would enhance newspapers' autonomy while shielding them from the economic forces that are now tearing them down," the pair wrote in an article headlined "News you can endow." It is understandable the authors should think in terms of universities because Swensen is the chief investment officer at Yale, which has one of the biggest endowments in the US, and Schmidt is a financial analyst at the university. An endowment of the country's "most valued sources of news" would free them from the grip of an "obsolete business model" and offer quality newspapers a permanent place in society, Swensen and Schmidt wrote. "Endowments would transform newspapers into unshakable fixtures of American life, with greater stability and enhanced independence that would allow them to serve the public good more effectively."

Bill Keller, executive editor of *The New York Times*, discussed the endowment idea in a Q&A published on the paper's web site the same day, noting it had

provoked a range of letters to the editor. "In my view, we should give serious study to anything that holds promise, but there are serious downsides to a not-for-profit model. For one thing charity, however well intentioned, can come with strings attached. For another, endowments are no insulation against economic hard times. (Just ask universities.)" Keller said competition was "mostly" good for journalism. "True, the scramble for readers' attention may contribute to tabloid sensationalism and press-pack feeding frenzies. But it also serves as a goad to aggressive reporting – and a check on the accuracy of our facts and analysis."

The *Columbia Journalism Review* criticized the Swensen and Schmidt article, suggesting an endowment would compromise newspapers' neutrality. But would it? As Megan Garber noted in the comments section of the *CJR* web site in February 2009, the hallmark of a good journalist is not their lack of prejudice, but their ability to transcend bias for the sake of the story. "In the same way, good journalism doesn't come from a journalist's being sheltered from commercial interests – such insulation is nearly impossible – but rather from his ability to rise above those interests. And if reporters at a given institution are able to go about their days learning new information and distilling it for readers – with no concerns save those of their stories – then that's what matters; the origins of the money allowing them to do that matter very little, I think, as far as ethics are concerned."

Charlotte Hall, president of the American Society of Newspaper Editors, put it another way: "A new kind of firewall would be needed to assure independent reporting and unencumbered editing." Jan Schaffer, executive director of the J-Lab at American University in Washington, said she saw nothing new about foundations supporting for-profits. Between 1993 and 2002, as director of the Pew Center for Civic Journalism, Schaffer said she funded 120 pilot projects with mainstream news organizations, many of them profit-seeking. "I would suggest that many news organizations have been open to this idea for the last 15 years," she said. Most newspapers appeared comfortable with a non-profit partner. They seemed happy to work with non-profits like ProPublica, or the Center for Public Integrity, or the Pulitzer Center on Crisis Reporting.

Chapter 4 discusses this idea. We bring up the idea here to introduce another option: the idea of partnerships, including those between universities and media companies. With successful partnerships, all parties benefit. The first example we use is the relationship between the graduate school of journalism at the University of California at Berkeley, and the PBS documentary series Frontline.

The graduate school of journalism at Berkeley has a long-established relationship with the PBS Frontline documentary team in California and *The*

New York Times. It has been a major success in terms of quality journalism. Programs aired on Frontline have won all of journalism's major prizes. The university-media group relationship works because students supply cheap labor, but those students get to work for a prestigious media company and put it on their resumes. Lowell Bergman is the Logan professor at the university and also reports for Frontline. He is the only reporter in American history to have won print and broadcast's major prizes, the Pulitzer and the Polk/duPont/Peabody awards, for one story. He was involved with a joint project called "A Dangerous Business" involving *The New York Times*, Frontline and the Canadian Broadcasting Corporation that was awarded the Pulitzer Prize for public service in 2004. The previous year the program received a George Polk award, an Alfred I. duPont-Columbia University award, and a George Foster Peabody award. In 2004 the program also won the Sidney Hillman prize. "A Dangerous Business" evolved out of Bergman's investigative reporting class in 2002. It detailed a record of horrendous worker safety violations coupled with the systematic violation of environmental laws in the iron sewer and water pipe industry.

Frontline gives its journalists and filmmakers the time needed to research a story thoroughly, and the time on-air to tell the story in a compelling way. The program has production studios in Boston on the east coast and San Francisco on the west. The California office is opposite the graduate school of journalism at the University of California in Berkeley. Students in Bergman's investigative journalism class become researchers for Frontline. The course is called J260 Investigative Reporting for Print, TV and the Web. "Every year we have one or more projects involving *The New York Times* and/or Frontline, Bergman said. "Projects with the students' roles credited have received the highest journalism honors." Bergman emphasized that good journalism education required that students practice journalism in a real-world situation. "I make the course relevant to the outside world and the students thrive," he said, noting the high caliber of people who applied to do the two-year MA in journalism program at Berkeley.

One of the authors audited the fall 2008 class. Guest speakers included Bob Baer, a former CIA case officer in the Directorate of Operations from 1976 to 1997, who served in Middle Eastern countries, including Iraq and Lebanon; and Tim Weiner of the *New York Times* whose history of the CIA, *Legacy of Ashes,* won a 2007 National Book Award. Weiner talked about national security reporting. Baer spoke about tracking corruption abroad as well as corrupting foreign officials. He wrote *See No Evil: The True Story of a Ground Soldier in the CIA's War on Terrorism* that was the basis for the feature film Syriana. Mike Kortan, Chief of the National Press Office of the F.B.I., visited the class, as did investigative reporter Marlena

Telvick, deputy director of the university's fellowship program in investigative reporting. Telvick served as an adviser to the class.

Bergman said the Logan family endowed his professorship, and his investigative journalism course received money from *The New York Times*, individual donors who believed in what he was doing, and foundations such as the Sandler foundation (which funded ProPublica – see Chapter 4). "So money comes from outside the university budget." Frontline has been the flagship public affairs series on American public television since 1983. When it was born the prospects for television news documentaries looked grim. Pressure was on network news departments to become profitable, and the spirit of outspoken journalistic inquiry established by programs like Edward R. Murrow's "See It Now" and "Harvest of Shame" had surrendered to entertainment values and feature-filled magazine shows. America's PBS decided to continue a tradition of quality broadcast news. Frontline remains the only regularly scheduled long-form public affairs documentary series on American television.

Bergman said the goal of his investigative journalism class was to provide an appreciation and understanding of this unique form of reporting. "The class emphasizes the history and role of investigative reporting as well as skills and techniques needed to do it." The steady stream of guests represented the kinds of people journalism students needed to cultivate as sources. "Instruction focuses on developing sources, techniques needed to find and report stories as well as the legal issues surrounding confidentiality and other issues." Students were required to check out leads, contribute to group projects and participate in projects for television, the web as well as print, Bergman said. The aim was to get students to develop a multimedia approach to reporting. Instructors and guest lecturers also came from the Center for Investigative Reporting, based near the university. The center's managing editor, Robert Rosenthal, and Frontline producers talked about the steps required to put together in-depth, multi-platform investigations. "These presentations include a review of past [Frontline] films and print stories that were in part reported and produced in the seminar," Bergman said. Frontline also has a web-based offshoot called Frontline/World. It was a model for in-depth investigative reporting on the web, Bergman said. Its web site is http://www.pbs.org/frontlineworld/.

Frontline/World is a national public television series that focuses on global events, covering countries and cultures rarely seen on American television. Frontline producers developed it in conjunction with public television stations KQED in San Francisco and WGBH Boston. Each episode of Frontline/World features two or three stories told by a diverse group of reporters and video journalists. They mostly use portable digital cameras. When necessary, Frontline reporters film

surreptitiously. An extensive web site backs up the program. All broadcast stories can be found on the web site, which received an award for excellence from the Online News Association and Columbia University Graduate School of Journalism in 2002. The web site also publishes web-exclusive stories by journalists enrolled in or recently graduated from leading graduate schools of journalism, as part of a Frontline/World fellows program. Candidates need to submit detailed plans to report an international story not covered in the mainstream media. Journalism schools that agree to participate in the program are responsible for recommending candidates. Applications from individuals are not considered.

The graduate school of journalism in Berkeley organized a major conference on how to fund investigative journalism in April 2008. The opening panel consisted of *The New York Times'* Keller; Len Downie, at the time executive editor of *The Washington Post;* Laurie Hays, editorial page editor of *The Wall Street Journal;* David Boardman, managing editor of *The Seattle Times* and Clara Jeffrey, editor of *Mother Jones* magazine. The moderator was Steve Engelberg, managing editor of ProPublica. The *Journal's* Hays said investigative journalism was at the core of all her paper's reporting. "Technology is making it easier," she said, relating an anecdote about the scores of hours *Washington Post* reporters Woodward and Bernstein spent sorting paper cards in a library catalog when they covered the Watergate story. "It would be so much easier now." Keller said the Internet provided a place and tools for a new form of investigative journalism. Downie of *The Washington Post* said major news organizations needed to explore partnerships, with the aim of sharing resources. Boardman said the fundamental question was how to find a business model to pay for all forms of quality journalism. "Maybe we need to move beyond the advertising model," he suggested. He pointed out the combined web and print audience of local newspapers in most American cities remained the most popular news source. Bergman, who organized the conference, agreed the key task was finding new business models for journalism. Paul Steiger of ProPublica, who was in the audience, said the newspaper business was going through what the music business had endured with the move to digital. The changes produced "tons of opportunities" for young journalists, though he noted that jobs would not be as well paid as in the past.

Sheila Coronel, director of Columbia University's investigative journalism program, said university-media partnerships were crucial to the media's future. "Most of the watchdogs we have are middle aged, like me," she said. "We need watch puppies, and this is where universities can play a role." Media partnerships were happening at schools across the US, Charles "Chuck" Lewis, founder of the Center for Public Integrity and president of the Fund for Independence in

Journalism, told a conference on investigative journalism at Columbia University in New York in early 2009. In recent months partnerships had launched in Wisconsin, Illinois, and the state of Washington, as well as in Boston, Los Angeles and Miami, Lewis said. More established models apart from Bergman's work at UC Berkeley included David Protess' death row innocence project at the Medill School at Northwestern University. Lewis was the founding executive editor of the Investigative Reporting Workshop at American University in Washington, DC, which began a project similar to Bergman's course in spring 2009. In June 2008 Lewis told the Mediashift blog he had been studying the economics of journalism for two years. "Like everyone, I've been to six or eight symposia and conferences on the future of journalism. I've never been in AA [Alcoholics Anonymous], but I imagine this is what their meetings must be like. I'm a doer, not a bemoaner, and I'm tired of bemoaning, I want to create." The investigative journalism workshop at American University was a platform for many things to follow. See http://www. investigativereportingworkshop.org/ for more details.

Another example of partnerships getting much attention in early 2009 was GlobalPost, which launched January in, 2009. The Boston-based site started with $8.5 million from private investors. It has 65 correspondents around the world and offers foreign news to media companies looking for alternative options. The news organization signed a deal with CBS News in September 2009 giving the broadcasting giant access to GlobalPost's content and correspondents. Part of the site is advertising supported. Philip Balboni, president and chief executive, said GlobalPost relied on marketing partnerships to generate subscriptions and hoped to have more than 2,000 by the end of 2009. He also planned to sell a separate paid section of the site, known as Passport. It launched in mid-March 2009. Passport costs up to $199 a year and members can commission GlobalPost correspondents to write exclusive reports or even breaking news via email.

Balboni was one of founders of the New England Cable News network. He said consumers should pay for at least part of their news, something he learned from the cable television business, which is supported by subscribers as well as advertisements. The next step, he said, was to prove a hybrid model could work in the marketplace. Passport subscribers can also suggest story ideas, said executive editor Charles Sennott, a GlobalPost founder. "If you are a member, you have a voice at the editorial meeting." But the site would decide which stories it pursued. *The Daily News* in New York and *The Boise Weekly* of Idaho carry GlobalPost reports and use its correspondents. Harvey Nagler, CBS Radio News's vice president, said CBS Radio had signed a contract whereby it could call on GlobalPost correspondents to cover breaking news, as a backup to its own reporters. PBS

Television's Worldfocus news program features reports from GlobalPost correspondents. They carry Flip digital video cameras when in the field. The cameras cost about $130.

GlobalPost correspondents' base pay for four stories a month is $1,000. But they also get shares in the venture and are paid extra for Passport work. The site had 500 applicants for positions, Sennott said. In January 2009 Fons Tuinstra wrote on the Poynter web site that $1,000 a month was enough for rent in Shanghai, but not much more. The number of foreign correspondents in China had expanded rather than declined. Most were "economic refugees" from other parts of the world where job prospects were declining. GlobalPost correspondents in Hong Kong and Tokyo could only survive by having a wealthy partner or another day job. GlobalPost did not seem to be investing in setting up its own corps of correspondents. "This might be a smart business strategy, but it is not helping people on the ground." GlobalPost's business model was a worry, Tuinstra wrote. "It's tough for stand-alone news sites to survive solely on web ads. Syndication depends on the willingness of media to pay up – more of a gamble now that the economic crisis is hitting hard. Their third revenue source, subscriber fees, is the most troublesome part. I suspect having a subscriber wall only drives away potential traffic (and, in the end, advertisers)."

In a *New York Times* article about GlobalPost in March 2009, Alan Mutter, the media analyst who writes the Reflections of a Newsosaur blog, described GlobalPost as "thoroughly modern" in its approach to revenue generation. Mutter praised the company for understanding that funding would not come solely from advertising or subscriptions. "They've identified every conceivable revenue stream I can think of." GlobalPost was a forward-looking project, Mutter said, but they key issue was the ability to attract a large audience. "I think everyone wishes them well because they are pretty close to what the future will be for news publishing."

In Washington, a new source of political news, Politico, has collaborated with Reuters to offer articles to newspapers and sell advertising on those newspapers' web sites. Politico offers newspapers a limited number of free articles. From December 2008 all newspapers that signed up to the Politico Network received daily content from Reuters. Newspapers can publish up to 10 articles and 10 photographs each day in the newspaper or on their web sites. Politico (http://www.politico.com/) retains the right to sell advertisements on the newspapers' web pages containing the Politico and Reuters articles. It shares the revenue with the newspapers. The partnership works for Reuters because, unlike America's Associated Press, Reuters has a relatively small staff in the US and does not cover local news at the saturation level the way AP does. Politico helps Reuters expand its coverage.

Politico's print edition has a circulation of about 32,000, and is distributed free on Capitol Hill and elsewhere in Washington, DC. The newspaper publishes a daily edition while Congress is in session, and usually one a week when Congress is in recess. Subscriptions cost $200 for domestic subscribers for one year, and $350 for two years. As with GlobalPost, most Politico journalists carry a video camera with them to every assignment. Politico's publisher and owner is Robert L. Allbritton, chairman of Allbritton Communications. The Allbritton Communications Company's main revenue source is a chain of television stations. Politico grew into one of America's most popular sources of news about Washington after it started in January 2007.

John Harris and Jim VandeHei left *The Washington Post* to become Politico's editor-in-chief and executive editor, respectively. Frederick Ryan Jr., a former aide to President Ronald Reagan, is president and CEO. Ryan currently chairs the board of trustees of the Ronald Reagan Presidential Library Foundation.

Harris said journalism had entered an entrepreneurial age. "That's been true of many professions for quite a while, and increasingly (and perhaps somewhat belatedly) it is true of journalism." The people who had the most satisfying careers were those who created a distinct signature for their work. They added value to the public conversation through their talents rather than "relying mostly on the reputation and institutional gravity of the organization they work for." Newspapers like *The Washington Post* or *The New York Times* have been insulated from the spirit of the age. "The reordering of the media universe because of the web has created opportunities for journalists of this sort that did not exist in an organization-driven age."

Harris said he had long puzzled over a phenomenon about many reporters: "They tend to be more interesting in conversation than they are to read in the paper." The typical newspaper story was written with a kind of austere, voice-of-God detachment. "This muffles personality, humor, accumulated insight – all the reasons reporters tend to be fun to talk to." When it was appropriate, Harris said, Politico would try to "loosen the style" and in the process "tell readers more about what we know, what we think, and why we think it."

Revenues and how they are shared vary, based on the volume of stories a newspaper partner chooses to publish. A newspaper can agree to use up to five Politico articles a week, and receive 50 percent of the advertising revenue that Politico sells on those web pages. If a newspaper publishes up to 10 articles a week it receives 40 percent of revenues. With up to 15 articles, it receives 30 percent.

Reuters also carries most of Politico's content on its news wires. The Politico Network launched in September 2008. "Admittedly, this is an experiment. But we're sure there's a need," Jim VandeHei, executive editor of Politico, told *The*

New York Times. Times reporter Richard Perez-Pena said Politico was pitching its network to newspapers as an important new revenue stream. "Newspapers fare best when they can sell their online ad space themselves, but they typically sell less than half that space. They turn the rest over to ad networks, which pay the papers a small fraction – often less than 5 percent – of what papers earn on their own." Roy L. Schwartz, Politico's vice president for business development and marketing, said Politico could get higher rates than the advertising networks by offering a specific and attractive AB audience, rather than the scattershot approach of the networks. "Where a large paper might get $20 for every thousand readers for an ad," he said, "we're targeting $10," he told *The Times*, with up to half that amount going to the newspaper.

Other forms of partnership

Late in March 2009 the *Los Angeles Times* and the *Chicago Tribune* announced plans to combine their foreign reporting operations. The Chicago-based Tribune Company owns both newspapers. In a memo to staff, *Chicago Tribune* editor Gerould Kern said the joint operation would be run from Los Angeles "where most of the foreign reporting and editing staff is based." The newspapers said they would share correspondents "placed strategically around the globe." At the time the *Chicago Tribune* had reporters in five overseas cities – Beirut, Islamabad, London, Mexico City and Moscow – while the *Los Angeles Times* had 15, ranging from Baghdad to London to Seoul. *Tribune* reporters in foreign bureaus not included in the new arrangements would be offered positions back in Chicago.

Changes to domestic reporting arrangements also occured. In November 2008 the Tribune Company consolidated all its Washington newsgathering operations into one bureau. That month Cissy Baker, the Washington broadcasting chief, took over as head of *Tribune*'s entire newsgathering operation in the capital. "One of our primary goals was to avoid duplication of stories," she said. "When a Washington reporter covers a story it will be produced for all of our newspapers, television stations and Web sites. We are one company with one Washington bureau that will serve all of Tribune's news needs."

On a smaller scale, the two main broadsheet dailies in Australia, *The Sydney Morning Herald* and *The Age* in Melbourne, owned by Fairfax Media, announced in February 2009 that they would establish a shared business desk for print and online. Rival News Ltd announced that same month it would consolidate production of all features for nine of its metropolitan daily and Sunday newspapers

at one desk in Sydney. The aim was to present a more uniform national offering across the mastheads and online, and ensure the features had a longer life in terms of exposure to audiences. Australian Provincial Newspapers, a regional publisher, announced in March 2009 the introduction of a central editing system for the entire group. Australian Provincial Newspapers owned 14 daily newspapers and 75 community weeklies as of mid-2009. Its "sub-hub" would operate out of the flagship *Sunshine Coast Daily* in Maroochydore in southern Queensland. Copy editors in the group were given options for new work arrangements, and the company said the change would not result in redundancies. Staff could edit from a remote location, relocate to Maroochydore or return to reporting.

Since March 2008 Ohio's eight biggest newspapers have been sharing content in a cooperative effort called the Ohio News Organization, or OHNO. They effectively formed a state-wide wire service, though they still belong to the Associated Press. Susan Goldberg, editor of *The Cleveland Plain Dealer*, one of the eight, said the state's tradition of fierce competition was changing. Other members included *The Columbus Dispatch*, *The Cincinnati Enquirer* and *The Toledo Blade*. Goldberg said her reporters liked getting bylines in newspapers across the state. "Our baseball writer is a fellow named Paul Hoynes. For the first time in *The Columbus Dispatch*, when they cover the Indians [baseball team], there's a byline of Paul Hoynes, and it says *Cleveland Plain Dealer* there in *The Columbus Dispatch*," Goldberg told NPR.

Goldberg said the state's newspapers had all made "pretty drastic cuts" in spending. But the Associated Press still charged her paper about $1 million a year. "That's a big hunk of my budget." Goldberg said the cooperative agreement allowed her newspaper to make some smarter choices. "We, and everybody else, have smaller staffs than we used to, and we've got to pick some priorities." And under the agreement, editors had the ability "to withhold stories from the others."

Meanwhile, the Asia News Network (ANN) celebrated its tenth anniversary as a cooperative in March 2009. The network was founded to reduce dependency on Western news agencies and to give readers an Asian perspective. Seven newspapers with a combined readership of seven million were the original members. By 2009 it had increased to 20 members with a readership of 30 million. Almost all member newspapers publish in English. ANN operates in one of the most vibrant and dynamic regions in the world. Asia and the Pacific account for almost 56 percent of the world's population and more than a third of global domestic product. Kishore Mabubhani, author of *The New Asian Hemisphere: The irresistible shift of power to the East*, said Asia was reclaiming the prominent role it played "before the surge of Western industrial and imperial power over the last two centuries." The World

Association of Newspapers reported that three of the largest markets for newspapers were in Asia: China with 107 million copies sold daily; India with 99 million copies; and Japan, with 68 million copies. Increased literacy rates and press reforms in some countries have fuelled media growth in the region.

All ANN members were free to publish news stories, analyses, features and photographs from the network members, said Paul Linnarz, regional media representative for the Konrad Adenauer Foundation, which helped form the association. Each network member contributes at least five stories every day. The newspaper that sourced the story, analysis or photograph is given credit in the publication that publishes them, along with the network. Members choose whether they publish. Any member can request photographs from any of the network. Members also exchange journalists, either on a bilateral basis or as a group. The network runs an extensive web site at http://www.asianewsnet.net/. Membership of ANN is by invitation. ANN's executive board, made up of a senior editorial manager from each member newspaper, has to agree unanimously for a new member to join ANN.

At most newspapers the commercial and editorial sides of the business know little about each other's work. This makes it difficult to combine skills and knowledge to create innovative products that news consumers would value enough to pay for. The next chapter considers ideas for creating a framework for new business models.

Microeconomic concepts – creating a framework for new business models

Summary

News organizations have followed the same basic business procedures and methods for decades. Changing social trends resulted in some alterations – afternoon newspapers no longer fit urban lifestyles and the content of sections for women has changed dramatically. But all in all, commercial operations within the news industry have stuck to established models. That all must change now. The ongoing transition of news production from print and broadcast distribution to digital platforms, which has made old business models obsolete, means that new ways of generating revenue must be created. In this chapter, we look at microeconomic concepts that could be adapted to the news business.

Editorial staffers at news organizations traditionally have had little involvement with the commercial processes of their employers, despite their critical role in producing the core product. This was by design. While this might seem incomprehensible in almost any other business or industry, the news business prides itself on not being like other businesses. News providers, with a few exceptions such as Britain's license-funded BBC, depend on generating profits for their survival. But they are also an unofficial public service, a watchdog representing the interests of ordinary citizens, free from the influence of governments, corporations and the rich and powerful. They are expected to maintain vigilance over some of the very advertisers whose expenditures keep news organizations commercially viable.

To deal with this inherent conflict of interest, news organizations have worked under a carefully constructed system that separates the editorial side of the business

from the advertising and other commercial divisions. In the US this is known as "separation of church and state." In the UK, where there is no separation between the Church of England and the government (the ruling monarch is head of both) the term Chinese Wall is still used. It refers to the impenetrability of the Great Wall of China, although the term is increasingly frowned upon because of concerns about racial stereotyping.

This system has not been perfect in barring outside influence into editorial policy. But it has generally worked well. However, the days when journalists could afford to remain willfully ignorant about the commercial operations at their own companies are over. As this book shows, the existing business models for the news industry are becoming obsolete and new models are needed urgently. News organizations must, of course, still retain their integrity and transparency, as well as avoid conflicts of interest and earn the trust of the public. But if they are to survive, then sources of commercial innovation cannot be hindered. Perhaps one reason newspapers have not developed new business models faster is that the commercial and editorial sides of the business had minimal understanding of each other's work and did not combine skills and knowledge to create innovative new information-related products that readers, viewers and online users would value enough to pay for.

Everyone in journalism must become more commercially minded and more entrepreneurial. The dilution of the separation between church and state in news organizations – the breaching of the Chinese Walls – will sound like heresy to some traditionalists. But combining the skills and knowledge of all departments could prove essential in developing new ways to fund journalism.

One way of looking for new solutions is to examine relevant concepts in microeconomics to see if they can provide a framework on which to build new business models for journalism. Microeconomics is the study of individual economic units such as businesses, consumers and markets, and how they interact. While the concepts below do not provide explicit solutions to the social, psychological, logistical and technological forces that have combined to break down existing journalism business models, they could be used as part of a toolkit to build new business structures.

Creative destruction: Explaining the transformation to the digital age

Austrian economist Joseph Schumpeter popularized the term "creative destruction" with his landmark 1942 book *Capitalism, Socialism and Democracy* in which he

uses it to explain his theory of how radical innovation builds economic growth as it destroys existing and outdated technologies, business models and companies. In a March 2002 article in *Wired* magazine about the economist's renewed high profile in the age of the Internet, the magazine said "Schumpeter argued that capitalism exists in the state of ferment he dubbed 'creative destruction,' with spurts of innovation destroying established enterprises and yielding new ones."

Schumpeter's concept of entrepreneurial drive destroying fading business models provided, and continues to provide, a framework for viewing the arrival of the digital era and its steady dismantling of so many industries. Remember cameras that used film? "The market must clean itself out by taking resources away from the losers, so it creatively destroys the losing companies and reallocates resources to the winning companies," *Wired* quoted then-US House of Representatives majority leader Dick Armey as saying. "That's really what's going on."

Nowhere is the concept of creative destruction more relevant than in the newspaper industry, where industry leaders have been accused of clinging to old methods and models, high profit margins and monopolistic practices, and not shifting resources into new technologies and models quickly enough.

Price discrimination: Discovering which customers will pay more than others

Price discrimination is the practice of selling identical, or similar, goods to different consumers at different prices. It is human nature that some people will place a greater value on a specific product than someone else might. As an extreme example, a parched man in a desert is willing to pay more for a bottle of water than a man in an office with a water cooler. Businesses, naturally, would like to know the maximum amount each customer would be willing to pay and then charge the customer that amount. But because that's not possible, they must set a price that will bring the greatest return. If the seller sets one price, and it's at the high end, only those who value the product the most will buy it, while those who might have bought it at a lower price will reject it. If the business charges too low an amount, the total number of sales will be higher. But they will miss out on all the revenue they might have gained from those willing to pay more. Price discrimination, then, is the way businesses try to extract the maximum revenue for their product or service.

Setting different prices for different customers normally involves segmenting customers into separate groups. This could be means such as geography, age, occupation, education or even new customers versus returning customers. For

example, pharmaceutical companies sell identical drugs at different prices in different countries, children pay less to see movies, truckers may get a discount at certain interstate cafes and companies like Microsoft offer discounted computer software to university students. Businesses have also recognized the importance of building a loyal customer base because repeat customers are often less sensitive to higher prices. So customers are sometimes segmented into new customers and old customers, with new customers getting a better deal for a limited time.

Amazon appears to have once experimented with displaying different prices for the same DVDs, depending on whether the person scrolling through the DVD section was a new or returning Amazon customer. The discovery was made by participants in a British online discussion group who found that Amazon was moving prices up or down by as much as $16, according to a September 2000 story from BBC News Online. Discussion group members who were regular Amazon customers found that if they deleted the Amazon cookies from their computers they got "bigger discounts on popular DVDs than on previous attempts." Amazon blamed the different discounts on "a price-testing scheme that went awry."

An important aspect of using price discrimination is ensuring that consumers excluded from lower pricing offers cannot buy products at those prices and that consumers who can buy at lower prices cannot resell the products to those in different market segments.

The classic example of price discrimination is an airline journey in which few of the passengers have paid exactly the same price as any other passengers. Some of those onboard will be affluent travelers willing to pay handsomely for wider, luxury seats with more legroom, better quality food and free newspapers. Some will be business travelers, willing to pay a premium for flexibility that allows them to change flights at short notice. And even in the lowest-tier economy section, a great number of passengers will have paid different prices for exactly the same standard. Children may get half off; university students may have received a reduced fare and passengers who booked seats months in advance may have received a discount for that. Passengers who bought seats through a particular travel agency that had obtained a block of tickets at a discount will have paid another price. Loyal passengers who travel frequently with the same airline could be traveling on a "free" flight they earned through an air miles program (this is also a form of "lock-in," another microeconomic concept discussed later in this chapter).

The intensity of the level of price discrimination in airline travel is a direct consequence to how perishable an airline journey is as a consumer product. That is, once the flight is over, the airline company can never sell seats on it again. It can sell seats on the same plane traveling the same route. But empty seats on completed

flights represent lost revenue. That is why airlines go to such dramatic lengths, and employ such complex pricing tactics, to fill them.

The transformation of news provision from print and broadcast to digital platforms has resulted in more deadlines. But news is still a perishable product that can become stale very quickly. So under what circumstances can price discrimination be used in the news business? Certainly some news consumers place a greater value on being informed than others. The segmentation becomes particularly acute when specific types of news are considered. Conventional wisdom about online news business models is that *The Wall Street Journal* and the *Financial Times* are among the only newspapers that can attract paying subscribers online because their readers value that content enough to pay for it, coupled with the immediate and continuously updated format that the web provides. (A parallel argument is the fact the *Journal* and the *FT* can charge for online content because readers put the cost on company expense accounts.)

If it is true that *The Wall Street Journal* can attract paying customers online because they offer business news, what does that mean for general news providers? Most newspapers have sections that cover business news – and probably local business stories not covered by the *WSJ* or the *FT*. Perhaps local business sections have a commercial value that has gone untapped. The editor-in-chief of *The Australian*, Chris Mitchell, told Sky Business News in June 2009 that the online business edition of his newspaper had been making money for several months through targeted advertising. What if newspapers decided to continue publishing online for free in an advertising-supported model, but without the business section? The business section might be available as a premium subscription service, sold at a carefully researched price point that would make it reasonable for anyone with a need for business news, or a strong interest, to subscribe. Advertisers would be able to target an attractive readership. And non-subscribers and users arriving via search engines might be able to see headlines and the first line of a story as an ongoing sales pitch for the premium service.

What about the "timeliness" of online business news and its commercial value? News providers could charge for real-time access to breaking business news, capturing subscription revenue from those who value this content the most. The same business news could be offered free (with advertising) on a time-delayed basis to readers interested in business news, but who do not value it enough to pay a subscription. (Placing a value on timeliness is a common segment differentiator in price discrimination strategies. For example, restaurants offer discounts on food and drinks outside of regular mealtime hours because the lost revenue from an empty table can never be reclaimed.) Of course, selling digital content of any kind

comes with its own set of problems, such as the ease with which anyone can copy and distribute material. Clearly these must also be addressed.

As it stands now, minimal use of price discrimination strategies occur in the online news business – largely because so little paid content is offered. In one example, though, the *FT*'s online subscription page offered three digital versions as of mid-2009. The first, at £2.99 ($4.90) per week, offered unlimited access to articles plus "keyword alerts" and "portfolio tools." For £3.99 per week ($6.50), subscribers get the addition of access to the "mobile news reader" and the "Lex" commentary column. Finally, the *FT* offers a bundled offer of the online edition plus delivery of the print edition for £9.99 per week ($16.30).

Price discrimination strategies are often used as a part of a larger microeconomic toolkit. In the *FT* example above, the newspaper uses price discrimination to segment readers into groups based on how much they are willing to pay. But the paper does this through versioning (offering different versions of the online news site) and bundling (packaging different products together and offering them at one price). These and other economic and management concepts that could be used in understanding and developing commercial strategies for newspapers are discussed below.

Versioning: Customers place themselves in market segments

Versioning is another form of price discrimination. But in this case, the seller creates different versions of the same product and offers customers the ability to choose which one they prefer. So rather than dividing customers into market segments by qualities such as geography or age, and then offering different prices accordingly, versioning results in customers "self-selecting" their own market segment according to which version they prefer. The prices for different versions could be different or they could be the same. The key is to ensure that there is a version to suit every potential customer. A common example is the release schedule for movies. Those who want to see the film badly enough will pay a premium to see a first-run, big-screen version in a theater. Those who are less interested, or unable to get to the theater, will have increasingly delayed and less expensive opportunities to see the same film on DVD, on cable television and then on free, advertising-supported online or television services. It is the same film, but the distribution methods come in different versions. Book publishing follows a similar trajectory, with bound hardcover versions preceding the publication of cheaper paperbacks.

In their seminal 1999 book on the networked economy *Information Rules*, Carl Shapiro and Hal Varian (the latter was chief economist at Google at the time of this writing) detail a range of methods sellers can use to extract maximum value from digital information products. "Delay" is one way of versioning that they believe is particularly well suited for information products. "Information is like an oyster," they write. "It usually has the greatest value when it is fresh. This is especially true of 'strategic' information such as stock market or interest rate movements, where individuals possessing the information have a strategic advantage over those lacking it. But the principle applies more broadly, since we all like to think of ourselves as being up-to-date." The relationship between fast-changing financial information and the ability of *The Wall Street Journal* and the *Financial Times* to charge for online content is clear. But perhaps there are other types of information that a specific segment of users would pay to obtain upon immediate release. Other users might be interested in obtaining the information – but on a free, delayed basis. Obviously the widespread availability of the same, or similar, information would damage the ability to charge for time-delayed information. But non-commoditized information, or content packaged or distributed in a convenient way could be exploited commercially.

Considering that "yesterday's news" is an expression still used to describe something that has no value, it remains an anomaly that so many news organizations give away their freshest, most valuable content while charging for access to their archives – which is "yesterday's" news. (Anyone typing "www.yesterdaysnews.com" into a browser window will find it is the name of a brand of kitty litter.)

Bundling: Selling different products for one price to maximize revenue

Bundling, another form of versioning, is the practice of packaging two or more separate items together and selling them for one price. As with other variants of price discrimination, the idea is usually to extract the greatest amount of total revenue from multiple products on offer. Sometimes purely promotional considerations are involved, though.

As an example of how bundling increases revenue, consider a music store selling two CDs to a theoretical group of 100 customers. The first 50 customers place a high value on CD1 and would pay $10 for it, but place less value on CD2 and would only pay $8 for it. Conversely, the second group of customers has different tastes and would pay $10 for CD2 and $8 for CD1. So how should the

store price the CDs? If they price the CDs at $10 each, they will sell 50 copies of CD1 and 50 copies of CD2, bringing in $1,000. If they sell the CDs for $8 each, they will sell 200 CDs and earn $1,600. But if the store bundles the CDs together and sells them for $18, they would sell 100 of the bundles, bringing in $1,800. This is because every customer, no matter which CD they prefer, is getting both CDs for the amount they would be willing to pay for them individually.

Generally speaking, the news business already offers bundled products. A newspaper or a news magazine is a collection of different sections – political news, sports, business, lifestyle and the like – each of which will hold different values to readers. Some readers buy a newspaper just for the sports section. Others discard the sports section without even glancing at it.

Newspaper and magazine subscriptions can also be seen as bundles because customers are paying for a pre-determined number of issues, some of which may be more interesting than others, and some of which may never be read. What other ways can news providers use bundling to increase revenue? What if print newspapers were offered and priced by individual sections – and readers could bundle the sections they valued and pay a single price for those without paying for the sections they did not want? On a larger scale, what if hundreds or thousands of online news sources went through a central clearing house and users could choose from an aggregate pricing scheme that enabled them to subscribe to five or 10 or any number of news providers for one price? What if users could subscribe to the business sections of 10 online newspapers without having to pay the cost of taking the entire newspaper? Obviously, practical and logistical considerations need to be taken into account with these ideas. But perhaps they can be used as a starting point for exploring ways to use bundling strategies to increase revenue.

Considering that general circulation newspapers already come bundled in some way or another, perhaps there also is a way of extracting added value from unbundling them. "Electronic distribution of information creates the possibility of novel forms of pricing," wrote economists Arup Daripa and Sandeep Kapur in their 2001 paper, "Pricing on the Internet." At the height of the dotcom boom, the London-based economists foresaw the opportunity to offer online customers exactly the information they valued without forcing them to purchase a bundle of unwanted articles. "If journal articles can be downloaded electronically," they wrote, "the economies of scale and scope that make it worthwhile to sell articles in bundled form are less important. Might it be sensible to allow readers to buy individual articles, each for a small fee?" They added: "The development of micropayment systems to enable small online transactions should encourage such unbundling."

As it turned out, academic journals did make the online transition to commercial unbundling and papers and articles are routinely sold individually in digital form. But for reasons discussed elsewhere in this book, including the slow development of suitable micropayment systems and the ubiquity of free news content, unbundling news articles and selling them (as opposed to offering free access) never took off on a noticeable scale. The sinking fortunes of traditional news providers and their business models has led to renewed efforts to get news consumers to pay for online content. Perhaps bundling and unbundling stories and topics in compelling ways will help news organizations surmount this problem.

Network externalities: How one new customer can benefit all existing customers

"Network externalities" is the term used to describe the effects that individual users can have on a system, market or service. Although the effects could be positive or negative, the term almost always refers to a situation in which the greater the number of people who are involved or connected, the greater the benefit for all users. Prior to the arrival of the digital age, the classic example of network externalities was the telephone – the greater the number of people with telephones, the more people reachable by phone. Today, some of the most successful sites on the web owe much of their success to the power of network effects. As the auction site eBay grew, for example, an increase in sellers made it more valuable for buyers, who were more likely to find items they wanted to buy. The increase in buyers created a more valuable market for sellers – eBay was where they would find the biggest market for their goods. The same effect can be found in Craigslist with its (mostly) free classified ads. Similar conditions exist for the Yahoo!-owned web site Delicious, which describes itself as a "social bookmarking service that allows users to tag, save, manage and share web pages from a centralized source." In other words, users bookmark web sites and web pages they are likely to want to view again and add keywords (tags) that will make them easy to find. But crucially, they also make it easy for anyone else searching for information on specific topics to find content on the same topic via the inserted keywords. Clearly, the more people who use Delicious, the more valuable it becomes to all users. Delicious also has an added value component not seen in many other services that benefit from network effects. It is also valuable to individual users who only want to store their own content, rather than sharing it. This has proved to be an important lesson for businesses looking to build scale through network externalities. In a 2006 profile

on Delicious founder Joshua Schachter, the MIT-owned magazine *Technology Review* wrote:

> Though del.icio.us [as it was then called] has become a way for users to collectively organize information across the Web, it did not begin as anything so grand. Rather, it emerged as a way to help individuals manage their own information. "For a system to be successful, the users of the system have to perceive that it's directly valuable to them," Schachter says. "If you need scale in order to create value, it's hard to get scale, because there is little incentive for the first people to use the product. Ideally, the system should be useful for user number one." This makes del.icio.us different from systems that rely on what economists call "network externalities" – meaning they're valuable only if lots of people use them. It was hard to get the first person to buy a fax machine, because a fax machine is useless if you're the only one who has one. But even for the first person to use del.icio.us – Schachter – it worked.

So what does this mean for the news business? News providers do not benefit from network externalities because news consumers do not gain any added value from more people consuming the news. There is, of course, a case for saying that having an informed public benefits society as a whole and strengthens democracy, and therefore the more people who are well-informed, the greater the value. But that is an indirect benefit, at best, and one that is unlikely to provide an incentive for more people to increase news consumption. Could news providers create a service that would become increasingly useful as more people joined it? "Newspapers could not do it as they exist now," said economist Kapur in an interview. "What difference does it make how many people read the paper?" But he did see potential if news organizations could inject more interactivity into their news products and build "critical mass" around it.

Lock-in and switching costs: Strategies for keeping customers loyal

If you have ever wanted to change your email address, or cell phone number or Internet service provider, but were reluctant to make the move because of the hassle involved, you will understand the concept of lock-in and switching costs. While all of these have become easier to do over time, they can still cause enough disruption to make customers reluctant to change. Phone number portability is no longer the nightmare it once was, but still requires a journey through telecom bureaucracy. Switching ISPs can mean an interrupted service. And while it takes two minutes

to create a new email address on Yahoo! or Google, you face a danger that not all your contacts will note your change of address and some email may go astray.

Lock-in is the business practice of tying customers to a product or service and creating barriers which make it difficult for them to change suppliers. Switching costs is the term used to describe the barriers that make customers reluctant to move to another product or service. Businesses commonly attempt to create high switching costs to lock in their customers. Loyalty programs, offered everywhere from airlines to coffee chains, are a form of lock-in. The switching cost gets higher and higher for customers as they get closer and closer to a free flight or free latte. While loyalty programs are rare among news organizations, they do exist, with *The Washington Post's* PostPoints being among the most high profile. Launched in 2007, PostPoints rewards offers tiered membership levels, for subscribers and non-subscribers, and awards points for interacting with the newspaper in some way, such as posting a comment on washingtonpost.com, or engaging in some form of community activity such as giving blood or volunteering for charity work. PostPoints members can save up their points for prizes such as store and restaurant discounts, free movie tickets and services from the *Post* such as free archive access. The *Post* signed up 140,000 loyalty scheme members the first year, according to the newspaper. In the technology industry, lock-in can be found in proprietary systems that are not interoperable with other systems rather than working to a universal standard. People continue to buy the same brand of mobile phone because of technological lock-in.

Another type of lock-in tactic is for businesses to sell (or even give away) one product that requires the customer to continue buying complementary products, such as refills. Razors and razor blades or printers and printer ink are textbook examples. Consumers were locked into buying expensive blades and ink from the razor and printer companies unless they were ready to purchase another manufacturer's razor or printer. However, the arrival of low-priced generic refills of razor blades and printer ink changed the dynamics on this example of lock-in. But similar effects can be seen in the sale of some personal technology products and the services they support. Cell phones are frequently sold at heavily-subsidized prices to customers who sign a lengthy contract that requires them to pay a monthly charge to one service provider. Even cell phone users who prefer the "pay-as-you-go" model rather than a contract can buy a phone at a subsidized price if they agree to install a SIM card from a particular operator and buy a designated minimum amount of phone call credit from that company. The service operator is betting that once the customer has installed their company's SIM and started using the phone, they will be unlikely to jump

to another provider because of the switching cost (such as researching new deals, physically obtaining and installing a new SIM card, and advising colleagues and friends of the change).

Traditionally the news business has had little reliance on lock-in and switching costs. Prior to the arrival of the web, newspapers with a monopoly or near-monopoly in their region locked in readers who preferred that paper instead of nothing. And readers who subscribed to a particular newspaper would know which parts of the paper they preferred and exactly where to find them – this is a form of lock-in called "brand-specific training." But the web has diluted even those mild forms of lock-in: News consumers need only tap a finger to get to another news site and they can find stories via a search engine or aggregator.

So how can news organizations introduce lock-in and switching cost techniques? If print newspapers were a growing, or even stable, business, an array of traditional tactics such as loyalty programs might prove more useful. *The Washington Post*'s PostPoints program is worth monitoring, but its overall value appears limited. The steady transformation of news to digital platforms will mean increasing customer promiscuity as consumers jump from news source to news source. High numbers of page views and unique users will not necessarily translate into loyalty or lock-in. Digital news providers need to create new products and features that will attract and hold audiences. These must be products that will encourage users to engage and interact with the news organization and other users as well.

In the next chapter, we look at how news organizations can build stronger connections with their readers and how to transform those connections into commercial relationships. And we consider why current payment systems scare away potential customers and how that dilemma might be resolved.

E-commerce and engagement – converting users into paying customers

Summary

One of the biggest commercial problems facing news organizations in the digital age is their limited ability to form a direct transactional relationship with their users. Major newspapers may count their online visitors in the millions – but who are those users? The vast number of "uniques" driven to free news sites by search engines and aggregators are proving to be of limited value to advertisers. So how can anonymous users be converted to paying customers? This chapter looks at ways to form commercial connections.

As the news industry struggles to stay afloat in the digital age, it's important to keep in mind that the digital age is good for business. New kinds of enterprises, such as search engines, have emerged and many mature businesses are undergoing renewal through increased productivity and efficiency. UK supermarket giant Tesco has made hundreds of millions of pounds in profit with a service that melds the old-fashioned notion of home delivery with the ease and efficiency of online ordering. Of course, the emergence of new business models has been painful for those working in outdated models such as travel agencies, record stores and camera film manufacturing.

In the news business, the product – news – has been improved in all sorts of ways. There are better and more plentiful ways to tell stories. News consumers can get information faster and in more convenient forms than in the past. The list goes on. But journalism has not made the great commercial leap forward, despite the ever-increasing sophistication of online news sites and the expanded methods by

which news is presented. The reasons, many of which already have been outlined in this book, are complex. One of the most fundamental is that "news" was never really a product that people paid for. It is a product that draws an audience, and advertisers have always been willing to pay good money to get their message in front of that audience. The cover price or subscription price that consumers pay for newspapers only covers a fraction of the cost of gathering the news, printing it and delivering it to readers. The profits – and they have been vast – came from the advertising revenue. Now, the competition for eyeballs and advertising is immense, reflecting the way digital content transcends time, geography and long-established business models. One of the most important ways news providers can fight back and reclaim advertising share is by providing content that is more engaging, more relevant, more useful and more valuable to people's lives. The days when news-papers could maintain a monopoly on advertising by publishing routine, bland stories designed not to offend anyone appear to be over. But how to shift news content into a greater engagement model will have to be the subject of another book. Here we will look at using online commercial techniques and audience engagement to create new sources of revenue to support journalism.

E-commerce

Though some form of e-commerce is already in use at many news organizations, particularly the web editions of printed newspapers, online shopping could be playing a greater role in building revenue. The building blocks to generate income from selling products and services online are there. But news providers must focus on the attributes they possess – trust and attention-getting – that will give them market power in the highly competitive e-commerce environment. Advertising will remain critical for commercial news providers, of course. But as stated elsewhere in this book, there will not be enough advertisers and advertising to fully support all news organizations. So consider these components that make e-commerce a revenue growth area to help fund journalism.

- A June 2009 report from leading UK retail industry analysts Verdict Research declared, "With Internet shopper numbers at an all-time high and online spending growing by £2.4 billion ($3.9 billion) in 2009, e-Retail has been a star performer in the recession. In 2009, online spending by consumers on retail purchases will rise by a substantial 13.3 percent to £20.9 billion: a rate of growth in severe contrast to the

historical decline being suffered by the total UK retail market. Although the Internet is undoubtedly starting to slow and become a much more competitive environment, online retail is still set to reach £31.2 billion ($50 billion) by 2013, accounting for 10 percent of total retail spending (in the UK)." So there is a growth opportunity.

- The British government's consumer watchdog agency, the Office of Fair Trading, published a report in May 2009 that said almost one in three Internet users are not shopping online, "with a lack of trust in the Internet the biggest reason." Among those who will not spend money online, the report said, "30 percent identified lack of trust as the main factor holding them back, while 20 percent cited fears over personal security and 15 percent said they did not trust companies that sell online. While consumer confidence is gradually improving, overall levels are still too low for the market to reach its full potential." What the report did not focus on, but is a critical e-commerce issue, is the great number of Internet users who do not even possess a credit card or debit card. This is a particularly acute problem with young people, who, nonetheless, are a key target demographic for digital content such as music downloads. Established news organizations generally have built up a high degree of trust and credibility among their readers, viewers and users. Trust is a valuable attribute that can be used commercially.

- There is widespread fear and mistrust among web users about handing over bank and credit card details online. Yet all major initiatives by news organizations to get users to pay for content or goods online have required them to do just that – hand over their financial details – effectively alienating a huge proportion of potential paying customers. But it doesn't have to be that way. Online payment methods that avoid the need for credit cards and bank accounts already exist. One example is a "prepay" card called SNAP, launched by a London and Geneva-based startup called TeleGlobal. (Disclosure: one of the authors has worked as a consultant for TeleGlobal). Here's a fast (and limited) explanation of how the SNAP card works: Anyone in countries where SNAP operates can obtain a plastic SNAP card for free by either requesting one at participating outlets, such as news agents and gas stations, or ordering one online at the SNAP web site (www.snapcard.com).

Unlike most other prepay cards, SNAP is not linked to the user's bank account. There is no monthly fee to have the card and there is no charge for using it. SNAP cardholders can top up the card with cash at designated top-up points – usually stores with prepay computer terminals. With cash

loaded onto the card, the SNAP user can shop online at any web site that accepts SNAP as one of its payment methods. The user just types in the number on the card, plus a secret pin number they have created themselves. For the SNAP card users, there is no danger of someone tapping into their bank accounts and credit cards. There is no minimum amount of spending for each transaction, which solves another problem that has hindered media companies trying to set up a micropayments system. TeleGlobal, like other card companies, earns money by taking a small commission from the seller for each sale using the card. Online retailers who accept SNAP, or other cards not tied to bank accounts and credit cards, are able to build a customer base and seize market share by offering security to those concerned about credit card fraud. And it enables those without credit cards to take advantage of online shopping and buying small items with micropayments.

Rather than lag behind and try to play catch up with new innovations and technologies, as has often been the case, the news industry has the opportunity to develop new payment systems that will transcend some of the basic problems hindering online commerce.

• SNAP, or cards like it, also offer news organizations the possibility of building transactional relationships with their users. That means they can maintain an ongoing financial connection with users, rather than spending valuable marketing resources to reach the same customers over and over again. In the US, newspapers have maintained a transactional relationship with subscribers because the newspapers handle circulation, distribution and billing functions themselves. But the steady drop in print subscriptions means that relationship is dwindling, but is not being replaced with an online counterpart. News organizations that require online users to register find some benefit but must deal with a high percentage of false information and, even more importantly, the loss of potential users who turn away at the first sign of a wall – pay, registration or other. In some other countries, much of the distribution process is not even handled by the newspapers themselves. In the UK, home delivery of newspapers has traditionally been handled by local newsagent shops whose owners arrange delivery. So the newspaper companies rarely had a direct financial relationship with their subscribers – it was the newsagents who had the customer relationship. That began changing slightly in the UK in recent years, particularly with Rupert Murdoch's British subsidiary, News International, which has taken control of home delivery of its

national newspaper stable of *The Times, The Sunday Times, The Sun* and the *News of the World.* Notably, it was also Murdoch who said he did not want to sell digital editions of his newspapers through Amazon's Kindle e-reader because it was Amazon, not his News Corporation, which would control the customer relationship. "We will not be ceding our content rights to the fine people who created the Kindle," he said during an earnings call in May 2009. "We will control the prices for our content and we will control our relationships with our customers. Any device maker or web site which doesn't meet these basic criteria on content will not be doing business long-term with News Corporation." Two of his papers, *The Wall Street Journal* and *The Times* (of London) were actually already available on the Kindle and remained so up to the publication of this book. Nonetheless, transactional relationships were clearly on his mind.

So how could a card like SNAP be used to connect news organizations to their users? The cards could be specially printed with a news organization's own branding, possibly with a special offer message on it. It could be distributed any number of ways, including attached to print publications as cover mounts (which are more common in Europe than the US) or mailed out after a phone or online request. The cards could come with a free gift, discount offer or a certain amount of money, say $5, already loaded onto the card toward the purchase of merchandise from the news organization's online store. Cardholders would not have to register anywhere to use the card, but they could be enticed to register to continue to receive special offers – or even to feel connected to the publication. At that point, a relationship has been secured.

One key lesson that has emerged so far about the use of prepay cards and news organizations is the importance of ensuring that the card can be used other places besides the news organization that distributed it. In 2007, London's evening daily, the *Evening Standard*, issued its own prepay card, but eventually dropped the project. Industry analysts believe the initiative failed because the card could only be used to buy copies of the *Evening Standard*, which apparently did not give potential cardholders enough incentive to keep the card and top it up periodically.

We discuss elsewhere in this book the kinds of editorial content that someone might pay for. But what kinds of products and services could a news organization sell? Ensuring that the items on offer align with the interests and needs of the readers is an essential, if not obvious, component. *The New York Times*, for example, launched a new venture in August 2009 called *The New York Times*

Wine Club, targeting its up-market readership. In an article about the Wine Club launch, *The Times* reported it will:

> "... offer members a selection of wines at two price levels, $90 or $180 per six-bottle shipment, and customers can choose to have wine delivered every one, two or three months. The club, an unusual brand extension for the paper, is one of several such ventures the company is considering, said Thomas K. Carley, the senior vice president of strategic planning for the *Times* Company. "*The Times* is looking at a lot of different ideas for engaging our audience," he said, "to make statements about what are our strengths, what are the ways that we can delve further into our audience and bring them products and services that basically enhance the bond with *The New York Times*."

In the UK, this alignment of reader segmentation and commercial offerings can be seen in various national newspapers such as the up-market broadsheet *The Daily Telegraph* and the colorful working class tabloid *The Sun*. While *The Telegraph*'s online shop is heavy with gardening supplies and sleek watches, *The Sun* offers a commercial mix of bingo, betting and Page 3 topless models. But there remains plenty of room for overlap among all kinds of sites – dating and diets now, but there could be much more. One avenue open to online news websites are so-called "white label" retailers, who do all the behind-the-scenes work of processing and fulfilling merchandise orders. For example, when customers log onto the web site of UK supermarket giant Sainsburys, they are offered the opportunity to buy a washing machine. They might decide that Sainsburys would be a good place to buy a washing machine because they have shopped there for years and it is a big company with a reputation to uphold. But if they did buy the washer, they would actually get it from a company called Appliance Deals, which acts as a storefront for other websites that want to sell appliances. Sainsburys would get a commission on the sale for driving the customer to the Appliance Deals web site.

White label music download sites are another common type of affiliate online shop front. *The New York Times* Wine Club is not run by *The Times*, but by a third party capitalizing on *The Times*' name for the benefit of both. These kinds of arrangements are available to news organizations, which have public trust and the attention of online users. But business arrangements like these carry obvious dangers for news sites because trust is one of the main selling points a news organization has and damaging it by working with a wayward commercial partner could stain the editorial side of the business. And unlike Sainsburys, news organizations must be careful about conflicts of interest.

At *The Telegraph*, e-commerce is playing a larger and larger role in newspaper's commercial planning. "One shouldn't expect advertising on its own to support

the costs of a newsroom," Telegraph Digital editor Edward Roussel told the News Innovation web site, produced by the CUNY Graduate School of Journalism. "E-commerce is less cyclical, less prone to downturn and more reliable as a revenue stream." As the CUNY site reported, publishers need to embrace the ways in which the web has drastically "shortened the transaction chain" between advertiser and consumer, Roussel said. Advertising used to be about delivering information to readers so they could then go out to make a purchase, Roussel said, but "now we can say: do it here and now. That's the value added for news sites – allowing people to make the acquisition on the spot." Far better, he said, for news sites to embrace this updated approach – providing valuable services for a fee – than to erect paywalls around content that in the age of Google is readily available elsewhere. "The fundamental value of journalism is that you pull in a wide audience, then you can direct them to a series of high value services that they'll pay for," Roussel says.

Engagement

As unique visitor numbers soared at some online news organizations in 2009, analysts inside and outside the news business began to question the value of such numbers, which are often comprised of waves of infrequent users who arrive via a compelling headline on a search engine or a link from an aggregator such as the Drudge Report. From a commercial point of view, those occasional or one-time users have little value to advertisers or to e-commerce efforts. (News organizations that chase huge numbers of "uniques" with uncharacteristically lurid stories and other questionable search engine optimization tricks are also reducing the value of the journalism, of course.) Examining the issue of reader numbers and revenue in a March 2009 blog commentary, former *Wall Street Journal* digital executive Bill Grueskin said, "What's missing is the more important quality: engagement. Readers' time can be as valuable as their money – more so online, where options to flee to another news source involve clicking a mouse, not heading to the newsstand to buy a different newspaper. You see this error in the way online publishers gauge their traffic. They usually cite monthly unique users, but, in fact, I've always thought total time spent per user, or page views per visitor, were more meaningful metrics. If a news site gets 250,000 new unique visitors thanks to a link on Drudge, and that generates exactly 250,000 page views, the value of that traffic is minimal. All it shows is that those readers are engaged with Drudge, not the news site."

That opinion is being echoed – and acted upon – elsewhere in the industry. Both *The New York Times* and Britain's *Guardian* – newspapers recognized as

leaders in developing online newspapers sites – separately floated the idea in mid-2009 that they would create "membership clubs" in which readers who joined would get access to things like events, discussions and special content. According to *The New York Observer*, *Times* executive editor Bill Keller told staff members in May that the paper's top executives were considering a plan in which "readers pledge money to the site and are invited into a *New York Times* community. You write a check, you get a baseball cap or a T-shirt…an invite to a *Times* event, or perhaps, like *The Economist*, access to specialized content on the Web. He said he wouldn't even be opposed to offering a donor access to a page one editorial meeting as long as it doesn't affect the paper competitively."

In August 2009, *The Guardian* sent a letter to some readers asking their opinion on a proposed "Members' Club" to "support *The Guardian* financially," according to the web site paidContent (which is owned by the *Guardian's* parent company). The web site quoted the letter as saying " *The Guardian* is considering launching a members' club, which will provide extra benefits in return for an annual or monthly fee. These benefits might include, for example, a welcome pack, exclusive content, live events, special offers from our partners and the opportunity to communicate with our journalists." Weighing up the viability of a *Guardian* members' club, paidContent commented " *The Guardian* not only has a degree of brand loyalty, it also has several niche audiences it could call upon from its daily supplements – media, education, society, technology and entertainment – some of which already have associated events and other extras. It may be that survey results will indicate a greater desire to *belong* to a 'club' than to *pay* for content."

A number of commentators expressed doubt that the monthly dues from members clubs would do much to generate revenue for big newspapers. But the writers did not appear to take into account the lesson from Marketing 101 that it is much easier and cheaper to sell extra products to existing, loyal customers than it is to attract new customers. *The Times* and *Guardian*, and others like them, are clearly trying to build a journalistic and commercial relationship with an engaged audience rather than depend on a capricious and promiscuous readership that arrives via aggregators and search engine headlines.

One of the greatest efforts underway in late 2009 to build a database of engaged readers was at Rupert Murdoch's News International newspapers in the UK. Murdoch's son James, who oversees News International as chairman and chief executive of News Corporation, Europe and Asia, announced in March 2009 that he had created a new NI division called Customer Direct, which would help "to build more direct, valuable and seamless relationships with our customers." Headed by Katie Vanneck, the former marketing director at the rival Telegraph

Media Group, her department, said Murdoch, "will ensure that we increase our focus and build better, more direct relationships with customers, developing profitable products and services for them, linked to our core brands."

Vanneck is among those who question the ultimate value of online news organizations having millions of monthly unique users who have no relationship with the news providers. "We've all gone slightly mad when we talk about what success looks like," Vanneck told the *Independent* newspaper in a June 2009 interview. "Why would publications that have only ever sold one million copies suddenly be able to have an engaged loyal audience of 23 million? Realistically, in terms of paying for products and services, people pay for the things that matter in their lives." Vanneck told the paper that her philosophy was about addressing not "readers" but "customers," or as *The Independent* put it, "people who have a transactional relationship with a newspaper brand." Said Vanneck, "In newspapers we've all been guilty of not giving enough justice to circulation as a direct customer revenue stream – we've very much thought of ourselves as driven by our advertising businesses. If you keep thinking about your consumers as readers you create the ongoing belief in volume versus value and you don't mind whether they've purchased you. It's quite a big change for us because actually a customer is someone you have a transactional relationship with, someone you deal with differently, it leads you to think about their customer experience and customer service."

Among new marketing efforts at News International since James Murdoch took over was an initiative to take control of deliveries to home subscribers, which has generally been haphazard and out of the hands of the newspapers themselves in the UK. *The Independent* reported that by June 2009, 140,000 "contract customers" were taking home delivery of *The Times* and *The Sunday Times* under the plan and that of those 80,000 took up a related offer to activate a membership offer in a "Culture+" program. That program "offers discounts on products and services from the Royal Academy of Arts and the National Theatre as well as Murdoch businesses such as Sky Arts and HarperCollins." Said Vanneck, "80,000 doesn't make us the biggest arts organization, but we are not far off." According to *The Independent,* "*The Sunday Times* Wine Club, set up 30 years ago [in 1979], has a database of 300,000 customers who have purchased £80m worth of wine in the past year, making it 'one of the largest direct wine businesses in Europe.' *The Times* Health Club has 100,000 members who share tips on how to lose weight."

Expanding on its membership efforts, News International newspaper launched Times+ in October 2009, a membership club offering readers of *The Times* and

Sunday Times access to exclusive events, special offers, and the chance to meet some of the papers' journalists. In addition to incorporating Culture+, the new initiative added another package called Travel+, offering a free subscription to *The Sunday Times* Travel magazine and discounts on various aspects of travel. The cost of joining Times+ was £50 ($80) but was free for those who had a seven-day subscription to the papers.

Despite the great urgency and focus on building customer relationships and developing new products and services to generate revenue, News International does not appear to have lost sight of what drives the whole process. As *The Independent* put it, "All these ventures, [Vanneck] says, must be driven by the editorial of their respective titles because the engagement with the newspaper is central to the relationship."

The program is an example of innovative thinking. As the next chapter argues, news organizations need to focus more on innovation to flourish in the digital age.

Building the news business through innovation

Summary

Innovation drives modern economies. But before innovation can happen in the news media, editorial managers need to foster environments that welcome it. Media companies are some of the least innovative organizations in the world because they have often been unwilling to risk failure, a precursor to innovation. This chapter will look initially at the role of innovation in improving the business models at news organizations, and how they can inculcate innovation and creativity. It will then provide examples of innovative practices in media companies around the world.

Juan Senor, a director of the Innovation International media consulting company, offers one primary piece of advice to media houses: "Innovate or die." Senor said the essentials of journalism had not changed, but the business model had. Jim Brady, former executive editor of WashingtonPost.com, believes that insufficient risk-taking occurred at newspapers. "We've done things a certain way for so long that change comes at too slow a pace," he said in a Q&A on the Poynter web site in 2009, arguing that the speed of experimentation needed to increase. "Launching blogs in 2009 isn't innovative anymore." All web newsrooms needed to devote resources to forward-looking experimentation. "If all your resources are focused on putting out today's site, tomorrow is going to sneak up quickly on you."

Meanwhile in Washington, National Public Radio CEO Vivian Schiller, in a keynote address at a conference about the future of news in March 2009, admitted the news industry was being tested. "Will we cower in fear or go forward?" she

asked the audience. "This is a crisis we will not waste. The answer for us is not to retrench and just go back to what we do best, but to regroup. We have to innovate, we have to push, we have to take risks, we have to accept that it's OK to fail on certain efforts."

Media companies around the world understand the concept of innovation. But evidence suggests that few embrace it. In 2006, Innovation International conducted a survey of newspaper executives in 33 countries. It asked executives what capabilities would be the most important for the growth of their businesses over the next five years. The highest response, at 43 percent, was the need to innovate. Given a competitive landscape, Innovation International also asked, what was the most important action a company could take to grow over the next five years? The ability to improve existing products received the highest response at 25 percent. Developing new products was next highest, at 22 percent.

What would an innovative newspaper or broadcast organization look like? There are many possible answers. But one certainly is: innovative media companies would produce products that people wanted to buy. Phillip Meyer put it another way in *The Vanishing Newspaper*: "The only way to save journalism is to develop a new model that finds profit in truth, vigilance and social responsibility."

Juan Antonio Giner, of Innovation International, said the role of the print newspaper had changed. Its job was to add value to news, not to be stenographers of what the mighty and mischievous said. "Breaking-news is not our business any more." That should be left for online. Print is more appropriate for analysis: Audiences already had an overview of the news from broadcast and online. Print's role is to tell readers why and how events happened, and then explain what would happen next. Giner called it a move "from journalist to jour-analyst."

Google's CEO Eric Schmidt, in an interview with *Fortune* magazine published in January 2009, summarized the problem for daily newspapers: People still want the product newspapers produce, the news. "People love the news," he said. "They love reading, discussing it, adding to it, annotating it. The Internet has made the news more accessible." The problem was with a funding model based on classified advertising and the costs associated with making a newspaper: paper, printing and delivery. "And so the business model gets squeezed," Schmidt told *Fortune*. Economists call this a market failure. It is a situation that must be solved through innovative thinking.

Mark Briggs is co-founder of Serra Media and author of the book and blog *Journalism 2.0*. He was formerly assistant managing editor for Interactive at *The News Tribune* in Tacoma, Washington. Briggs believes two qualities are essential to an innovative approach: risk and optimism. But most journalists "aren't wired for either," he said, which was "a huge problem during this painful transition into

the digital age." Journalists need to get comfortable with taking risks and develop optimism for the future of news in the digital age. "It's not easy, but it is essential," Briggs told a seminar on entrepreneurial journalism at the Poynter Institute in Florida in March 2009.

Innovation and entrepreneurship are a state of mind, Briggs said. Innovators create things that people have not seen before. "The state of mind of entrepreneurship can happen in the largest corporations or the smallest companies," he said. Being entrepreneurial is about creating new products, new markets, new ideas and new businesses to capture some of the economic benefit from the vision and the hard work. But it also involves communicating a vision of where the company could be. The key questions are how to aggregate the resources, and how to motivate people and execute against that vision.

The world of journalism in the early twenty-first century was changing much in the way it had changed with new technology in the 1980s, Briggs said. People adapted then, and they would be forced to now. "This new reality will allow a new form of journalism to emerge with new job titles, new roles and new responsibilities." This was happening in many other industries. It did not make sense to have a single job description (journalist) from a single industry (newspapers) with a single business model (print advertising). The practise of journalism would diversify and emerge with many job descriptions and many business models. "But we don't know what those will be yet. And living with uncertainty isn't something most people enjoy."

Tom Foremski, a former Silicon Valley correspondent for the UK's *Financial Times*, runs the SiliconValleyWatcher blog. He maintains that Silicon Valley has become a media valley. "Google publishes pages of content with advertising. So do Yahoo!, eBbay and many others. Facebook is a media company, and so are thousands of startups in the Web 2.0 space." Why were newspapers not part of this innovative media industry, he asked. Rafat Ali, CEO of ContentNext Media, parent of paidContent, said Silicon Valley companies succeeded because they were open to change. "Companies in Silicon Valley depend on having a fast-paced culture of innovation where no ideas are bad ideas, all voices are heard, and technology is embraced not feared." To achieve goals in competitive environments, teams had to work together without hidden agendas or "obsessive attention to where in the chain of command a new idea originates," he said.

Columnist Steve Outing said it was important for media organizations to experiment, fail and experiment more. Build plenty of digital services. "Every new experiment, and there should be lots of them, needs to have the content, technology, advertising and marketing people on the design team from the

beginning." Innovations that worked would produce advertising revenue and possibly user fees. Failures would bring more knowledge for the next project. It was important to involve people from other departments apart from editorial with each experiment. "Newspaper companies need to break down old walls during the innovation process. So if a team is developing a set of 'long-tail' niche mobile content services, for example, the advertising department should be in from the start."

Ben Hammersley, deputy editor of the UK edition of *Wired* magazine, agreed. News organizations should take their lead from companies like Google and Amazon who "killed" projects when they did not work, he told a conference for software developers *The New York Times* hosted in February 2009. New projects needed to be seen as applications, not media products. "You need to have a whole series of iterative testing and actual data-based research and development, which you just don't just get with old school media." The people who looked at new projects from an old-media point of view were not at fault. They did not have the mindset of software developers or software business people, he said. "The key metric that people should be looking at is not which companies launch new stuff the fastest. The key metric is which online companies kill the rubbish stuff the fastest," Hammersley said.

He suggested media companies had two options: Either aggregate cheap and plentiful content to draw in a mass audience, or choose high quality content that attracted fewer but more valuable people for advertisers. "Everything in the middle [between aggregation and high quality] will die away and you're going to see that in every industry." The current economic climate needed to be used as a catalyst for innovation, Hammersley said. "It's a difficult time to be launching a bad magazine." But even in a downturn people still wanted to advertise in a quality publication, he said.

Martin Baron, editor of *The Boston Globe*, emphasized the need for change in his 2009 Ruhl Lecture at the journalism school at the University of Oregon. Journalism needed many experiments and many new models, he said. "Some will be non-profit. But many will seek to make a profit, a big one. An era of entrepreneurship for journalism has begun." Baron noted that entrepreneurship was risky. "Experimentation will bring business failures. So do not go into this field for lifetime job security," he told students. "I am not here with easy answers, or even to provide comfort and reassurance. The answers must come from you – from a generation of journalists who are willing to try new things, journalists who will tell revealing stories in new ways and with dazzling new tools, and journalists who lust for professional adventure. And from a generation of journalists who can embrace all that is new without abandoning the best of journalism's traditions and principles...."

Global innovation

The rest of this chapter considers a range of innovations and entrepreneurial activities taking place at media organizations around the world. These ideas could easily be employed elsewhere. A good example of an innovative new newspaper is *E15* (15 minutes), which launched in the Czech Republic in 2008. It costs half a Euro (about 65 cents). Each day *E15* has 32 pages of A4, similar to American letter size, in full color with a consistent five-column grid on each page. The focus is business, but it appreciates that business people have limited time so the paper is designed for ease of reading, with lots of graphics and charts so readers can absorb information quickly. The five sections – news, culture, business, features and sport – are color coded so readers know where they are regardless of where they open the paper. A typical page has a lead story over the top two fifths of the page, a large (minimum 3 column) photograph, plus a combination of NIBs (News in brief items) and charts and graphs.

Peter Judd, former editor of the *Geelong Advertiser* in Victoria in Australia, is widely regarded as one of the most innovative editors in the Asia-Pacific region. Could newspapers achieve long-term viability in a universe of disloyal consumers who jump from web site to web site? The answer was a link between the virtual world and the real world. "MySpace and Facebook work because people share their physical world experiences – their photos, where they will meet, what shows they will see, their opinions about events – online." It was vital, he said, for media organizations to position themselves between the two worlds. "The real battleground is the local built environment. If newspapers own the built environment, then we create a valuable bridge to our papers and online."

Newspapers need to engage their audiences to be a catalyst for positive change. They have to become citizens' "real and true champions," Judd said. "Our role must change to be an even more powerful, trusted representative of the Fourth Estate. If we own that value positioning in the physical world, then this translates to positioning online. And it is a loyal following, with deeply embedded values." Judd cited his web site's Just Think anti-violence campaign, which was a spin-off from the news agenda in the newspaper. "This is where news meets society, where the *Geelong Advertiser* executes its role as a news medium, but reaches beyond that to make a real difference in our readers' lives within the Geelong community." The newspaper was accrediting safe nightspots and venues in partnership with Victoria Police. "Venues will need to lift their standards on such things as more CCTV, crowd control, safe areas to qualify for the branding – the Just Think tick – that will be affixed to their entrances." Staff would wear the *Geelong Advertiser* brand on their uniforms. That brand would be in every nightspot in the Geelong region,

promoting the value of increased community safety. "The Just Think positioning will extend to a code of conduct that every crowd controller in Geelong must sign as a requirement of working in a Just Think nightspot. Victoria Police and the Geelong Nightlife Association have agreed to these conditions."

The state government's Drinkwise campaign, which had the goal of raising awareness of alcohol-related violence and changing perceptions, had committed $70,000 to a new campaign, the Just Think Awards, Judd said. These would be available in every school in the Geelong region. "Drinkwise will follow-up with a second research study to measure the effectiveness of newspaper brand engagement as a means of changing community attitudes. A positive outcome from this has far-reaching implications for the role of newspapers in society." Plus it had a commercial value proposition that would resonate with advertisers, especially the state government. The Just Think awards were also available as a creative outlet for children: Awards would be given for best multimedia, best opinion, best poster, best research project and best web design around the Just Think theme. The newspaper publicized the awards, using a pool of writers recruited from high schools and the local university journalism program. The *Geelong Advertiser* was also working on new directions for the campaign: The relationship between alcohol and domestic violence, and accreditation of teen parties in conjunction with police and parents, Judd said. These would lead to a similar extended approach into the community. A range of community newspapers had adopted the Just Think campaign, Judd said, and it was likely other newspapers would get involved.

In an article published in January 2009 columnist Steve Outing suggested newspapers should employ a vice president for social networking. "Just as the traditional newspaper company has long had a vice president of circulation, the modern, digital-centric newspaper company needs a VP of social media." The aim is to integrate the newspaper's digital initiatives with social networks in the community. This would build traffic for a newspaper site's online and mobile services and also offer a revenue opportunity. A newspaper company with a social media VP could educate businesses in their market about the benefits of digital social marketing, and provide related services alongside other advertising options. "The Internet is slowly killing off the old model of marketing; the savvy newspaper can guide its client businesses into Marketing 2.0 (a.k.a., social marketing)." Newspapers already had established relationships with most businesses in their markets. Now they needed to add social media/marketing services to what they did for local businesses, Outing said.

Rich Gordon, a professor at the Medill school of journalism at Northwestern University, said newspapers should integrate content and user contributions via

existing social networks such as Facebook. "Why try to build your own network when your users have already formed them," he asked rhetorically. Facebook allowed people through its Facebook Connect service to log into "other" sites using a Facebook ID and to do things on those sites based on their social connections. The New Media Publishing Project class at Medill in fall 2008 set out to solve two challenging problems: Improving conversations around news, and building news engagement among young adults. The class launched News Mixer. It melded comments, short-format "quips" like question and answer, and letters to the editor into a site that used social networks via Facebook Connect. See http://www. medill.northwestern.edu/studentwork/archives. aspx?id=110531 More details can be found at http://www.pbs.org/idealab/rich_gordon/

Outing also suggested using beat reporters to create new niche products. Journalists should reach out to topic experts in the community to build interactive, conversational communities around the topic. "What I'm proposing is a bit of a do-more-with-less strategy, by amplifying the work of one professional journalist and topic expert with the voices of local experts, independent bloggers and enthusiasts of the topic. Build a network of these niche blog-social communities and get the ad department to sell into them. I'm talking about a newspaper using its existing resources (staff journalists who have specialties) to build a blog network locally."

Another innovation came from Daniel Victor, a reporter for *The Patriot-News* in Harrisburg, Pennsylvania, who launched Central PA NewsVote in March 2009. Victor, a general assignment reporter, took the best story ideas from the comments section of his blog, created a poll on the site and asked readers to vote on which story he should cover next. The audience became his assignment editor. The idea was to report on the hyper-local stories that mattered most to the community, Victor said. "I am trying to build up a bank of story ideas that people can vote on." Victor has already done a lot of work on Facebook and Twitter to get people used to sending pitches. "Our role is shifting. We are not just storytellers we are community-builders. Harnessing the power of the web is a crucial part of that." Victor said he started the blog to ask readers for their ideas of community-based, next-door stories that deserved attention. "I'm looking for stories of personal triumph, innovative classroom projects, new businesses opening, emerging trends, or anything else that shines the spotlight on a corner of your community that you consider a hidden treasure," he wrote when he launched the blog. "You'll submit your ideas as comments in the blog. I'll take some of the best ideas, throw them in poll form, and allow all readers to vote on which story I should tackle next. And that's the story I'll tell, in both the blog and the print newspaper."

The public response was very positive at the launch, and a good story was pitched the first time he tried, Victor said in an email interview. But the innovation was not designed to lessen the professional journalist's role. "At a challenging time in our industry, we need to be adapting to the interactivity that Internet users demand while still producing the ink-and-paper product that so many depend upon and love," he said.

On a much larger scale, Thomson Reuters launched a video news service in June 2009 for financial professionals as part of a $1 billion plan to appeal to a new generation of customers. The service provides live and searchable coverage of financial markets, analysis and breaking news. It contains no advertising and is not available to the public. But paying customers can access on-demand news segments in the same way people watch video clips on YouTube. Customers will be able to select videos on channels grouped by category, such as foreign exchange, equities or political news. They can find key words in transcripts that accompany the videos, send whole segments or parts via email to other people, and send segments to their Blackberry mobile devices to watch later. Despite the global economic downturn, the company had to invest in new ideas to keep performing well, said Devin Wenig, chief executive of Thomson Reuters' markets division. The new service gave financial professionals news they can use to make trades and other business decisions, but did not replace news articles, Wenig said. "To me, this is just Reuters News 2.0," he said. Chris Cramer, Reuters' global editor of multimedia, said content was vertical and designed for clients' needs. "We know through detailed user research that they want the facts, uncluttered and at a length they can cope with. Timely information and analysis in bite-sized chunks," Cramer said in a telephone interview. Users communicate with Reuters' program makers and journalists in real time, Cramer said, creating a financial community and an array of information verticals not currently available in the media marketplace. Cramer described it not as broadcasting, but "narrowcasting."

Dare to be different: *TriCityNews* of Monmouth County, New Jersey is prospering because it aggressively ignores the web. More importantly, it understands its audience. Dan Jacobson, publisher and owner, said putting content on the web would only help destroy his paper. "Why should we give our readers any incentive whatsoever to not look at our content along with our advertisements, a large number of which are beautiful and cheap full-page ads," he told media writer David Carr in an article published in *The New York Times* on December 21, 2008. That month the weekly newspaper published the biggest issue in its history. It has been growing about 10 percent a year since it launched in 1999. Jacobson said his newspaper had no debt. "Our office in downtown Asbury Park is very small, and

we have never raised our rates, so people tend to stick with us regardless of what is happening in the economic cycle," Jacobson said. *TriCityNews* has a print run of 10,000. It employs three journalists, some freelance columnists, and a half-time circulation person. "By setting rates low almost 10 years ago and never raising them or offering a web option, Mr. Jacobson has built a reliable cadre of advertisers who call for ads, sign up for full pages, and pay in advance. There are no people working for sales commissions," Carr wrote.

New lifestyle publications developed by *The Sydney Morning Herald* and the *Sun-Herald* produced $3.5 million of new revenue in less than a year for Fairfax Media in Australia. These were not "advertorials" or special reports, said Kylie Davis, managing editor for strategic publication, but high quality "customized environments for select clients." They were priced at a premium. Davis argued that customized editorial products were needed in today's market.

The "individuated" or personal newspaper was becoming more a reality as digital printing developed and distributors grew accustomed to new practices, said Peter Vandevanter, vice president for targeted products for the MediaNews Group in the US. The individuated newspaper would make possible highly targeted advertising and compete with direct mail advertising, a category that had grown significantly in the last 10 years. Readers would choose only the news and information they wanted to see each day. It would be printed at home or sent to a computer or cell phone. MediaNews Group is the fourth-largest newspaper chain in America. It has trademarked the term "individuated news" or "I-News" for a new delivery system. Audiences would become their own editor and publisher, said Mark Winkler, executive vice president of sales and marketing for MediaNews Group. "We want to give the consumer exactly what they want," he said. The "individuated" stories readers selected were sent to a special printer being developed for MediaNews. The printer that each customer would have at home would format the stories and print them, or send them to a computer or mobile phone for viewing later in the day. Where possible, advertisements would be matched to each reader's choice of stories. "Our greatest expense is printing and delivering a newspaper," Winkler said. Eliminating it would produce significant savings.

One technology identified for future distribution of news is "object hyperlinking." It involves using a mobile phone camera to photograph an image similar to a bar code with an encrypted URL in it. The URL opens in the phone browser. Object hyperlinking aims to extend the Internet by attaching tags with URLs to tangible objects or locations. These tags can then be read by a wireless mobile device and information about objects and locations retrieved and displayed. Several

different tagging systems are available. They include RFID or radio frequency identification devices, also known as an "arphid." These consist of a small transponder that can be read at short range by a transceiver or reader. Other forms include a Quick Response or QR code, various types of barcodes, and proprietary systems like ShortCodes. Semapedia is a project that uses QR codes to link Wikipedia articles with the actual subject. Reading a tag with a camera phone would retrieve an article from Wikipedia and display it on the phone screen, the so-called Mobile Wikipedia.

Tags have several advantages. They are cheap to produce and can be printed on almost anything, including t-shirts. Barcodes are popular forms of tagging because they are already widely used, and camera phones can read them easily. SMS tags consist of a short alphanumerical code that can be printed on a marker or written on a wall. A mobile phone's Short Message Service is then used to send the code and return a message. Nick Bilton from *The New York Times'* R&D Labs said sensors could make people's lives easier. "If your phone has GPS, then your location can influence what content you see. Or if you're in your car, your phone could sense that and so NYTimes.com could deliver the news to you in audio." The company had also been experimenting with semacodes in the newspaper. A semacode scans another person's phone screen or semacode social card. It has many applications for targeted advertising. A range of technologies such as e-ink and flexible displays (see the next chapter), full immersive video and graphical experiences, and more user-generated content were in train, Bilton said. All of these tools offered new ways for storytelling.

ShopItToMe emails members when retailers discount members' favorite designers. Users specify their preferred sizes and brands, and choose how frequently they want to be alerted. Could a newspaper employ a similar approach with targeted advertising, or details of an update to a favorite columnist? In Switzerland, Edipresse launched small community websites aimed at particular audiences. Funded by large international corporations and by universities, the websites are aimed at the Russian and English expatriate communities.

In Jordan, the newspaper *Alghad* faced a market saturated with television channels. Instead of reacting against the amount of television, it worked with the medium and launched a trivia program on television that awarded prizes for the audience's knowledge of the newspaper. *Alghad* secured the timeslot by agreeing to share profits from advertising with the station.

Coverage of the major bushfires in Victoria in Australia in February 2009 provided a good example of the power of a combination of online and print, said newspaper consultant Bernadine Phelan. She was impressed with the value,

speed and volume of content from the audience. "Many of the most compelling images and video/audio coming from the fires coverage were taken by the public." The bushfires highlighted many issues, such as proper process for handling huge volumes of contributed content, the kind of rigor a publisher should apply to material from the audience, and its presentation online to ensure readers were given correct "ownership." The *Herald Sun*, the highest-circulating daily in Victoria, realized quickly that many people were trying to find friends and family. The Red Cross could not release information and their switchboard was constantly engaged. The newspaper's online team set up an interactive message board for the public. Phelan said it was hugely popular. "So much so, it nearly melted the servers. The *Herald Sun* added even more servers and bandwidth because dozens of messages were arriving every few seconds." Phelan said the immediacy of the news that needed to be told obliterated any barriers between print and online. "Each realized the strengths of the other in telling the full story across all platforms."

Meanwhile in the UK, reporters at the *Financial Times* edit parts of their stories and write draft headlines as part of the paper's digital integration plan called Newsroom 2009. Editor Lionel Barber said reporters had to "take responsibility" for adding hyperlinks to their stories, running style checks and writing to a specific length for the newspaper. Although these added responsibilities do not appear onerous, assigning new tasks to reporters beyond the traditional work of researching and writing stories is a contentious issue at some newspapers. Barber said Newsroom 2009 did not alter the paper's approach to newsgathering or news priorities: "Our philosophy remains to deliver a snapshot of relevant business and financial news, analysis and commentary to a global audience around the clock." In a memo to staff in March 2009 he wrote: "We are not a news agency, we are not a general newspaper, we are the *FT* – and we intend to be a twenty-first-century news organization."

A former student came to see one of the authors. For five years after leaving university Brendan McAloon worked for two daily newspapers, before becoming a television producer. In the half decade since he left the print world, McAloon has developed a world reputation as a producer of surfing documentaries. He asked a question that is very relevant to the subject of this book: We live in a multimedia world, he said, yet newspapers continued to produce a single, linear product with limited options for distributing their content. Why?

McAloon focuses on producing multimedia content. His television programs about surfing are a niche focus. But a one-hour documentary on surfing that screens on free-to-air television is not his only format. His production company

puts rushes and out-takes from the filming of the documentary on the web as a promotion device and teaser. Shorter and longer versions of the documentary are cut into DVDs. All documentaries are produced in conjunction with their own magazine, which sometimes gives those DVDs away for free, attached to the front cover, to boost sales. He also organizes a web site dedicated to those documentaries. And sometimes his company will sell products related to the documentaries such as caps or shirts or bags or board-shorts. The point here is simple: Even a niche product like surfing can be offered in multiple forms. The challenge for media houses is to work out how to do that. They must become innovators and more entrepreneurial.

Clay Shirky summarized the state of journalism in an essay published July 2009 in the online journal *Cato Unbound*. "The journalistic models that will excel in the next few years will rely on new forms of creation, some of which will be done by professionals, some by amateurs, some by crowds, and some by machines. This will not replace the older forms of journalism, but then nothing else will either; both preservation and simple replacement are off the table. The change we're living through isn't an upgrade, it's an upheaval."

The next chapter examines how new forms of mobile reading devices such as e-readers and digital paper could reshape the news business.

Digital deliverance? Electronic paper and e-readers

Summary

Distribution and printing represent the most expensive part of producing the print version of a newspaper, accounting for at least 60 percent of costs, and often up to 70 percent. News consumers are turning increasingly to mobile devices to stay on top of events. Could new electronic reading devices such as Amazon's Kindle help reinvigorate the news industry by reducing production costs and satisfying readers' demands for convenient distribution models. This chapter focuses on issues related to e-readers and the effects this form of electronic distribution may have on journalism.

The world's largest newspaper printing plant, owned by News Corporation's UK arm, News International, started production in March 2008 in Broxbourne, north of London. It is larger than 20 football fields and can produce 3.2 million newspapers a night. Most of the national titles in the UK have purchased new presses in the past three to five years or use the Broxbourne site.

The plant, plus two other new presses built by Rupert Murdoch's UK unit, cost around $1billion. The cost of a printing press tends to be amortized over 30 years, so the money News Corporation spent works out at more than $30 million a year, not counting interest charges. By comparison, the cost of hosting a major web site that transfers a few hundred gigabytes of data a day is negligible. Distribution costs for online editions of newspapers are almost zero. But as earlier chapters have explained, revenue from online advertising has not grown enough to make it possible to turn off the printing presses.

Distribution, paper and printing account for at least 60 percent of the cost of a daily newspaper. Advertising subsidizes the newspaper's newsstand price. In a typical large daily, only about 15 percent of the total budget is spent on producing content. Amazon CEO Jeff Bezos told PBS's Nightly Business Report in February 2009 the newspaper industry was under "significant distress" because of the high costs of distribution and printing. A device like his company's Kindle e-reader could help remove those costs, and would change the economics of the newspaper business, Bezos said. He had a good point.

The e-reader is a mobile reading device designed primarily for storing and displaying digital documents. The best-known e-reader devices by mid-2009 were the Amazon Kindle, the iRex iLiad and the Sony Reader, though others have been announced for future release. They are used mostly for reading books, but daily newspapers are also available on them.

The number of e-readers sold in the US as of mid-2009 was tiny in comparison to the population as a whole. But it was way too early in the product cycle to know whether e-readers held little appeal to consumers, whether they were about to explode as a mass market device or somewhere in between.

Taking into consideration how much money could be saved on print production and distribution costs, some industry analysts have suggested news organizations look at subsidizing e-readers for subscribers, just as mobile phone operators have subsidized the cost of handsets for subscribers. Practicable problems with the idea abound. But consider the math, as calculated by *Silicon Alley Insider* in January 2009. The tech news web site looked at the cost of producing and distributing the print version of *The New York Times* versus the cost of giving away a Kindle to everyone who had subscribed to the paper for more than two years. After deducting the $200 million editorial department costs, which would remain constant under any form of distribution, the web site determined *The Times'* annual print delivery cost would be about $644 million compared with about $298 million to give a $359 Kindle to the 830,000 long-term *Times* subscribers. It's a substantial difference, obviously. As *Insider* pointed out, the concept is not realistic right now, not least because of the loss of advertising revenue a switch to the Kindle would entail. But it does reveal how inefficient print distribution is compared with digital alternatives.

Early in 2009 the Hearst Corporation announced it would release an e-reader for newspapers some time in 2010. It would be American letter size and weigh less than half a pound. In March 2009 the Silicon Valley-based Plastic Logic said it planned to release an e-reader in January 2010. The Plastic Logic product will have a screen 10.7 inches diagonally (about 27 cm) compared with the 6-inch (15cm) display of the Kindle. The Plastic Logic device would weigh about the same as

the Kindle (10.3 ounces or 292 grams) because it will be made from plastic rather than glass and silicon. It will also be more robust and durable, the company said. In April 2009 News Corp chief executive Rupert Murdoch suggested his company also was investing in a mobile device for reading newspapers on a screen. He did not provide details.

Amazon announced a large-screen version of the Kindle, the DX, in May 2009 at a packed press conference in New York. The Kindle DX has a 9.7-inch display and 3.3 Gb of storage. It allows people to read pdfs as well as download a huge range of books from Amazon. Three newspapers announced they would pilot the Kindle DX for distribution. *The New York Times*, the *Boston Globe* and the *Washington Post* said they would offer the DX for a subsidized price in exchange for long-term subscriptions. The publisher of *The New York Times*, Arthur Sulzberger Jr., told the audience during the May 7 announcement that his company had "embraced" the Kindle DX to demonstrate how the newspaper was interested in using all forms of distribution.

The e-readers on the market in 2009 were personal, like a cell phone, and about the size of a paperback book, while the Hearst, News Corp, Kindle DX and Plastic Logic versions were intended for newspapers. They are potentially attractive to audiences if newspapers can get the content and business model right. Hearst and its partners plan to sell the e-readers to publishers and take a cut of the revenue derived from selling magazines and newspapers on these devices. The publishers will develop their own branding and payment models.

The devices have other selling points. They are perceived as being greener than newsprint. Don Carli, executive vice president of SustainCommWorld, and senior research fellow with the Institute for Sustainable Communication, said print had come to be seen as a wasteful and environmentally destructive "despite the fact that much of print media is based on comparatively benign and renewable materials." Companies like Kodak had faced the same challenge as newspapers in trying to decouple the business of capturing and preserving memories from the business of selling analog film photography and photo-finishing systems. Newspapers were likely to face similar problems trying to decouple newsgathering, journalism and advertising from production and delivery in print to delivery via e-readers, Carli said.

"The carbon cost of print will no longer be swept under the rug. It will soon have to appear on the balance sheets of advertisers, publishers and retailers. It will also appear in the price tags of goods and services. Business models that fail to recognize full lifecycle cost and value will be unlikely to succeed going forward. As we exit the global recession we will simultaneously be transitioning to a low carbon global economy that will change the meaning and value of waste and

inefficiency," Carli said. Print would survive if it reconfigured its supply chains to use energy and materials more eco-efficiently and publishers would survive if they could decouple the message from the medium while meeting the requirement for "triple bottom" line results that were economically viable, environmentally restorative and socially constructive, he said. "The growing demand for sustainable business practices, lifecycle analysis and environmental product disclosure will impact e-reader manufacturers and digital media companies as well."

Desirable audiences

It is important to remember that desirable audiences (the AB demographic) for newspapers like *The New York Times* tend to be time poor. And time poor people appear to be reading fewer books than ever before. In February 2008 Apple CEO Steve Jobs, commenting on the first version of the Kindle e-reader at the Macworld show, said: "The whole conception is flawed...It doesn't matter how good or bad it [the Kindle] is, the fact is that people don't read anymore." Forty percent of the population of the US read one book or fewer in 2007. The issue for media companies trying to reach time-poor people is to give them content that is convenient to access and easy to absorb.

People might be reading fewer books. But they do spend a lot of time online, reading everything from newspapers to blogs to social networking updates to Twitter feeds.

The key attraction of an e-reader is the simplicity of operation, and the fact people can hold so much content on one lightweight device. Another key attraction is the ability to download a daily newspaper to the Kindle wirelessly in seconds. As of 2009 it was possible to subscribe to several dozen newspapers and magazines via Kindle. Most contain no advertising. *The Wall Street Journal, The New York Times* and *The Washington Post* were all available before people woke in the morning. A subscription to *The Washington Post* and the *Chicago Tribune* cost $9.99 a month, while *USA Today* cost $11.99 and *The New York Times* $13.99 a month. Magazines were delivered to the device before they hit the newsstands.

People who read newspapers and magazines also tend to be book readers. Bezos described the Kindle as a "purpose-built reading device," also noting that "the screen size is very good for reading," "it's readable in bright sunlight" and "it's just like a printed page." Blogs were also available, and updated throughout the day, Bezos told PBS's Nightly Business Report. In March 2009 Amazon said it would start selling e-books for reading on Apple's iPhone and iTouch devices.

Analysts had expected Amazon to follow the template Apple had created with the iPod and try to dominate the market with a must-have device. But it appeared Amazon's plan was to sell as many e-books as possible on its site, and make its money that way. Consumers will buy other Amazon products once they start buying e-books. "A lot of people thought Amazon was slavishly imitating the Apple model," Bill Rosenblatt, president of the consulting business GiantSteps Media Technology Strategies, told *The New York Times* that month. "It turns out they have a different model than Apple. They are smarter than everyone thought."

Meanwhile, Google announced plans to try to digitize all published books and as of early 2009 had scanned more than 1.5 million books into its online book search directory. People can read books in the public domain for free online at Google sites. For books under copyright, Google includes a brief description and links to places where people can buy the book or borrow it at a nearby library. In a statement on its web site, Google said: "Some of our critics believe that somehow Google Book Search will become a substitute for the printed word. To the contrary, our goal is to improve access to books – not to replace them."

Late in May 2009 Google said it planned to introduce a program that would let publishers sell digital versions of their newest books direct to consumers through Google. The move would pit Google against Amazon. Google has also made its Book Search service available on iPhones and phones like the G1 that run Google's Android operating system. In an era dominated by a recession, and with some people believing they are too time poor to read, will individuals buy e-readers if they can read books on hardware they already own?

A short history of e-books and e-readers

Michael Hart at the University of Illinois created the first e-book in 1971, when he put the text of America's Declaration of Independence on a computer network, like an early form of the Internet. Hart later founded the Gutenberg Project, an online collection derived from public domain books available for free download, along with audio books and digitized sheet music. By early 2009 the collection included more than 27,000 e-books.

A range of e-reader devices appeared in the late 1990s but they failed as consumer products because they could access only a limited number of file formats, their screens could not be read in bright light, and battery life was short. Most people ignored e-books and the e-reader remained a dream. But a new wave of

interest in e-readers and e-books emerged in the past few years. People started reading books on iPhones and new devices like the Sony Reader. iRex Technology's iLiad (a spin-off of Royal Philips Electronics) and Amazon's Kindle emerged, using "e-ink technology." Their screens have reduced glare and use less power than the LCD screens of previous devices.

Spread of e-ink

The E.Ink company was a startup based in Cambridge, Massachusetts that came out of research at M.I.T. The company supplies the electronic-ink technology used in the vast majority of e-readers on the market today, including Amazon's Kindle, devices from Sony and a range of new products like those Hearst and Plastic Logic plan to launch. In early June 2009 a Taiwanese company, Prime View International, or PVI, (http://www.pvi.com.tw/) bought E.Ink for $215 million. PVI is the world's largest maker of e-paper display modules. It acquired the e-paper business of Philips Electronics in 2005. E.Ink will continue to base its headquarters in Cambridge.

The beauty of the e-ink concept is that it simulates the look of ink on paper. The technology uses a layer of microcapsules filled with sub-micrometer black and white particles that create a low-power, reflective screen. These particles form images on the screen as though printed on the surface of the glass, and reviewers say the devices are extremely satisfying to read at long stretches. E.Ink products rely on the reflection of ambient light rather than on battery-sapping backlight. A company goal was to make displays that were not only flexible, but that also responded to touch. Sri Peruvemba, vice president of marketing at E.Ink, said adding touch sensing to this kind of display presented a whole new set of challenges. A number of ways were available to make screens touch sensitive, he said, but most were designed to work with a rigid screen.

Sony was a pioneer with e-ink with its first Sony Reader in 2005. In December 2008, Sony told *Forbes* magazine it had sold 300,000 Readers. In August 2009 Sony announced three new readers. These readers incorporated an interface similar to Apple's iTunes store, allowing people to buy books from the Sony Connect eBook store. Readers can display pdfs, blogs, RSS feeds and JPEGs and they can also play MP3 and other unencrypted audio files. Books are available via Sony's proprietary BroadBand eBook (BBeB) format.

The iRex iLiad e-reader (http://www.irextechnologies.com/products/iliad) can also download content from dedicated servers via a built-in wireless connection or

an attached Ethernet connection. In the United States, the iRex iLiad and Digital Reader 1000 could be purchased online. Consumers in Europe could buy the iLiad directly from iRex Technologies at www.irexshop.com, though the price in euros tended to be higher. Many of the devices do not carry advertising.

The top of the range Sony Reader, the PRS-900 released in August 2009, cost about $400 at the time of writing, and had a 7-inch touch screen and virtual keyboard. It was presumably meant to rival the Kindle 2. Amazon released the first version of the Kindle in 2007. Analysts estimate Amazon sold somewhere between 250,000 and 500,000 kindles in its first year on the market, though the company refused to disclose actual numbers. Amazon's kindle 2 appeared in February 2009 at a cost of $359. At the time of writing the cost of the device had dropped to about $300.

Amazon released the Kindle 2 in February 2009 with a more ergonomic display and a new joystick controller. It cost about $400. The top of the range Sony Reader, the PRS-700, also costs about $400 and has a 6-inch touch screen and virtual keyboard, which makes it smaller than the Kindle. The Sony Reader has a backlit display if people want to read in the dark, plus a touch-screen. In the US, the iRex iLiad and Digital Reader 1000 could be purchased online for $699 and $750, respectively, in early 2009. Consumers in Europe could buy the iLiad directly from iRex Technologies at www.irexshop.com, though the price is higher in euros.

One likely group of early adopters is frequent travelers who enjoy reading and want to lighten their carry-on bags. E-readers are about the size and weight of a single paperback book and can hold hundreds of books, periodicals and documents. They also have a long battery duty-cycle (all companies claim more than 10 hours on a single charge), turn on and off quickly, are relatively simple to use, and can be read comfortably in most lighting conditions, including bright sunlight. Amazon announced the Kindle 2 e-reader could hold up to 1,500 books, and the DX 3,000.

Forbes magazine argued in late 2008 that the iPhone was now a more popular e-reader than the Kindle because a free iPhone application called Stanza had been downloaded 1.2 million times, more than the number of Kindle units sold. Stanza offers mainly public domain content. With Stanza, people can buy books from a variety of e-book retailers directly from the phone. In late April 2009 Amazon bought Lexcycle, the company behind Stanza. At the time Stanza allowed users to browse a library of about 100,000 books and periodicals for the iPhone. Many were in the ePub format, a widely accepted standard for e-books that Amazon had yet to make available on the Kindle platform. An interesting contender is Shortcovers, an e-book application that includes the ability to share chapters with friends, offer commentary, Twitter about something they are reading, or rate a book. Writers can also upload their books to the site for consumption. Shortcovers

offers an example of what newspapers could be doing with an e-reader for their subscribers, giving them options that suit their lifestyles.

Smartphones like the iPhone have color screens, while most e-readers like the Kindle and the Heart and Plastic Logic devices have black and white screens. But the proposed Plastic Logic device has a touch screen like the iPhone. If the iPhone or other smartphones had larger screens (a tablet-sized Apple device was predicted for 2010), and services such as Stanza and Google Book Search continued their push for more mobile content, the e-reader concept could be applied to constantly changing information such as breaking news. We could then see more people reading newspapers on a plastic screen.

Technologies promised by Plastic Logic and the Hearst Corporation could revolutionize newspaper reading. Plastic Logic said its device would be thinner than a pad of paper and lighter than most business magazines, and would offer a better-quality reading experience than other electronic readers on the market today.

Bill Keller, executive editor of *The New York Times*, described himself as an "incurable optimist" when asked about the future of journalism. In a Q&A published on the newspaper's web site on January 28, 2009 Keller wrote of a "diminishing supply of quality journalism, and a growing demand" for it. He noted that *The Times* made a "modest" amount of money selling a downloadable newspaper for Kindle users and for subscribers to a service called Times Reader. "These services allow readers to load the entire paper into a portable device. In the case of Times Reader, the download has been especially designed to include full-color pictures, graphics and so forth. So some people *are* paying for *The Times* online. Just not enough of them. So far." The last two words of the quote suggest Keller's optimism, or the potential of e-readers.

One of Plastic Logic's key aims was to provide newspaper content on its e-reader. "Because of the size of our device, newspapers and magazines really are our core focus," Plastic Logic's vice president of business development Daren Benzi told the World Editors Forum of the World Association of Newspapers in early March 2009. Plastic Logic had signed deals with the *Financial Times* and *USA Today* and a range of other daily newspapers. Most will be offered on a subscription basis. With these partnerships Plastic Logic was building "the world's most relevant collection of digital content for business users on any e-reader platform," the company announced in a media release in February 2009.

The first version, due out in 2010, will have 16 levels of gray scale but Benzi said his company intended to produce a color device "in the near future." Eventually the device would show video. This would accommodate advertising as a revenue stream in addition to income from subscriptions. The aim was to provide an "overall mix of business models." Benzi said his conversations with

newspapers had focused on how they could work together to "drive new revenue and hopefully reach new customers for our partners." Customers had shown in the past they were prepared to pay for content, Benzi said, "you just have to give them the right experience."

Benzi said the time was right for e-readers: "I think that the factors and trends are much more aligned now than five years ago." Devices were smaller, lighter and easier to use, but mindsets had also changed, meaning that "people are a lot more comfortable reading digital content, and are more conscious of the benefits of getting their information this way." Reading the news on a smartphone was acceptable for people seeking only basic information, Benzi said. But Plastic Logic aimed to deliver a reading experience similar to newsprint.

Plastic Logic must expect competition from Hearst, which announced its large-format wireless e-reader would be "suited to the reading and advertising requirements of newspapers and magazines." Kenneth Bronfin leads the interactive media group for Hearst. He told *Fortune* magazine Hearst had deep expertise in the technology. Analyst Steve Yelvington noted that the Hearst Corporation invested in e-ink in the late 1990s. "I can't tell you the details of what we are doing, but I can say these devices will be a big part of our future," Bronfin told *Fortune*. The Hearst device has been designed with the needs of publishers in mind. It is likely to debut in black and white and later transition to high-resolution color with the option for video as the displays become more commercialized. Downloading content from participating newspapers and magazines will occur wirelessly. For durability, the device was likely to have a flexible core, perhaps even foldable, rather than the brittle glass substrates used in some e-readers.

Specialized newspaper e-readers would let readers "turn" digital pages instead of scrolling through them, so users will be able to see all advertisements on a page. This means advertisers might pay higher rates for e-reader advertisements than for web site advertisements, said Robert Larson, vice president for digital production at NY Times.com.

Plastic Logic was founded in 2008 and is based in Mountain View, California. The company's investors include Oak Investment Partners and Dow Venture Capital, and they have already poured more than $200 million into the project. Hearst is one of the largest and most diversified media companies in the world. It owns or has interests in almost 60 daily and 141 weekly newspapers and almost 200 magazines around the world. Some of the magazines are international brands, such as *Cosmopolitan, Country Living, Esquire* and *Harper's Bazaar.* Through Hearst-Argyle Television it owns 28 television stations that reach a combined 18 percent of American viewers, plus ownership of leading cable networks.

Digital Newsbooks

The Reynolds Journalism Institute, a research arm of the University of Missouri, has been test marketing a new revenue-generating digital product for publishers that the institute calls "Digital Newsbooks." These are visually rich e-books on newsworthy topics optimized for reading and navigating on electronic displays. Articles are repackaged and designed on a two-column grid. Digital Newsbooks have a page-based structure with no scrolling. Navigation is both sequential (by turning pages) and non-sequential (via hyperlinks). The content they produce consists primarily of investigative and explanatory journalism, including photos and graphics originally published in newspapers or magazines. Digital Newsbooks require no special software other than a pdf viewer. They are especially designed for speedy downloading and can be read on e-readers and most other mobile display devices including tablet PCs and notebook computers. The project initially produced Digital Newsbooks for members of the Digital Publishing Alliance, the institute's web site said. The alliance pursues new digital publishing strategies, products and business models that can be put to immediate and practical use. The Digital Publishing Alliance is a consortium of newspapers, magazines, news web sites, advertising agencies, public relations firms, and associations and foundations.

The institute planned to produce up to six Digital Newsbooks for members in 2009, at no cost beyond the publishers' annual membership fees. *The New York Times* has been selling Digital Newsbooks through its online store since August 2008. The URL is www.nytstore.com/NewsBook.aspx

Alliance members, the hosting services and the institute share revenues from the sale of Digital Newsbooks on the pilot web sites. The Reynolds Journalism Institute also works with alliance members and online companies to create and manage pilot web sites on which Digital Newsbooks are marketed and sold. The institute aggregates and analyzes data from the pilot web sites on which Digital Newsbooks are sold as well as from focus groups and other sources.

Digital Newsbooks are produced at the Reynolds Journalism Institute using Adobe Creative Suite publication design software in combination with a set of JavaScript automation tools developed at the institute. The institute said it would maintain high quality and preserve each publisher's branded presentation styles within the Digital Newsbook format. Roger Fidler, the institute's program director for digital publishing, and Amit Anil Vyawahare, a graduate research assistant from the university's Department of Computer Science and Engineering, developed the Digital Newsbook automation tools in 2008. The tools were written in

the JavaScript programming language for use with Adobe InDesign pagination software. They automate all of the repetitive, non-creative production processes from setting up the InDesign files and placing text files to adding hyperlinks for navigating between articles, pages and tables of contents. "With these tools, the time required for the non-creative production processes has been reduced from about eight hours to just a few minutes. And they have completely eliminated the errors that often occurred when these processes were done manually." These tools were being modified in 2009 to automate production of other types of complex documents intended for reading and navigating on computers and e-readers, the institute's web site said.

Ensuring that Digital Notebooks can be produced quickly is a key consideration. Right now, the time needed to produce one depends on the number of articles, photos and graphics. Conversion of information graphics tends to be the most time consuming task. Once the master styles file is created and the automation tools adapted, the turn-around time for a simple Digital Newsbook with four to eight articles and no information graphics that required conversion can be as short as one day, the institute site said. Digital Newsbooks with multiple information graphics usually can be produced in less than a week. Completed Digital Newsbooks are emailed to publishers for review and approval. "Ideally, Digital Newsbooks should be produced and made available for sale immediately after a series or special report has been published in print."

Where do we go from here? The final chapter brings all of the issues in this book together to assess how we can move forward through challenging times.

Into the future

The future is not some place we are going to, but one we are creating
— John Schaar, political theorist

The news business is undergoing turmoil and uncertainty as it makes the transformation into the digital age. Yet there is reason to be optimistic about the future. Interest in accurate and timely news and analysis is stronger than ever. Advances in technology have enabled journalism to flourish in remarkable ways – from instant global distribution to community participation to more powerful storytelling techniques. And the widespread perception remains that an informed public is necessary to uphold democracy. The problem still left unsolved, however, is how journalism will be funded. Traditional business models and methods have become outdated, but it is not clear what will replace them. Advertising will remain the single most important source of revenue for the news industry. But as we explored in previous chapters, the advertising business model for news organizations has been permanently undercut by increased competition online, free advertising sites for classified ads and dramatically lower rates for digital advertising compared with print. Throughout this book we have examined new commercial models beyond advertising and in some cases, new ways to attract advertisers. Some of these new models may flourish, some will fail.

Ultimately, we believe, news organizations will rely on a combination of revenue sources. Each news provider will employ models that are particularly well-suited to their own style of journalism. It will be impossible to apply a one-size-fits-all commercial solution to the wide-ranging forms of news dissemination that are now possible. Hyperlocal to global, bedroom blogger to supersize

newsroom, trained journalists to community activists – all forms will require a tailor-made approach to funding.

Amid the confusion over what will happen to the news industry, some outcomes and scenarios appear certain. Print publishing will continue to recede. Whether that happens slowly or rapidly will depend on a number of factors such as the general health of the economy – and with it the advertising industry – the influence of government regulation, the speed at which new communication technologies are adopted by the masses and the efforts by news media proprietors to either slow down or speed up the transition from print to digital news distribution. Although the decline of print publishing is inevitable, it makes short-term commercial sense for some newspaper owners to perpetuate print publishing for as long as possible while the bulk of their revenue is generated through that format. The problem with that strategy, though, is that it delays finding a solution to the urgent issues the industry faces. But whatever the time frame, the marginalization of print is certain. John Puchalla, a senior analyst at Moody's Investors Service, highlighted the problem in a June 2009 report in which he called the cost structure of newspaper publishing "distorted." He noted that 70 cents in each dollar of a newspaper's costs were spent on paper, printing, distribution and corporate functions. Only 14 per cent of American newspapers' operating expenses were spent generating editorial content. The other 16 percent of costs were related to advertising and marketing. Similar cost structures operate at newspapers elsewhere in the world.

Technology pundit and academic Clay Shirky believes organizational forms perfected for industrial production like the newspaper need to be replaced with structures optimized for digital data. "It makes increasingly less sense even to talk about a publishing industry," he wrote, "because the core problem publishing solves – the incredible difficulty, complexity, and expense of making something available to the public – has stopped being a problem." Print newspaper publishing will contract but is likely to remain as a niche product for some time, as long as there is a receptive audience and as long as it continues to solve problems. For example, printed newspapers continue to thrive in India, which has a low penetration of broadband Internet (5.2 percent of the population in 2009 and concentrated in the major cities). But as literacy rates and Internet penetration increase, as trends show they will, Indian news consumers are more likely to seek information online, just as their counterparts in other countries do.

Of all the new digital formats and platforms for distributing news content, the ones which most closely resemble the traditional print newspaper are e-readers, such as Amazon's Kindle and the Sony Reader. Although content on e-readers arrives digitally and is viewed on a screen, the hand-held devices

still provide the look and sense of reading print material. Initial public reaction to e-readers as a vehicle for newspaper and magazine distribution shows some promise – but also highlights problems to be worked out. Some early technology adopters have proved willing to pay subscription charges to receive newspapers on their Kindles. But the subscription numbers remain small as e-readers try to attract mass market status. Even if e-readers begin selling in huge volumes, there are additional problems to surmount for the news business. For example, publishers have voiced concern about the huge cut Amazon is demanding from subscription fees – up to 70 percent, according to reports. Media executives, including Rupert Murdoch, also have complained that when they sell news content through the Kindle, it is Amazon that controls the important transactional relationship with the customer, not them.

Also hindering business development is the lack of single technology standard among the range of competing e-reader devices. Content formatted for one device cannot be viewed easily on a competing device. Lack of interoperability would also hinder any attempts for news organizations to rally around one standard. Industry strategists have discussed the possibility of subsidizing the relatively high cost of e-readers for committed news subscribers, as some cell phone operators and cable TV companies have done to get their equipment into the hands of customers. But, again, fragmented standards would make this difficult.

Another aspect of the Kindle and other e-readers that is often overlooked in commercial discussions, but is worth exploring, is that it operates outside of web browsers. This appears to hold psychological significance for some digital content consumers. In the ongoing drive to get consumers to pay for online content, analysts have observed that some online users believe that by paying for Internet access, they already have paid for all the content on the Internet, so there should not be extra charges. However, there is noticeably less resistance to paying for content that exists outside of browser windows. Besides e-reader content, examples include cell phone ringtones, Apple's iTunes store and Sony's computer games magazine *Qore*, which can only be purchased through a PlayStation. The highly popular London-based digital music service Spotify, which operates a free ad-supported service and a premium subscription service also operates outside web browsers. Users must download proprietary software to access the service. It is not clear at this writing whether Spotify will prove successful. But it is worth noting that the fledgling service has attracted tens of millions of dollars in venture capital and millions of subscribers in Europe – mostly to its free service – while a number of web-based digital music services were faltering or closing.

In researching this book, we were encouraged to see widespread experimentation with new forms of journalism. Hyperlocal, citizen journalism and pro-am efforts are emerging in great numbers, often spurred by the large number of journalists who have lost their jobs at mainstream news organizations in recent years. At the time of this writing, a new organization was being created in the San Francisco Bay Area that combines elements of philanthropy, non-profit status, and a partnership between a university and a professional news organization – all models we have discussed at length. The new service, which will receive $5 million seed money from financier Warren Hellman, will provide local news across multiple platforms, but mainly online, with editorial work provided by staffers at San Francisco public radio station KQED-FM and the 120 students of the University of California, Berkeley's graduate school of journalism, who will work for free, but receive course credit. The initiative is a response to the decreased news output from the *San Francisco Chronicle* and other mainstream Bay Area news providers. While the news project has been generally welcomed, there were immediate concerns, including whether the free student labor from the UC journalism school amounted to exploitation, would meet journalism quality standards and if it would result in fewer jobs for professional journalists. Concerns such as these will continue to arise as journalism reinvents itself.

Among the other model and concepts we believe deserve greater exploration are the use of social media to create greater user loyalty, and e-commerce to capitalize on user loyalty and generate new sources of revenue. Though developing a social media strategy and an e-commerce strategy are completely different kinds of exercises, they share the need to connect with users. As we pointed out in the chapter on microeconomic concepts (Chapter 10), marketing tools such as "lock-in" and "network effects" can be highly effective methods of building user loyalty. These tactics can be developed through greater use of social media. Having a committed and engaged group of followers will mean more commercial opportunity. We believe that e-commerce must play a larger role in generating revenue for news organizations as advertising expenditure continues to dissipate and spin off in new directions. Media companies that are trusted by their users and engage with them will be the most successful at building commercial relationships with them. As we have also pointed out, it will also be essential to create a simple payment system, particularly one that does not exclude the many news consumers who cannot, or will not, use a credit card online.

As we write this, a great debate is raging within journalism circles about whether it is possible to get users to pay for online news content. Notably, the

most vocal advocates pushing the idea that consumers can be forced to pay on the web come from the highest executive levels of the traditional print news business. These proponents say that, given the right kind of payment system, and the threat of being blocked from reading their favorite newspapers and magazines, online consumers will start anteing up for digital publications the way many people still do for printed news – with a dollar for a copy of the paper, or maybe a daily subscription. Or perhaps even paying a few pennies for each story they read. We are among the many who believe this is not possible. Yes, there will be types of content that some users will pay for. We have discussed why people will pay for financial news in the online editions of *The Wall Street Journal* and the *Financial Times*, the value of difficult-to-obtain professional information and the user loyalty generated by niche and passion content. But there is no evidence that large numbers of consumers will ever pay for commoditized news that is freely available elsewhere.

Other ways of funding journalism will have to be found. We believe that, through innovation, experimentation, collaboration, entrepreneurship and, probably, serendipity, they will be. And we hope that with this book, we have helped move that process forward.

Index